Digital Video For Dummies, 2nd Edition

Cheat Sheet

Adding Sound Effects to Movies

Here's how you can add a sound effect to a movie in iMovie on your iMac:

1. **With a movie on the Storyboard, select a sound effect from the Audio list.**
2. **Drag the sound effect to the approximate place where you want it to begin.**

 After you have released the mouse, you can highlight the sound effect and drag it to the exact starting point.
3. **Using the same procedure, drag additional sound effects onto a soundtrack until you have covered the area you want to have sound.**

 You can layer sounds on top of each other if you wish to create a whole forest of sound.
4. **Modify the sound effect's volume by clicking the left dumbbell and then sliding the audio volume slider to the left (softer) or the right (louder).**
5. **Set fade in and fade out as needed.**
6. **Continue with your editing or proceed to export your movie.**

Attaching Movies to E-mail

When using Windows Movie Maker, you can send your movie as an e-mail attachment.

1. **Click File⇨Send Movie To⇨E-mail.**

 The Send Movie via E-mail dialog box appears. If you wish, you can give your movie a title and add a text description of the movie.
2. **Click OK.**

 The Name the movie to send dialog box appears. Give your movie a name.
3. **Click OK.**

 Movie Maker makes your e-mail attachment movie file. The E-mail Movies dialog box appears.
4. **Select your e-mail program.**

 Most likely, you should choose the Default e-mail program option. Your e-mail program appears with your movie attached. After your e-mail program appears, simply complete your letter like any other e-mail.

For Dummies®: Bestselling Book Series for Beginners

Digital Video For Dummies, 2nd Edition

On-Location Checklist

When you are going to shoot some video, you usually need more than just your camcorder. Don't forget the following:

- Tripod
- Microphones
- Extra batteries
- Spare tapes for the camcorder
- Permission from the people you are shooting
- Blankets (drape them over flat surfaces to prevent echoes)
- Lens cloth and canned air
- Storyboard or script

Adobe Premiere Shortcuts

Using the keys on your keyboard (but not the numeric pad at the far-right of your keyboard), perform these shortcuts in the Monitor, Timeline, or Clip window:

Premiere Keyboard Shortcuts

Key	Function
2	Move forward one frame
1	Move back one frame
4	Move forward five frames
3	Move back five frames
A	Go to first frame
S	Go to last frame

For Dummies®: Bestselling Book Series for Beginners

 ™

BESTSELLING BOOK SERIES

References for the Rest of Us!®

Are you intimidated and confused by computers? Do you find that traditional manuals are overloaded with technical details you'll never use? Do your friends and family always call you to fix simple problems on their PCs? Then the *...For Dummies*® computer book series from IDG Books Worldwide is for you.

...For Dummies books are written for those frustrated computer users who know they aren't really dumb but find that PC hardware, software, and indeed the unique vocabulary of computing make them feel helpless. *...For Dummies* books use a lighthearted approach, a down-to-earth style, and even cartoons and humorous icons to dispel computer novices' fears and build their confidence. Lighthearted but not lightweight, these books are a perfect survival guide for anyone forced to use a computer.

> *"I like my copy so much I told friends; now they bought copies."*
>
> — **Irene C., Orwell, Ohio**

> *"Quick, concise, nontechnical, and humorous."*
>
> — **Jay A., Elburn, Illinois**

> *"Thanks, I needed this book. Now I can sleep at night."*
>
> — **Robin F., British Columbia, Canada**

Already, millions of satisfied readers agree. They have made *...For Dummies* books the #1 introductory level computer book series and have written asking for more. So, if you're looking for the most fun and easy way to learn about computers, look to *...For Dummies* books to give you a helping hand.

1/99

Digital Video

FOR

DUMMIES®

2ND EDITION

Digital Video
FOR
DUMMIES®
2ND EDITION

by Martin Doucette

IDG Books Worldwide, Inc.
An International Data Group Company

Foster City, CA ◆ Chicago, IL ◆ Indianapolis, IN ◆ New York, NY

Digital Video For Dummies®, 2nd Edition

Published by
IDG Books Worldwide, Inc.
An International Data Group Company
919 E. Hillsdale Blvd.
Suite 300
Foster City, CA 94404
www.idgbooks.com (IDG Books Worldwide Web Site)
www.dummies.com (Dummies Press Web Site)

Library of Congress Control Number: 00-109066

ISBN: 0-7645-0806-7

Printed in the United States of America

10 9 8 7 6 5 4 3 2 1

2B/RT/QS/QR/IN

Distributed in the United States by IDG Books Worldwide, Inc.

Distributed by CDG Books Canada Inc. for Canada; by Transworld Publishers Limited in the United Kingdom; by IDG Norge Books for Norway; by IDG Sweden Books for Sweden; by IDG Books Australia Publishing Corporation Pty. Ltd. for Australia and New Zealand; by TransQuest Publishers Pte Ltd. for Singapore, Malaysia, Thailand, Indonesia, and Hong Kong; by Gotop Information Inc. for Taiwan; by ICG Muse, Inc. for Japan; by Intersoft for South Africa; by Eyrolles for France; by International Thomson Publishing for Germany, Austria, and Switzerland; by Distribuidora Cuspide for Argentina; by LR International for Brazil; by Galileo Libros for Chile; by Ediciones ZETA S.C.R. Ltda. for Peru; by WS Computer Publishing Corporation, Inc., for the Philippines; by Contemporanea de Ediciones for Venezuela; by Express Computer Distributors for the Caribbean and West Indies; by Micronesia Media Distributor, Inc. for Micronesia; by Chips Computadoras S.A. de C.V. for Mexico; by Editorial Norma de Panama S.A. for Panama; by American Bookshops for Finland.

For general information on IDG Books Worldwide's books in the U.S., please call our Consumer Customer Service department at 800-762-2974. For reseller information, including discounts and premium sales, please call our Reseller Customer Service department at 800-434-3422.

For information on where to purchase IDG Books Worldwide's books outside the U.S., please contact our International Sales department at 317-572-3993 or fax 317-572-4002.

For consumer information on foreign language translations, please contact our Customer Service department at 1-800-434-3422, fax 317-572-4002, or e-mail rights@idgbooks.com.

For information on licensing foreign or domestic rights, please phone +1-650-653-7098.

For sales inquiries and special prices for bulk quantities, please contact our Order Services department at 800-434-3422 or write to the address above.

For information on using IDG Books Worldwide's books in the classroom or for ordering examination copies, please contact our Educational Sales department at 800-434-2086 or fax 317-572-4005.

For press review copies, author interviews, or other publicity information, please contact our Public Relations department at 650-653-7000 or fax 650-653-7500.

For authorization to photocopy items for corporate, personal, or educational use, please contact Copyright Clearance Center, 222 Rosewood Drive, Danvers, MA 01923, or fax 978-750-4470.

is a registered trademark under exclusive license to IDG Books Worldwide, Inc., from International Data Group, Inc.

IDG BOOKS
WORLDWIDE

About the Author

Marty Doucette is a video producer, multimedia author, and freelance educational program developer and writer. His clients include Sylvan Learning Systems, Delphi Automotive, the Department of Justice, FEMA, the American Institute of Architects, and the State of Indiana. Marty has designed video production studios and frequently consults corporations in selecting video production equipment and software. He is also author of *Microsoft Project 2000 For Dummies*.

Marty resides with his beautiful wife, Lorita, and their four children, Nicole, Ariel, Lindsay, and Eve, in Indianapolis, Indiana.

ABOUT IDG BOOKS WORLDWIDE

Welcome to the world of IDG Books Worldwide.

IDG Books Worldwide, Inc., is a subsidiary of International Data Group, the world's largest publisher of computer-related information and the leading global provider of information services on information technology. IDG was founded more than 30 years ago by Patrick J. McGovern and now employs more than 9,000 people worldwide. IDG publishes more than 290 computer publications in over 75 countries. More than 90 million people read one or more IDG publications each month.

Launched in 1990, IDG Books Worldwide is today the #1 publisher of best-selling computer books in the United States. We are proud to have received eight awards from the Computer Press Association in recognition of editorial excellence and three from Computer Currents' First Annual Readers' Choice Awards. Our best-selling *...For Dummies®* series has more than 50 million copies in print with translations in 31 languages. IDG Books Worldwide, through a joint venture with IDG's Hi-Tech Beijing, became the first U.S. publisher to publish a computer book in the People's Republic of China. In record time, IDG Books Worldwide has become the first choice for millions of readers around the world who want to learn how to better manage their businesses.

Our mission is simple: Every one of our books is designed to bring extra value and skill-building instructions to the reader. Our books are written by experts who understand and care about our readers. The knowledge base of our editorial staff comes from years of experience in publishing, education, and journalism — experience we use to produce books to carry us into the new millennium. In short, we care about books, so we attract the best people. We devote special attention to details such as audience, interior design, use of icons, and illustrations. And because we use an efficient process of authoring, editing, and desktop publishing our books electronically, we can spend more time ensuring superior content and less time on the technicalities of making books.

You can count on our commitment to deliver high-quality books at competitive prices on topics you want to read about. At IDG Books Worldwide, we continue in the IDG tradition of delivering quality for more than 30 years. You'll find no better book on a subject than one from IDG Books Worldwide.

John J. Kilcullen

John Kilcullen
Chairman and CEO
IDG Books Worldwide, Inc.

**Eighth Annual
Computer Press
Awards ≥1992**

**Ninth Annual
Computer Press
Awards ≥1993**

**Tenth Annual
Computer Press
Awards ≥1994**

**Eleventh Annual
Computer Press
Awards ≥1995**

IDG is the world's leading IT media, research and exposition company. Founded in 1964, IDG had 1997 revenues of $2.05 billion and has more than 9,000 employees worldwide. IDG offers the widest range of media options that reach IT buyers in 75 countries representing 95% of worldwide IT spending. IDG's diverse product and services portfolio spans six key areas including print publishing, online publishing, expositions and conferences, market research, education and training, and global marketing services. More than 90 million people read one or more of IDG's 290 magazines and newspapers, including IDG's leading global brands — Computerworld, PC World, Network World, Macworld and the Channel World family of publications. IDG Books Worldwide is one of the fastest-growing computer book publishers in the world, with more than 700 titles in 36 languages. The "...For Dummies®" series alone has more than 50 million copies in print. IDG offers online users the largest network of technology-specific Web sites around the world through IDG.net (http://www.idg.net), which comprises more than 225 targeted Web sites in 55 countries worldwide. International Data Corporation (IDC) is the world's largest provider of information technology data, analysis and consulting, with research centers in over 41 countries and more than 400 research analysts worldwide. IDG World Expo is a leading producer of more than 168 globally branded conferences and expositions in 35 countries including E3 (Electronic Entertainment Expo), Macworld Expo, ComNet, Windows World Expo, ICE (Internet Commerce Expo), Agenda, DEMO, and Spotlight. IDG's training subsidiary, ExecuTrain, is the world's largest computer training company, with more than 230 locations worldwide and 785 training courses. IDG Marketing Services helps industry-leading IT companies build international brand recognition by developing global integrated marketing programs via IDG's print, online and exposition products worldwide. Further information about the company can be found at www.idg.com. 1/26/00

Dedication

To my mother. I wish that all of us could see life as beautifully as you do.

Author's Acknowledgments

Writing is not a lonely experience. At least it isn't for me. I have had help from some very talented and dedicated people — without whom this book wouldn't be possible.

First, thanks to Steve Hayes, acquisitions editor at IDG Books Worldwide, Inc., for his ongoing commitment to seeing that only the best is acceptable. Thanks to Mica Johnson, project editor, for her kind ways of keeping the reader the focus of the writing. Thanks to Amy Pettinella for her commitment to every detail of the book. Also my thanks to the contributions made by Dr. Dennis Short for his technical expertise, Maridee Ennis for her coordination efforts, and the entire IDG staff for their assistance.

Publisher's Acknowledgments

We're proud of this book; please register your comments through our IDG Books Worldwide Online Registration Form located at www.dummies.com.

Some of the people who helped bring this book to market include the following:

Acquisitions, Editorial, and Media Development

Project Editor: Mica Johnson

Senior Acquisitions Editor: Steven H. Hayes

Copy Editor: Amy Pettinella

Proof Editor: Mary SeRine

Technical Editor: Dr. Dennis Short

Permissions Editor: Laura Moss

Media Development Specialist: Jamie Hastings-Smith

Media Development Coordinator: Marisa Pearman

Editorial Manager: Jeanne Criswell

Media Development Manager: Laura Carpenter

Media Development Supervisor: Richard Graves

Editorial Assistant: Candace Nicholson

Production

Project Coordinator: Maridee Ennis

Layout and Graphics: Brian Drumm, Jill Piscitelli, Brian Torwelle, Jeremey Unger

Proofreaders: Carl Pierce, Dwight Ramsey, Marianne Santy, Susan Sims

Indexer: York Production Services, Inc.

Special Help
Nicole Laux, Rebekah Mancilla, Sarah Shupert, Keith Underdahl

General and Administrative

IDG Books Worldwide, Inc.: John Kilcullen, CEO; Bill Barry, President and COO; John Ball, Executive VP, Operations & Administration; John Harris, CFO

IDG Books Technology Publishing Group: Richard Swadley, Senior Vice President and Publisher; Mary Bednarek, Vice President and Publisher; Walter R. Bruce III, Vice President and Publisher; Joseph Wikert, Vice President and Publisher; Mary C. Corder, Editorial Director; Andy Cummings, Publishing Director, General User Group; Barry Pruett, Publishing Director

IDG Books Manufacturing: Ivor Parker, Vice President, Manufacturing

IDG Books Marketing: John Helmus, Assistant Vice President, Director of Marketing

IDG Books Online Management: Brenda McLaughlin, Executive Vice President, Chief Internet Officer; Gary Millrood, Executive Vice President of Business Development, Sales and Marketing

IDG Books Packaging: Marc J. Mikulich, Vice President, Brand Strategy and Research

IDG Books Production for Branded Press: Debbie Stailey, Production Director

IDG Books Sales: Roland Elgey, Senior Vice President, Sales and Marketing; Michael Violano, Vice President, International Sales and Sub Rights

◆

The publisher would like to give special thanks to Patrick J. McGovern, without whom this book would not have been possible.

◆

Contents at a Glance

Cartoons at a Glance

By Rich Tennant

The 5th Wave — By Rich Tennant

"WELL! IT LOOKS LIKE SOMEONE FOUND THE 'LION'S ROAR' ON THE SOUND CONTROL PANEL."

page 265

The 5th Wave — By Rich Tennant

"I failed her in algebra but was impressed with the way she animated her equations to dance across the screen, scream like hyenas, and then dissolve into a clip art image of the La Brea Tar Pits."

page 233

The 5th Wave — By Rich Tennant

NOT EVERYONE AT MEDVILLE HIGH SCHOOL EMBRACED MULTIMEDIA TEACHING WITH EQUAL PROFICIENCY.

"Multimedia is a wonderful combination of video, sound, graphics, animation, text... ...and nightmares."

page 7

The 5th Wave — By Rich Tennant

"What do you mean you're updating our Web page?"

page 31

The 5th Wave — By Rich Tennant

"Of course graphics are important to your project, Eddy, but I think it would've been better to scan a picture of your worm collection."

page 105

The 5th Wave — By Rich Tennant

"I found these two in the multimedia lab morphing faculty members into farm animals."

page 175

Cartoon Information:
Fax: 978-546-7747
E-Mail: richtennant@the5thwave.com
World Wide Web: www.the5thwave.com

Table of Contents

Introduction

Scenario one: At this moment, thousands of people are recording video with their digital camcorders or editing digital video with their computers. Such a lovely, peaceful, pastoral image!

So excuse me, but I need to ask you a little question. What are you doing reading this book when you could be out there recording and editing with all those happy people? My guess is that you're smart. You probably wonder how much of the hoopla about digital video is for real. You've learned through experience that knowledge is always the key to success. So you want to know more — maybe a lot more — before you buy. You want to make sure you get the most out of what you purchase. Very smart.

Scenario two: You've just purchased a digital camcorder, and you've got a computer with video editing software. Congratulations! If you have a bead of cold sweat on your brow and your heart is thumping more loudly than normal, it might be because you don't know what to do next. Take a deep breath. You're going to be okay. You haven't made any bad decisions. In fact, you've made some great decisions in choosing digital video. You're just feeling the normal reactions of a savvy individual who has just realized something: You need some help in getting the most out of your camcorder and your computer's editing software! Well, guess what? You've made another great decision. You bought this book.

About This Book

A well-made digital video movie is a compilation of successful decisions. This book shows you how to make those decisions. You don't need to have any prior experience. To begin, all you need is a little curiosity and the desire to have some fun.

Digital Video For Dummies, 2nd Edition contains helpful ideas on how to:

- ✔ Record or film your video.
- ✔ Edit your video.
- ✔ Create better videos by adding graphics and sound.
- ✔ Edit your videos with iMovie, Movie Maker, and Premiere.
- ✔ Place your end product on videotape, CD-ROM, or the Web.

You also find out about the kind of equipment and materials you need to get started in digital video, along with some important tricks of the trade. By the time you finish this book, you'll be beyond just shooting videos; you'll be producing *professional-looking* videos. You'll be creating graphics and performing video editing. You'll know how to produce video that can be recorded to VHS video, CD-ROM, and the Internet.

The CD at the back of this book is a gold mine of sample software programs, example graphics, audio files, and movies — all awaiting your discovery.

Conventions Used in This Book

As you read this book, you'll see that some words have a letter that's underlined. These letters denote keyboard shortcuts for commands. For example, you can press the Alt key in combination with the underlined letter to choose a command quickly.

On the other hand, two words that are joined by a little arrow are actions you select in the given sequence. For example, if you see File⇨Print, click the File menu and then click the Print command in the menu. Or, as I mention above, you can also press Alt plus F and then P.

What You Don't Have to Read

I've labeled some interesting, but not absolutely essential, information within the chapters with a technical stuff icon. Some of you like to know the reasons behind the reasons so you may want to peruse this information. If not, skip right on by (figuratively of course) and enjoy the rest of the book!

Foolish Assumptions

I base all the steps and my computer and software suggestions on the assumption you are using Windows 98 on your PC or OS 9 on your Mac. The tryout software and sample files on the CD work on Windows 95, Windows 98, and Windows NT 4.0 or later operating systems and on iMac computers.

How This Book Is Organized

This book is organized into five parts. Each part is a logical grouping of chapters with each chapter focusing on a major point about digital video. In each

chapter, you'll find enough — but not too much — specific direction to make you a budding star in home moviemaking and video creation.

You don't have to read this book chapter-by-chapter. Each chapter is written to stand on its own. But, then again, you may find the logical order of the chapters quite helpful. Read the book any way you want. You're the boss.

Part 1: Diving Into Digital Video

The first couple of chapters in *Digital Video For Dummies,* 2nd Edition provide an overview of digital video and the kinds of things you need to know when selecting the right digital camcorder for your needs. Chapter 1 introduces you to all the pieces that make up digital video. Chapter 2 walks you through all the important features of digital camcorders and compares one camcorder to another.

Part 11: Shooting Digital Video

One of the easiest and most important ways to maximize the potential of digital video is simply to know how to use a camcorder. I don't mean knowing how to turn it on and off; I mean knowing how to make the most of your camcorder's lens and electronic features. Your digital camcorder is a tribute to incredible breakthroughs in video technology. You need to take advantage of that new technology. Part II introduces you to your digital camcorder's potential (Chapter 3).

Your digital camcorder is amazingly faithful in reproducing what it sees and hears. For that reason, the more you know about light and sound, the more you can take advantage of your camcorder's high-quality reproduction capability. Part II walks you through the time-honored practices of using light (Chapter 4) and sound (Chapter 5) to enhance your videos.

Digital video offers you the opportunity to paint a beautiful picture — to capture a breathtaking moment. You may want to know some simple steps that make the most of your shots. Part II concludes by introducing you to the basics of video production planning and scene direction (Chapters 6 and 7).

Part 111: Editing Digital Video with Your Computer

A revolutionary aspect of digital video is what you can do with your video on a computer. Chapter 8 describes the hardware and operating systems information you need to import video into your computer and use your computer

as a video editing workstation. Chapter 8 also shows you a sample digital video capture card and its accompanying software.

Part III also introduces you to some awesome and easy-to-use computer software programs. Although these programs are shareware, trial versions, or demos, you can try these programs out and see if they fit you and your goals for digital video. Within minutes, you'll be able to you create a timeline in Adobe Premiere 5.0, edit movies with Microsoft Movie Maker, and make marvelous movies on your iMac with iMovie.

Part IV: Jazzing Up Your Video with Photos

Have a clip of video that would be perfect as a photo? Then Film Factory and Adobe Photoshop are just for you! I round off this section with ideas on how to take your absolutely fabulous videos and photos and upload them to the Web, send as e-mail, or print them out.

Part V: The Part of Tens

So you want to make a fascinating movie but you don't know where to start? This Part has a couple of chapters that just might get you going in the right direction. Chapter 15 gives ten helpful hints for making a home movie that people actually would like to watch. Chapter 16 provides some suggestions on what to do and not do when you shoot a wedding.

Unless you live in a very large city, you don't have access to all the equipment and software you may need for digital video shooting and editing. No problem. In Chapter 17, you hit the Internet and find some amazing bargains for your camcorder and computer. Chapter 18 is a companion to Chapter 2: It helps you make informed decisions about purchasing a camcorder and a computer.

Part VI: Appendixes

This part has two appendixes. Appendix A tells you how to copy or install all the neat-o stuff from this book's CD onto your computer. Appendix B is a glossary of video creation and editing terms.

Icons Used in This Book

 Alerts you to relevant sample files or to try out software on the CD that comes with this book.

Suggests that you commit to memory an important fact about creating or editing video.

Signals something technically wild and wonderful (if you're not already tuned in to technospeak). The information here may be interesting and useful, but it's not essential to doing business.

Flags a friendly little shortcut on your road to digital video success. This icon usually signals a way to do your work easily and quickly.

Gently suggests that the future of the free world and humanity's well-being for countless generations to come hinges on your next action. Actually, this icon just cautions that you're about to make a decision or perform an action that may have some kind of permanent outcome. (So maybe my first description is on the mark after all.)

Where to Go from Here

By the way, the publisher of this book loves to hear from readers. To contact the publisher (or authors of other ...*For Dummies* books), visit the publisher's Web site at www.dummies.com, send an e-mail to info@idgbooks.com, or send paper mail to IDG Books Worldwide, Inc., 10475 Crosspoint Boulevard, Indianapolis, IN 46256.

Video producers and editors are straightforward, no-nonsense types. They size up the job, determine the best course of action, begin, and never look back. The time has come. I'll see you somewhere in the book.

Part I

Diving Into
Digital Video

In this part . . .

*J*ust a few short years ago, you needed oodles and scads of money (or wealthy friends) to create high-quality video. And if you wanted to use a computer for editing, well, again, you had to have (et cetera). But not any more — technological advances in the computer industry and in digital video have changed all that. Part I tells you how.

The chapters in the first part of the book give you a working background to the world of creating video and the revolutionary changes being brought about by digital video. And, you get a first-class tour of the parts that make up a digital camcorder.

Chapter 1

Setting Your Sights on Digital Video

• •

• •

Something exciting has happened to video. Video wizards have "digitized" it, thereby creating (drum roll, please) digital video!

Digital video is a new way of making and playing video. Through the radical changes made possible by advancements in computer chip technology, you can now create and play video of a quality that could previously be done only with the most expensive equipment! And you can do it right on your home or office desktop computer.

Digital video refers to two things: video that is shot with a digital camcorder or video that is captured into a computer. *Capturing* is a procedure performed by a computer (via a capture card) to convert video into a computer file. In this book, I use the term digital video in both ways. I tell you how you can get the most out of a digital camcorder and how to use your computer as a digital video editing station. With digital video and a little creativity, you can produce cutting edge, professional-looking videos. It doesn't matter if the subject of your movie is a backyard barbecue or a documentary on kangaroos, you want your video to look and sound the very best it can. With digital video equipment and a little practice, you can make home movies that match the picture and sound quality of what you see on TV.

Comparing Digital Video to Analog

To get the big picture of what digital video has to offer, you might find it helpful to know how digital video differs from analog. The terms *digital* and *analog* refer to the format that the actual video is stored in. Digital video — or any digital data — is basically made up of billions of ones and zeroes. On the other hand, analog video — like analog data — is stored using a system of waves that hold virtually infinite variables.

In English? When you write a name on a piece of paper, you have just recorded information in an analog format. But when you punch a hole in a data card — such as a ballot on election day — you are providing digital data. The hole is either punched or it isn't, open or closed, on or off, one or zero, Coke or Pepsi, fish or cut bait . . . Sorry about that. The important point here is that computers can only process digital data. This means that if you want to edit video on your computer, it must be digital video.

If you really want to delve into this digital versus analog thing, visit Chapter 2 to read about digital and analog video signals.

You can still edit video from an analog camcorder using your computer. To get that analog video into your computer, however, it must be digitized by a capture card. See Chapter 8 to find out how capture cards work.

Why digital video is better

Until recently, virtually all camcorders shot analog video. VHS, VHS-C, 8mm, and Hi8 are all analog formats. Because analog video can be influenced by the very smallest fluctuations of the recording, it loses a bit of its original quality every time it is played or copied. The tapes stretch and deteriorate, causing the analog data to change and fall gradually down the slippery slope of poor video quality.

Digital video is not affected by subtle changes in the storage media; it either works or it doesn't. And if it works (which it should so long as the storage media isn't seriously damaged) it always has the same quality as when the video was first recorded. The video begins life as digital and remains digital, even as you transfer it into your computer.

Understanding Digital Storage Formats

Until the coming of digital video, the quality of video production was based on the size of your pocketbook. If you wanted good-looking and good-sounding video, you needed expensive equipment — and lots of it. A very wide gulf of dollars and expertise separated what you could do with your camcorder and what professionals could do to make broadcast-quality programs. Digital video is changing many of the "givens" associated with video creation.

The most common format for storing digital video in a camcorder is MiniDV. MiniDV makes a high-quality video image, and MiniDV equipment is relatively inexpensive and simple to operate. Two other formats that are currently popular include:

- **Digital 8.** Also called *D8,* some Sony digital camcorders store video on Hi8 tapes. Hi8 tapes are widely available and cheaper than digital camcorder tapes, and Digital 8 cameras can play 8mm and Hi8 tapes from your older analog camcorder. The digital video uses more storage space, meaning that a Hi8 tape designed to hold 120 minutes of analog video holds only 60 minutes of digital.

- **CD-RW.** A few digital camcorders have a built-in CD-RW (Compact Disc-ReWritable) drive that they record digital video onto. This makes the camcorder very compact, but one 650MB CD-RW can only hold about 20 minutes of video.

Professional video has for many years used a format called Betacam SP. This kind of video has been used until recently in virtually all the videotaped programs you view on television. This equipment is so expensive that only the big boys could afford to produce high-quality video. Today, a majority of those same professionals have or are converting their equipment to a commercial version of digital camcorder.

Linear and Nonlinear Editing

The art of video creation has been around for only about 20 years. Video creation, for the most part, has always used *linear editing.* Linear editing refers to the method in which video is copied from one machine to another. Machine-to-machine editing is performed sequentially or chronologically, meaning that one video segment is recorded, followed by the next segment, followed by the next segment. If you make a mistake, you must go all the way back to where you made the mistake and start over from that point.

Multi-generational survival capability

Whether you record analog video or digital video, you normally edit your video in multiple generations. Good-looking video has to have *multi-generation survival capability.* Say what? In creating a video, multi-generational means that a finished video has been re-recorded (or edited) a number of times. Before digital video, multi-generations meant multiple machines and multiple stages of recording of a program on videotape.

Prior to being distributed as a final product, a typical video creation, whether it was a network broadcast, a corporate training video, or a home movie, was at least three to five generations old. Expensive recording equipment, such as Betacam SP, maintained the quality of a video image across multiple generations much better than did less expensive recording equipment, such as VHS.

✔ **Generation one:** The video is shot using a camera and recorder or a combined unit. The videotape is then placed in a video player.

✔ **Generation two:** Portions of the video are chosen and edited onto another tape. Sometimes a second video player is used where video A dissolves or wipes into video B. (Incidentally, this A to B transition is called *A/B roll* editing.) Whether one or two video

players are being used, the resulting recorded tape is still generation number two.

✔ **Generation three (program master or finished product):** Frequently, the video needs additional editing, such as adding background music or a special graphic. The generation two tape is placed in the video player. Now the added graphic or audio is mixed in and recorded onto a third tape.

✔ **Generation four (duplication master):** Because of the time and money put into the creation of the generation three tape, a fourth copy is made, and the generation three program master is put in safe keeping.

✔ **Generation five (duplicated copy):** This generation includes all the tapes that are copied from generation four — and is the one purchased by the customer.

Digital video has dramatically changed the method and quality of outcome of multiple generations. Now, using a single computer, you can make multiple copies of video without losing any image quality. From one digital program master, you can make countless duplicate videos, CD-ROMs, and Web-based movies. And the cost of the equipment is only a fraction of the costs related to conventional multiple-generation video creation.

Imagine doing linear editing for hours upon hours, laying one visual sequence after another in a seemingly never-ending row of edits, and then realizing that you have to make a change in the middle of the video. In linear editing, this means that you have to go back to that particular edit and reshoot everything after it.

The best way around this problem is to do *nonlinear editing*. Nonlinear editing is the kind of editing that you can do on a computer; if you want to go back and add a scene, you simply squeeze it into the timeline in your editing program. The editing program — whether you use Windows Movie Maker, Apple iMovie, or Adobe Premiere — moves all the subsequent scenes over to make room for your addition. You don't need multiple machines to perform an edit; one machine (your computer) does it all! With nonlinear editing, you can modify a video as many times as you want and in any order you want — not much different from the way you edit on a word processor. When I mention editing from here on out, I am referring to nonlinear editing.

In 1998, Adobe Systems launched Premiere 5.0, a nonlinear editing application for Windows 95, Windows 98, Windows NT, and the Mac. Premiere is a powerful program that makes digital video a professional-quality reality for home moviemakers. In 2000, Mac introduced a digital home moviemaking software program called iMovie as part of the iMac operating system. (You get to kick the tires of iMovie in Chapter 11.) Later in the year, Microsoft countered by including a program called Windows Movie Maker with its new operating system called Windows Millennium Edition (Windows Me). I cover Windows Movie Maker in Chapter 10.

Desktop Software

Last but not least, an important part of home moviemaking is state-of-the-art desktop publishing. With digital video, you can do a number of things with your movie, such as:

- ✔ Post it to a Web site
- ✔ Send it as an e-mail
- ✔ Incorporate it into a PowerPoint presentation
- ✔ Put it on videotape
- ✔ Burn it onto a CD-ROM
- ✔ Turn it into individual photos for printing

Desktop publishing also allows you to use specialized software programs to create things such as high-end graphics and special effects for your video. In Chapter 13, you use Adobe Photoshop to create beautiful graphics for your videos.

Using Prerecorded Video and Sound

Artists don't necessarily have to put the copyright mark on their art in order for the work to be protected by copyright laws. Just because you don't see the copyright mark on a video, a graphic, or a piece of music, you can't automatically assume that the art isn't protected.

The best and safest way to incorporate professionally developed video and audio into your movie is to purchase stock footage. Many stock footage companies advertise their products on the Web.

Where can you find stock footage for sale? Visit Chapter 18 for some timely suggestions.

Chapter 2

Touring a Digital Camcorder

This chapter contains tons of information on all types of digital camcorders and their innovative features. I've also included information on how digital video enables you to create and maintain beautiful video play on your television, a CD-ROM, or the Internet. When you finish this chapter, you will better understand the pieces that make up the whole puzzle of a digital camcorder. If all you want to do is shoot video for the Web or home movies, you probably don't need a very expensive camcorder. You just need specific features. Conversely, if you're planning to use your camcorder for more demanding tasks such as wedding videos or student film projects, then you may need to spend a bit more money.

Digital camcorders also make use of IEEE 1394 (FireWire) technology that allows the direct transfer of digital signals into computers without any loss of image resolution or audio fidelity. This book is written for people who are considering or have already purchased a digital camcorder.

This chapter contains two parts. In the first part, I explain all the parts of a digital camcorder that you'll need to know about. In the second part, I discuss the features of various digital camcorders. Happy shopping.

Pricing Digital Camcorders

Digital camcorders vary in price and features. This chapter describes a number of details that will help you decide which price range and features best suit you. To get you started, here is a list of three camcorders representing the range of manufacturer's retail prices (MSRP) and features that are available.

- ✔ **Sony DCR-TRV310 (MSRP $1,099).** Sony offers a wide selection of cam-corders, including the DCR-TRV310. This is a Digital8 camcorder, mean-ing that it records digital video onto 8mm and Hi8 tapes. It offers good resolution, has a 20x optical zoom lens, and even has a feature that enables you to shoot video in total darkness. You can usually find it for much less if you shop around.

- ✔ **Canon Opturi Pi (MSRP $1,799).** If you want to step up to near-televi-sion quality video, consider a camera like the Opturi Pi. The Opturi Pi records on digital camcorder tapes, and is extremely good for still photos as well as video. The Opturi Pi also allows VHS input for turning all your old VHS home movies into digital movies.

- ✔ **Canon GL1 (MSRP $2,250).** When you need a professional-quality camera, you may want to step up to the GL1. The GL1 is for serious home moviemakers and for professional videographers (Canon claims the two ownership categories are split about 50/50). The GL1 has a professional-quality lens, three Charged Couple Devices (CCDs), and numerous manual and automatic features.

Focusing on Camcorder Essentials

Hold on to your chair for some earth-shattering information: A camera and a camcorder are *not* the same thing. A camera acquires (collects) a visual image. A camcorder acquires and records that visual image. In professional video creation, you often find "cams" without "corders." With live television, for instance, no recording is necessary. Of course, you probably want to record all of the video you shoot, so a camcorder is what you really need.

"Corderless" cams are common among non-professionals too. Have you ever seen those little Web cams that people connect to their computers for video conferencing? Those are examples of digital video cameras that have no built-in recording mechanisms.

Now that you understand the difference between a camera and a camcorder, you are ready to go shopping. I recommend several important features that you should evaluate:

- ✔ Lenses
- ✔ Single-chip and three-chip camcorders
- ✔ Viewfinders and LCD screens
- ✔ Input and output devices
- ✔ Preprogrammed settings

These features vary greatly from camcorder to camcorder, so a good rule of thumb is to determine how important each feature is to you and judge each camcorder on how it fits your needs.

Lenses

A camera's lens is its eye. The reason for this earth-shattering analogy is to point out the fact that, like human eyes, some camera lenses "see" better than other camera lenses. The nice thing about a camcorder lens is that you get to choose the "seeing quality" you would like rather than having to accept the "seeing quality" you are born with. For more about lenses, see Chapter 3.

 Because the digital camcorder's lens is likely to be built into the camcorder, choosing your camcorder lens is tied in with choosing the camcorder. The quality of your lens combined with the quality and quantity of CCDs is directly related to the overall quality of your camcorder. Therefore, carefully consider what you want in a lens and CCDs and what you're willing to pay for that quality.

Almost all digital camcorders offer two kinds of lens magnification, or *zoom*:

- ✔ **Optical:** A zoom lens actually consists of two glass lenses. The distance between these lenses can be adjusted to change the length of the lens, or zoom ratio. A longer lens provides greater magnification of subjects that are far away. This type of magnification is called *optical zoom,* because it uses only the glass optics of the lens. Optical zoom has no effect on the resolution of video captured by the CCD.

- ✔ **Digital:** Many digital camcorders also offer *digital zoom*. Digital zoom merely enlarges the image captured through the glass lens by the CCD. Resolution is lost as you zoom in using digital zoom, making it far less desirable than optical zoom.

Often when you buy a digital camcorder, it advertises something like "20x optical/100x digital zoom." This means that the glass lenses in the camera can magnify subjects up to 20 times, or you can magnify that subject up to 100 times digitally. Keep in mind that as soon as you start zooming beyond that "20x optical" mark, you are going to lose video quality. In other words, don't let that huge digital zoom number sway your buying decision; optical zoom is what you really need.

Figure 2-1 shows three stages of a zoom — from the least magnification to the most. The first stage is a wide shot using the minimum optical range on the lens. The second shot was taken with the maximum range of the optical lens. The last stage is with the digital lens and as you can see, shots within the digital zoom range don't compare in quality to shots within the optical range. The image lacks detailed information.

Fig. 2-1a

Fig. 2-1b

Figure 2-1:
Levels of
magnification
from
minimum
optical (top)
to maximum
(middle) to
digital
magnification
(bottom).

Fig. 2-1c

Lenses don't vary much among lower-priced camcorders. You might see a
variation in digital magnification, but that's about it. The jump in quality and
the variation of offerings occurs mostly among camcorders beginning in the
$2,000 range. For example, the Canon GL1 provides a fluorite lens that,
according to Canon, corrects sharpness problems typical in high-magnifica-
tion lightweight lenses. The Canon XL1 provides a professional-quality inter-
changeable lens system that meets just about any magnification demand. The
Sony DCR-VX2000 provides a professional-quality lens with very high glass
optic quality.

Single- and three-chip camcorders

If the lens is a camcorder's eye, the CCD is the optic nerve of a camcorder. The CCD is sometimes referred to as a *chip*.

In video, a camcorder acquires light and color on computer chips called *Charge Coupled Devices,* or CCDs. These CCDs collect visual images and convert the images into a digital signal. Digital camcorders have at least one of the following:

✔ **Single-chip:** Less expensive camcorders ranging in price from around $500 to $1,500 usually have only one CCD. A typical single-chip camcorder uses 300,000+ pixel elements to collect red, green, and blue information.

✔ **Three-chip:** Many of the more expensive camcorders ($2,000 and up) have three CCDs rather than just one. On a typical three-chip, each CCD collects 300,000+ pixel elements of red, green, or blue information respectively. A prism in the camera splits light into red, green, and blue elements and reflects each color to its respective CCD (see Figure 2-2).

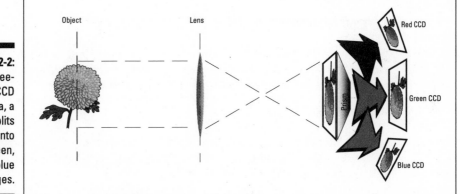

Figure 2-2: In a three-CCD camera, a prism splits color into red, green, and blue images.

The distinction between single-chip and three-chip camcorders is the quality of the image each produces. Manufacturers of single-chip camcorders, to some degree, compensate for the lack of color clarity by including a RGB primary color filter. This filter separates light passing through the lens into red, green, and blue color components, assisting color reproduction. Even with a RGB primary color filter, however, the video produced by single-chip camcorders cannot match the quality produced by three-chip camcorders.

How many chips are enough?

When it comes to CCDs, three chips are better than one. But are they so much better that you should postpone that orthodontic work your kid needs just so you can afford a top-of-the-line camcorder? A camcorder with three CCDs provides far better color in your video, but just how much color clarity do you actually need? Consider what you're actually using your camcorder for. If your primary uses are the following, you probably don't need a three-chip camcorder:

✔ Home movies

✔ Family vacations

✔ Your kids' sporting events and other activities

✔ Videos for the Web

Three-chip camcorders provide that final 20 percent (or so) of video quality that professionals need for broadcast-quality video. If your videos will be broadcast, or if people are paying you for high-quality video creation, a three-CCD camcorder is probably what you need (just be prepared to spend at least $2,000). But if you'll be producing videos mainly for personal use, don't strain your budget just to get those two extra chips.

Viewfinders and LCD screens

When you're comparing the pros and cons of camcorders, remember that if you want to shoot good-looking video, you need to be able to see exactly what you are shooting. This isn't always easy with a tiny viewfinder, so most modern digital camcorders provide both viewfinders and LCD view screens. What is the difference?

✔ **A *viewfinder* is an eyepiece you look into with one eye when shooting video.** Most viewfinders are black-and-white, making it easier to determine whether or not your subjects are in focus.

✔ **A *view screen* is a small monitor attached to the side of a camcorder.** Many people find view screens easier to work with in a variety of shooting situations.

Camcorders costing less than $2,000 generally have viewfinders with 130,000-pixel resolution. Camcorders costing $2,000 or more have viewfinders with 180,000-pixel resolution. Many viewfinders offer a focusing feature for correcting near-sighted vision problems.

LCD view screens are helpful when shooting indoors or for playing back your video, but are less useful for daytime outdoor shooting. Their images just don't show up well in bright light. I use the view screen a lot indoors when I

can keep the camcorder on my lap during recording or when I have to hold the camcorder over my head when shooting, such as when recording someone walking through a crowd.

Viewfinders generally use less battery power than view screens. If you need to conserve power, use the LCD view screen sparingly.

Input and output devices

All digital camcorders have IEEE-1394 (FireWire) input/output, allowing you to connect the camcorder to your computer. A FireWire connection can transfer up to 400 million bits of data per second, more than enough to handle digital video without any loss in sound or video quality.

Although most modern Macs come with a FireWire port built in — FireWire was invented by Apple, after all — few Windows PCs have one. If you use Windows, chances are you will need to buy a FireWire adapter card before you can import video into your PC. FireWire cards are widely available for less than $100.

Additional terminals vary from one camcorder to another. Many camcorders offer analog video in and out. This is a great innovation. With analog video in, you can transfer all your old VHS tapes to digital video. With analog video out, you can send your digital recording to VHS tape. Some camcorders also offer S-VHS (a higher quality, professionally oriented form of VHS) input and output.

Camera weight — it matters!

If you're wondering which camcorder will be perfect for you, don't forget to consider weight. Some camcorders weigh as little as one and a half pounds. Others, such as the Canon XL1, weigh as much as six and a half pounds. I love the XL1. But I have to tell you, sometimes, by the end of the day, it seems to weigh as much as a boat anchor. The camcorder is definitely worth every ounce it weighs. And the XL1 weighs a heck of a lot less than older camcorders. But you might find that your circumstances call for a much lighter piece of equipment. This weight stuff isn't a big deal, but it's helpful to keep in mind when you're shopping for that perfect camcorder.

While you are at it, check to see whether the camcorder's primary controls fall easily to hand. Practice with a camcorder you plan to buy to make sure that the Record button, zoom control, and *focus ring* (the dial you turn right or left to bring your subject into focus) are all easy to operate while you shoot.

Evaluating Other Camcorder Features

Digital camcorders — even the cheapest ones — are relatively high-end items compared to most analog camcorders, so you can usually expect your camcorder to include a lot of features above and beyond just the basics. These extras aren't critical, but they do add value that you may want to consider. In this section, I look at some of the extra features you may find when you are shopping for a digital camcorder.

Preprogrammed exposure settings

Your eyes adjust to varying light levels by opening and closing the iris. Cameras do the same thing, but the iris in a camera lens is called the *aperture*. If you have ever used an older, manual-focus 35mm still camera, you probably learned to adjust the aperture by turning a ring on the lens. All digital camcorders can control the aperture automatically, and many offer manual control as well.

Most digital camcorders, regardless of price, offer some amount of programmed auto exposure (Program A/E) control. Program A/E provides preprogrammed control settings for the aperture. Each program is a menu of preset relationships of aperture settings and shutter speeds; for more on apertures and shutter speed, see Chapter 3. The programs can be helpful in challenging lighting situations, such as a light-colored subject in front of a dark background, or vice versa.

Auto exposure programs are set by the manufacturer and are part of the camcorder's internal programming. This means that, generally speaking, you aren't able to modify the existing programs or add your own.

Following are some examples of common program names and their settings. Exact A/E programs vary from camera to camera, so check your camcorder's documentation for program names and their recommended uses.

Easy Recording program

The Easy Recording program is a nice way of saying "fully automatic" recording. If you want to simply aim the camcorder and allow it to automatically adjust the focus and exposure settings for you, this is the program for you. Some shooting conditions are no-brainers and, in those cases, the Easy Recording program works just fine. For example, Figure 2-3 is a medium close-up shot with a well-lit foreground and no overpowering background light, predominance of color, glare, or fast movement, which makes Easy Recording a good choice. The big drawback with this program, however, is that all of the manual functions are unavailable.

Fig. 2-3a

Figure 2-3:
In the top photo, the camcorder uses automatic focus; the bottom photo uses manual focus.

Fig. 2-3b

Tv program

The Tv program gives priority to shutter speed. (For more on shutter speed, see Chapter 3.) You probably want to use this program when you're shooting fast-moving objects. Figure 2-4 is a frame from a video of someone in fast movement. By adjusting shutter speed from $\frac{1}{60}$ of a second to a faster speed, you are able to prevent streaking and blurred movement in your video. Depending upon which camcorder you choose, you can adjust your shutter speed to as fast as $\frac{1}{15,000}$ second (hummingbird speed).

Figure 2-4:
With the Tv program, you can set a shutter speed to best capture fast-moving subjects.

Av program

Other than the Auto program, the Av program is probably where you'll spend most of your shooting time. The Av program gives priority to your camcorder's aperture. Aperture, which I discuss in Chapter 3, refers to the amount of light that reaches through the lens to the focal plane inside your camcorder. Figure 2-5 shows two frames of video of the same subject using different aperture settings. By adjusting aperture, you can choose how much of the picture you want in focus (depth of field). The first picture is a low aperture setting with narrow depth of field. The second picture is with a high aperture setting with greater depth of field.

Figure 2-5:
By manually adjusting aperture, you can make images tightly focused (top) or generally focused (bottom), creating different effects.

Fig. 2-5a

Fig. 2-5b

Manual program

Some digital camcorders offer fully manual A/E program options. This may seem odd, but just think of the Manual program as a switch that turns off the automatic aperture, shutter, and manual gain settings. Many professional videographers consider the Manual program their program of choice. In order for the Manual program to be effective, all the controls have to be easily activated without requiring you to take your eye out of the viewfinder and, preferably, without requiring you to manipulate more than a couple of switches or dials. You can read more about manual operating a camcorder in Chapter 3.

Special programs

Every camcorder manufacturer provides you means for shooting in extreme lighting conditions. The extremes are low-light conditions, extremely bright conditions, and bright light sources in otherwise dark environments. Canon, for example, provides two special programs — one for extremely bright conditions, such as daylight on a beach or in snow, and one for bright light sources in dark environments, such as someone in a spotlight on a dark stage. Both of these conditions push your camcorder to its limits to provide you a good image. In both cases, the problem is a matter of overloading your CCD (or CCDs) with too much light information without an equal amount of color information. Your lens is closed to its minimum to reduce the onslaught of light, so your chip (or chips) doesn't have enough information to properly separate red from blue from green. Sand and Snow programs play some tricks with your camcorder (primarily with the shutter control) to compensate as well as possible. The Spotlight program prevents or minimizes glare on your overlit subject while, at the same time, preventing your camcorder's automatic settings from attempting to overcompensate for the dark areas of the screen.

Another special feature of almost all camcorders is the ability to operate in low-light conditions. The problem with low light is that your CCD or CCDs try to create a video image even though the available light is not providing a well-defined image. This results in what's known as *video noise*. Your camcorder's ability to compensate for low light is measured in a technical designation, called *lux*. A low number, such as 4, says your camcorder is reasonably well equipped to compensate for lack of sufficient light and to digitally enhance anything that reflects light, such as human skin.

 Some Sony camcorders offer a feature called Night Shot that allows you to shoot video in *no* light. The Night Shot program uses infrared technology and slower shutter speeds to capture video in total darkness. The only drawback to Night Shot is that very little color information is captured, so that video appears almost black and white.

Digital shooting modes

Most digital camcorders offer more than one digital-shooting mode. The modes are usually one of the following:

- ✓ **Video mode.** The video mode (or normal movie mode) is normal 30-frames-per-second video recording — what you probably bought your camcorder for in the first place.

- ✓ **Digital photo mode.** The digital photo mode permits you to take still photos. Normally, the photos are recorded for six seconds or so. This allows you to easily find each still on the tape during playback and it also allows you to speak a short narration for describing the shot.

✔ **Progressive scan mode.** The progressive scan mode allows you to shoot as if you are recording video, but in fact you are recording 30 full-frame images per second. If you are interested in the more technical aspects of Progressive Scan, turn to my sidebar "More on Progressive Scan" to quench your thirst for information.

The names of the modes may be slightly different from one manufacturer to the next, but they still accomplish the same thing.

Some camcorders record still photos as several-second video clips on tape. Others store still photos on another kind of removable media, such as a SmartMedia card, CompactFlash card, or Memory Stick. SmartMedia and CompactFlash are industry standards and replacement media is widely available. MemorySticks are used only by Sony products.

Other image controls

The development of the digital camcorder has opened up a whole world of possibilities for the amateur videographer, enabling the amateur to shoot video with near-broadcast quality. At your fingertips are many of the features that just a couple of years ago were available only on very expensive camcorders.

More on progressive scan

Many camcorders — both 1-CCD and 3-CCD — offer what's called *progressive scan,* which enables you to shoot still video that is sharp and focused and works well when you are shooting fast-moving objects or when you are using your camcorder to shoot still photos.

NTSC (*National Television Standards Committee,* this is the type of video used in the Americas) video is shot at 30 frames per second. Each frame is made up of two fields of video. Every thirtieth of a second, video displays those two fields. Until recently, the two fields were *interlaced.* This means that half of the 525 horizontal lines would appear in each of the fields. One field would hold all the odd lines (1, 3, 5, and so on) and the other

field would hold all the even lines (2, 4, 6, and so on). Interlacing was necessary because the older technology simply couldn't feed all video information onto the screen at one time. By alternately showing odd and even lines every sixtieth of a second, television appeared flicker-free. Progressive scan takes advantage of digital technology's ability to display all the video information fast enough to equal or exceed one-sixtieth of a second. With progressive scan, each field has all 525 lines of information. This is very useful when you are shooting still shots. You won't run the risk of seeing jagged lines because a lack of individual field information. Also, you'll find that fast-moving video is more likely to be true-to-form.

Automatic and manual white balance control

White balancing (see Chapter 3 for more about this) is the function that your camera uses to interpret color. Automatic white balance is often available on lower-cost camcorders. What's unusual is that some digital camcorders allow you to perform a manual white balance. Manual white balance is very important where you have predominant colors in a video shot.

Neutral density filter

Some digital camcorders provide a *neutral density* filter (ND). ND helps you in very bright situations where your camcorder's aperture is at its very smallest. In such cases, your camcorder may have trouble providing a sharp focus. By applying the ND filter, you are providing a little relief to your aperture control, which in turn increases your camera's ability to sharply focus.

Zebra

Some digital camcorders include the *zebra* feature. I'm not talking about a *National Geographic* special here; I'm talking help in determining when you've got too much light in a picture. When you turn zebra on, your viewfinder shows a slightly different image than what is actually being recorded. In your viewfinder, you see black and white stripes where the light is too bright (thus the name zebra). This feature is particularly helpful to you when you are recording people against a bright background. When you see zebra, you know that the background light might cause the foreground figure to be a dark silhouette. You can adjust your exposure until the zebra disappears. When it's gone, you know you've got a good picture.

16:9 (Widescreen TV recording)

Today, most television sets have a 4:3 aspect ratio. This means that if the screen is four inches tall, it will be three inches wide. It could also be eight inches by six inches, or sixteen inches by twelve inches, or any measurement that conforms to the 4:3 ratio.

In the not-too-distant future, television sets are going to have a 16:9 (Widescreen) aspect ratio — 16 horizontal measurements for every 9 vertical measurements, the same as that used for most movie theater screens. Luckily, most digital camcorders offer you the option of recording in either of the two aspect ratios. Your camcorder won't be obsolete when the world changes to Widescreen TV. Just flip the switch to 16:9. This feature is a pain in the neck, but most camcorders now feature it.

Sharpness control

Some of the more expensive digital camcorders offer a sophisticated feature called *sharpness control*. Have you ever wondered how evening newscasters continue to look so young after so many years? The answer is simple. Their producer keeps cranking the camera sharpness control to a softer and softer setting. I bet you think I'm kidding. Well, all I ask is to give it a try yourself.

Phase (hue) control

If you've always wanted to express your mood in your video creation, consider buying a digital camcorder with *phase control,* which enables you to adjust the camera's interpretation of hue. If you happen to be in your blue period, declare it to the world by tending toward a predominance of blue in all your shots. A touch of Bohemian, but very controlled, very cool. You are an arteeste!

Phase control is not the same as white balance. White balance works with "color temperature" in the available light. Phase control is independent of available light and is simply a skewing of the camera's interpretation of red, green, and blue.

Using a flash with your camcorder

On certain camcorders, you can use a flash unit in photo mode. Such camcorders come equipped with an accessory shoe that accepts standard flash units for 35mm film cameras. This is a really cool feature. The flash automatically adjusts the magnitude of light based on the camcorder's zoom and focus controls, which enables you to preset your flash photo in complete darkness and get a great photo almost every time. The flash sends out an invisible-to-the-eye beam and sizes up your light needs.

Color bar generator

One of the oldest standards of the video production industry is the color bar. If you're old enough, you'll remember getting up very early in the morning before the television stations would begin their programs and seeing a series of colored vertical bars on the screen. Those were color bars.

Today, in professional video production, camera operators turn on the camera's color bar generator and record a few seconds of color bar. Later, in the editing suite the editor uses the recorded color bars to adjust the editing equipment to interpret color in the same manner as the camera did. This is especially important when more than one camcorder are used in the same video creation. Editors use the color bars to insure that all the equipment is interpreting human skin tones in the same manner. Some of the more expensive digital camcorders provide a color bar generator.

Stabilizing the image

Image stabilization removes the shake from much of your video shooting. Camcorders with image stabilization are programmed to "recognize" certain kinds of movement and vibration, such as walking and riding in a car. As long as your moving and shaking of the camcorder is predictable to your camcorder's computer-type memory, the camcorder will automatically compensate

for a lot of the movement. Image stabilization used to be a very big deal in the video production industry. Now it's like yesterday's news. You would be hard pressed to find a digital camcorder that doesn't offer image stabilization.

Just one small point. I hope that this doesn't shake you up, but sometimes you are going to get a better picture by turning your image stabilizer off because it slightly reduces the CCD's efficiency. If you are shooting video with a tripod or if you are able to rest the camcorder on a solid surface, such as a table, you can improve your camcorder's performance by turning off the stabilizer feature.

Recording high-quality sound

All digital camcorders have a built-in microphone for recording sound along with your video. However, unless you are buying a really high-end camcorder (say, one that costs more than $2,000), the sound quality recorded by the built-in microphone is probably barely adequate. Built-in microphones become especially problematic when you are recording events, such as a wedding or school play, because chances are the camera must be positioned far from the subject. And while you can easily get nice video by zooming in with the lens, zooming in with a microphone is not so easy.

To expand your options for recording quality audio, try to get a camcorder that has a microphone jack. This enables you to attach a high quality external microphone to the camcorder, ensuring that your sound matches the great video you capture. For more information on sound and your digital camcorder, turn to Chapter 5.

Part II
Shooting Digital Video

The 5th Wave By Rich Tennant

"What do you mean you're updating our Web page?"

In this part . . .

Probably the single most important skill you can possess in video production is an understanding of what your digital camcorder can do for you. A lot of space-age technology has been crammed into that little electronic device, and the technology is all there for you to use. You just need to understand what's possible. Part II helps you do just that.

In this part, each of the chapters dwells on a specific subject related to digital video recording. One chapter is about the camera itself. Another chapter shows how to provide the right kind of lighting in your recording environment. One of the chapters walks you through the basics of audio recording. And the last two chapters familiarize you with the pro's approach to planning your video creation and how to shoot on location. All in all, you're in for a full-course video production extravaganza.

Chapter 3

Maximizing Your Digital Camcorder's Capabilities

In This Chapter

▶ Outlining key image terms

▶ Using your camcorder's aperture

▶ Using focal length and perspective

▶ Making the most of your battery

You don't have to ponder the principles of photography to get a great shot with your camcorder. However, you can greatly increase the quality of your shot if you have a working knowledge of the concepts provided here. So delve into this chapter as little or as much as like; you can always read portions of it and come back later.

Not so long ago, the most important factor in determining video quality was the amount of money you were willing to spend. If you wanted television-quality video, you had to spend tens of thousands of dollars on equipment.

Today, that is not always the case. Sure, spending more money usually yields improvements in quality, but you can now shoot in a format that rivals television without breaking the bank. So, I challenge you to go all the way and make the most of what's being offered. By understanding some basic terminology, the principles behind what makes an image an image, and some simple procedures that make your videos better, you'll be able to pick up some useful habits and make your camcorder *sing* as you want.

Get ready, because you're about to find out how to get the most out of every shot you take.

Defining Key Image Terms

Most language and practices of video creation are rooted in film production. Terms that were first coined in the era of silver nitrate film and megaphones

are still the fundamental lexicon of videography. This rich language continues to exist because video technology has, in many ways, simply improved rather than evolved. Today, when you talk about shutter speeds or wide shots, you're communicating ideas based on the development of a time-honored craft. Your understanding of key words and concepts make a world of difference in the quality of your videos. I've prepared the following list of a few key terms and ideas that you can use to develop those wonderful shots:

- ✔ **CCD:** In video, a camera acquires light and color on chips called *Charge-Coupled Devices,* or CCDs. These CCDs collect visual images and convert them into either an analog signal (waves with varying amplitudes) or, in the case of your digital camcorder, a digital signal (a series of ones and zeroes).

- ✔ **Focal point:** The convex (curved outward) shape of a lens bends an image and reduces it to a point, which is called the focal point.

- ✔ **Focal plane:** The point where the object being photographed is in focus and optimized in the lens. The image is an exact two-dimensional (2-D) likeness of the object being photographed.

- ✔ **Focal length:** The distance between the lens and the focal point. (See the section "Understanding focal length and perspective," later in this chapter, for more on this topic.)

- ✔ **Aperture:** The opening of a lens that controls the amount of light permitted to reach either the film or CCD in video cameras. It controls the amount of light that reaches the focal plane. The aperture is also sometimes called the *iris.*

Aperture is measured as focal length divided by the diameter of your lens. This measurement is also referred to as *f-stop.* For example, a 100mm lens with a diameter of 50mm has a maximum aperture (or f-stop) of f/2 (100mm divided by 50mm). See the section "Understanding focal length and perspective," later in this chapter, for more on focal length.

If you have photography experience, you'll be happy to know that the same concepts in photography apply in video (and digital video). If you aren't versed in the subject, the following section will help you make the most of your camcorder.

You can also check out *Digital Photography For Dummies,* 3rd Edition, by Julie Adair King or *Photography For Dummies* by Russell Hart (both published by IDG Books Worldwide, Inc.).

Controlling Light with the Aperture

When you shoot video, the camcorder's job is to produce a high-quality 2-D likeness of the 3-D reality you are shooting. A number of issues affect the

success of this mission. The first issue is aperture. The aperture — also called the iris — controls the amount of light that is allowed through the lens and exposed to the CCD. The aperture can be adjusted, just like the iris in your eye. A smaller aperture lets in less light, and a larger aperture lets in more.

If your camcorder manual does not contain the words *aperture* or *iris,* look for information on adjusting *exposure* levels. If the camcorder lets you manually adjust exposure, it is actually adjusting the aperture in the lens.

Adjusting the lens and iris

Before shooting video, many people are overcome with an urge to point the camcorder at their nose and stare into the darkness of the lens.

This may be a very special moment, so I don't want to intrude. But while you and your camcorder bond, you may notice some rather interesting sights. If you're in a well lit room with a light background behind you, the lens responds to you as you move the camcorder toward and away from your nose. Hold the camcorder at arm's length and move it towards you. Something is happening inside the lens. You may think it's winking at you (bonding is a wonderful thing), but actually it's automatically adjusting the aperture.

If your aperture control has f-stop numbers (such as f/2, f/8, and so on), larger numbers mean a *smaller* aperture opening.

You have two very good reasons for adjusting your aperture:

- ✔ Narrowing your iris (making it smaller) decreases the light hitting your CCDs.

 Often, you will use your camcorder in a highly lit environment, such as in the sunshine on a beach. Too much light robs your camcorder of color information.

- ✔ Narrowing your iris deepens your depth of field on either side of the focal plane. (I describe depth of field in the section "Dipping into depth of field.")

 Depending on what you are shooting, sometimes you want the background in focus. Other times, your shot is more effective if only the subject is in focus. An adjustment of the iris causes a change of focus depth.

You can use a manual aperture control to manipulate light when your object is dark and your background is bright, such as when you shoot video with the sun behind the subject. In this case, you would open the aperture more to improve the view of your subject. The bright background will be a little overexposed, but at least your subject will be much clearer.

Videographers often compensate for this problem by zooming in to take an up-close shot with the aperture setting at automatic. After the aperture has adjusted to the dark object, the videographer changes the aperture to manual and zooms out. The result is that the iris setting is based on the dark object (subject of the picture) and not on the overwhelming light of the background.

Videographers like to stay in the middle settings, if possible, for several reasons:

✔ A wide-open iris is usually undesirable because most of the shot will be out of focus (of course, this may be the effect you're looking for).

✔ A wide-open iris sometimes produces distorted edges on the video image.

✔ A middle iris setting allows for some play of iris manipulation if the lighting conditions go through subtle changes.

✔ A middle iris setting usually creates a comfortable feel to the picture by allowing a little of the foreground and background to appear out of focus. This middle setting aids in giving a 3-D look to the shot.

✔ A middle iris setting, if adequately lit, usually produces a comfortable range of brightness and shadow without starkness or high-contrast images.

✔ A nearly closed iris setting requires a highly lit shot resulting in overly lit foreheads and nuclear white clothing.

✔ A nearly closed iris creates an uncomfortable shot resulting in everything in the foreground and background appearing unnaturally in focus — you don't see both in focus in three-dimensional reality (again, this may be the effect you want).

What if you want to leave the light alone and let your camcorder adjust to a proper light level on the focal plane? Only the following two answers exist so far:

✔ Make the lens diameter adjustable.

Adjust the iris (f-stop) to change the diameter of the lens.

✔ Make the focal length adjustable.

Use the zoom lens to change the length of the lens. Zooming in on an object lengthens the lens.

Video noise

Although you can use manual aperture adjustment to play with depth of field, you won't want to do so at the expense of video quality. A CCD chip typically has 300,000 or more pixels. (See Chapter 2 for more on CCD chips. Each of those pixels must receive information in the form of color and light. If the object is poorly lit (the aperture is too small), many of the pixels do not receive this information. As a result, the camcorder replaces the missing visual information with gibberish, causing dark colors to appear as though they're covered with dancing specks. These dancing specks are _video noise._

Too much light on an object, which can be caused by an aperture that is too wide, causes the CCD to be overwhelmed, which in turn causes a loss of detail and tends toward _whiteout_ (a loss of all detail) or _blooming_ (a loss of detail in bright areas). Too little light causes the electronics of the camcorder to exhibit video noise.

Both work well and yield very different results. Adjusting f-stop changes relationships of light and focus within a specific shot. Zooming changes the shot to adjust light and focus. See the section "Controlling the need to zoom" for more about camcorder zoom lens capabilities.

If you leave your camcorder's aperture control on automatic, you'll see the aperture setting go from wide to narrow when you point the camcorder at a dark area and then at a well lit area. Left on automatic, a camcorder adjusts aperture to compensate for light levels. As you become increasingly proficient with your camcorder, set the aperture control to manual so that you can manipulate depth of field (which I discuss next), or light, or both.

Dipping into depth of field

Depth of field is a dimension in front of and behind the focal plane where objects appear to be in focus. One of the basic facts of video creation is that the higher the f-stop (and thus, the smaller the aperture opening), the greater the depth of field.

Figure 3-1 illustrates this principle. In the figure, you see three iris settings. For this figure, assume that the light is adequate for all three settings. The first setting illustrates a nearly wide-open iris, and the last a nearly closed iris. Ideally, if you can control the lighting of a shot, your best f-stops are in the middle, such as f/5.6 (f/5.6 simply means that the f-stop is 5.6), as indicated in this figure.

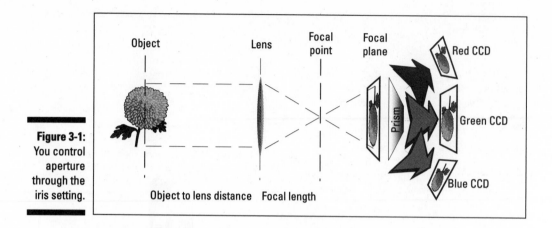

Figure 3-1:
You control
aperture
through the
iris setting.

Understanding Focal Length and Perspective

Focal length is the distance between the lens and the focal point. When you *focus* an image, you simply make a minor change to the lens's focal length. (See the section "Adjusting focal length and perspective," later in this chapter, for more on focal length.) In Figure 3-2, focusing stretches the focal length until the focal plane intersects with the CCD prism. In Figure 3-3, I shortened the distance of the object to the lens, which pulled the focal plane away from the prism.

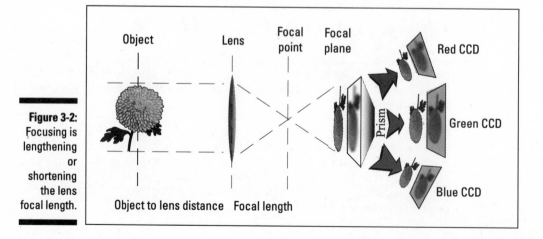

Figure 3-2:
Focusing is
lengthening
or
shortening
the lens
focal length.

If you were to leave the lens unchanged and decrease the distance between the subject and the lens — say, by moving the camera closer — the focal plane would now be behind the subject. As the relationship of the subject to the lens shortens, so does the location of the focal plane — this time in front of the CCDs' prism (see Figure 3-3). As a result, the images on the CCDs are unfocused.

Figure 3-3:
When the focal plane doesn't rest on the prism, the image is out of focus.

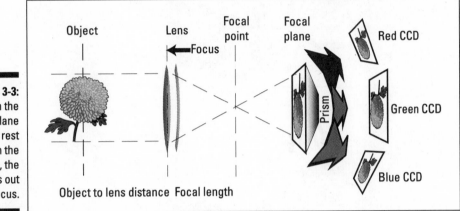

Adjusting focal length and perspective

You can change the depth of field without changing your f-stop by using the focal length and perspective. Focal length is the distance between the lens and the focal point. Perspective is the way objects appear through the lens.

Take a look at Figure 3-4. In this figure, the iris setting remains unchanged and the camera has progressively *dollied* back (moved away from the object).

This figure shows something significant happening. Even though the distance between the camcorder and the object is progressively greater, the image size remains the same and the depth of field increases. What's happening? The camera is zooming, also called adjusting the focal length.

Focal length

A short focal length creates a wide angle, causing the lens to capture a wide area in a relatively short distance. A long focal length creates a narrow angle, causing the lens to capture a narrow area in a relatively long distance.

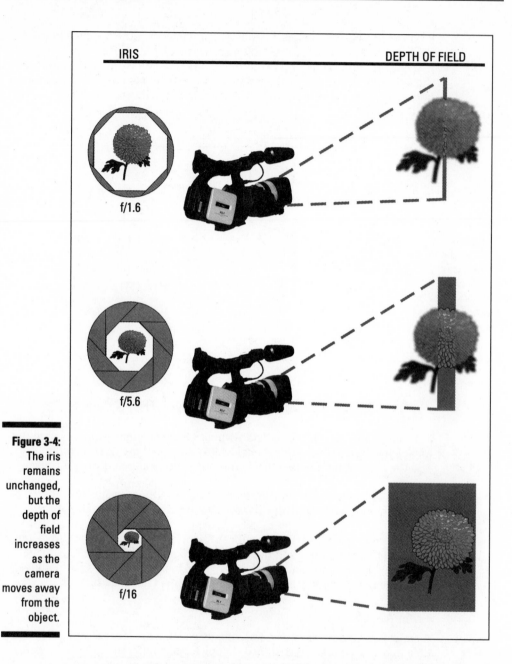

IRIS

DEPTH OF FIELD

f/1.6

f/5.6

Figure 3-4:
The iris remains unchanged, but the depth of field increases as the camera moves away from the object.

f/16

Take a look at Figure 3-5. Focal length affects more than one thing. By increasing focal length (from the top to the bottom image), you narrow the angle of the picture. Imagine standing in a tunnel looking at the tunnel entrance. If you are 100 yards into the tunnel, your view of the outside world is considerably narrower than it is if you stand ten yards from the entrance. The same is true of the effect of focal length.

Figure 3-5:
A wide focal length (upper image) can exceed what the eye typically perceives, and a narrow focal length (lower image) can imply a partial visual message.

Though the increase of focal length reduces the angle of view, the magnification of the image increases. A narrow angle of view creates a telephoto image (an image similar to what you might see in a telescope — magnified but narrow). This extension of the focal length also increases the need for light, somewhat like increasing f-stops. The reason for this is simple — the aperture is farther from the focal plane.

Perspective

Perspective is the way that objects appear to the eye in respect to their relative positions and distance. In plain English, this means that your eyes are accustomed to judging size and distance of objects by the way the objects spread out or bunch together three-dimensionally. Artists are judged on their abilities to successfully reproduce perspective in the two-dimensional world.

Although it's a rather subjective term, *normal* is the term used in videography when describing angles of view and perspective that seem natural to the eye. Normal angles lie somewhere between wide and telephoto angles.

Normal angles and perspectives display views typical to the human eye. Of course, if you're a budding Hitchcock, you'll know when you want to break

from normal to provide a shocking or unnerving perspective or angle. And you'll know how to lull your viewer into a false sense of comfort with preliminary normal shots.

A wide-angle view exceeds what would usually be seen unaided by normal vision. As a result, wide-angle shots tend to seem somewhat grotesque. On the other hand, when focused to infinity, extreme telephoto shots seem to tighten and flatten out perspective, which makes images in the shot seem closer and more crowded.

Take a look at Figure 3-6. Depending on your goals, you can use a lens's focal length to convey beauty or pathos. The wide-angle shot distorts the vertical plane, implying an inappropriateness, isolation, and abandonment to a building. The wide/normal angle shot communicates a building that has been closed and is awaiting a new owner. The normal angle shot depicts reality — the building that has seen better days. The telephoto (narrow) angle highlights the architectural uniqueness of the structure, while hiding its glaring blemishes.

Controlling the need to zoom

I have to admit, I use zooming all the time. Zoom is a great feature of most digital camcorders, but it can be easily misused. My only problem with zooming is that you can do so much more with manual controls — if you just practice a little. Zooming does a bunch of things all at the same time, like changing focal length, perspective, aperture, depth of focus, and focus. Many camcorders have a hard time adjusting all of these things at once, and adjusting them manually can be a challenge.

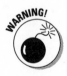

Frequently, some automatic features of the zoom controls get you into trouble. A perfect example is when you're zooming from a wide angle to a close-up using automatic focus. If your subject is off-center and takes up only a portion of the screen, the automatic focus controls go crazy. Another example is when you are zooming out from a close-up of a human face to a bright wide shot. As you zoom out, the human face darkens if you are in automatic iris. The subject becomes a silhouette.

Bottom line: Whenever possible, go manual.

Constantly zooming in and out in the middle of a shot can be very disorienting to your viewers. If you must zoom, try to zoom in or out on your subject before you begin recording.

Controlling the shutter speed

Many moons ago, as a means to pay for college, I was a motion picture projectionist in a movie theater. Though the pay was good and the movies were

free, the work was ridiculously easy and boring. So, in addition to studying my textbooks, I studied the two 35mm motion picture projectors in my projection booth. Quite frankly, I was amazed by cinema. Twenty-four frames per second of film streamed past an intersection of a light source and the lens.

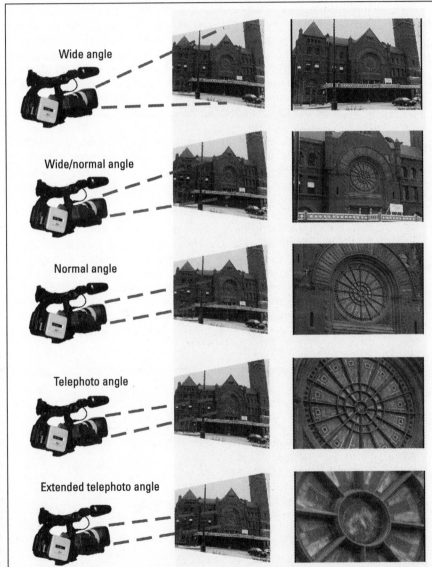

Figure 3-6:
The differences between wide, normal, and telephoto lenses are obvious when compared by using the same subject.

That was basically all there was to it — except for one major problem. Twenty-four frames of film per second should be a blur. Why are they sharp and in focus? The answer is so simple that only a genius would have thought of it. Twenty-four times per second the film stops in front of the lens and then continues. During each frame advance, a mechanical fan shutter crosses the lens opening and blocks out light. Therefore the movement of the film was always in the dark. All you saw on the screen was the stopped frame — 24 times per second. Twenty-eight years later, film projection is basically still the same. In somewhat the same manner, shutter control is used for video creation.

Using this description of shutters in film helps explain shutter control in video. With the video equipment used in the Americas, video is shot at 30 frames per second instead of the 24 frames per second used in film production. Most European and Asian video is shot at 25 frames per second.

The default shutter speed per second for NTSC video production is 60 (PAL equipment is set at 50), meaning that the shutter is open for $\frac{1}{60}$ of a second. Once in awhile, the speed of your subject exceeds the normal collection of visual information. An example is an automobile race, where the fast moving cars become blurs on the video.

If your digital camcorder is a good one, you can compensate for this blur by manually adjusting the shutter control. For example, on the Canon XL1, you can adjust from $\frac{1}{60}$ second to $\frac{1}{15,000}$ second if needed. Though you're increasing the shutter speed by doing so, the video is still being shot at 30 frames per second. An increase of shutter speed means that the amount of time your shutter is "closed" increases, while your exposure decreases. In this way, you are taking extremely brief snapshots with increased blacked out time in between each field. The result is that your car's movement is no longer blurry.

NTSC and PAL video

Two major video standards exist in the world: NTSC (National Television Standards Committee) and PAL (Phase Alternating Line). The NTSC standard is used by video equipment in the Americas, while video equipment in Europe and most of Asia uses the PAL system. How do the systems differ? First of all, NTSC video is delivered at 30 frames per second, whereas PAL video displays 25 frames per second. The systems also deliver individual frames differently. A single frame of video is actually made up of hundreds of horizontal lines of resolution. PAL video uses 625 lines of resolution, and NTSC has 525 lines.

Why does this matter to you? It doesn't, so long as you only buy video equipment in the country where you live. Video equipment — including TVs, VCRs, and camcorders — can only support one system or the other. If you live in North America and buy a PAL camcorder while on vacation in Europe, the video you record with that PAL camcorder will not play on NTSC televisions and VCRs back home.

When you dial up the shutter speed to the higher numbers, a strobe effect may begin to appear. A flutter strobe effect happens because your eye is beginning to detect the increased black time of the shutter.

Managing Your Camcorder's Battery

Improperly using a camcorder can cause painful and embarrassing experiences — especially when you power your camcorder with a battery. Imagine that you and your spouse purchase a camcorder to record epic moments in your child's life. The day comes when little Susie is probably going to take her first step. You and your spouse put life on hold for this momentous occasion. One of you probably takes the day off from work. You spend hours coaxing and encouraging Susie to move from her nearly erect stance. Finally, the moment comes — she is standing. She is about to venture into the world of ambulatory bipeds. You pick up your camcorder and she indicates that she is going to go for it. You turn your camcorder from pause to record. She stretches her leg. Your camcorder goes dead. She takes her first step. Your spouse says something like, "Oh, I'm so glad we got this moment on tape." You wonder if there is an order of obscure Nepal monks that has a category for taking in former spouses who suffer from acute life moment videography failure.

If you're grimacing from this little scenario, it's probably because you relate. Camcorders have this simple little need — it's called power. Unfortunately, batteries have a knack for no longer supplying power at the very moment when that power is most needed. I sometimes wonder if camcorder battery engineers go to the same school with people who concoct Internet viruses. What is a smart videographer to do to outwit battery gremlins? The answer is simple. You just need to know a little about batteries.

The following is combination of my own knowledge gleaned from the school of hard knocks coupled with some downright useful information from the Video Battery Handbook, published by Anton/Bauer, Inc. online at www. antonbauer.com.

Regulating battery usage

With rechargeable camcorder batteries costing $40 or more, it is crucial for you to know how to prolong the life of your battery and the perils of not caring for your battery properly. First, you need the right battery for your camcorder. This is no big deal when you purchase your camcorder, because a battery and charger are normally included in the purchase. If you're like most camcorder users though, it won't be long before you start noticing certain limitations of your camcorder's battery, for example:

✔ The battery doesn't seem to stay charged as long as you would like.

✔ You find that the battery takes too long to recharge.

Now you have entered into the never-never land of camcorder rechargeable battery dilemmas. You ask yourself (because you don't know who else to ask):

✔ **Is it okay to partially charge a battery before taking it off the charger and putting it back in the camcorder?**

Yes — providing you own a newer camcorder, such as a digital camcorder. Newer camcorder manufacturers typically provide Lithium Ion batteries. Lithium Ion batteries can be partially recharged before reuse. Other batteries — especially nickel-cadmium (NiCad) batteries — can be damaged by only partially charging them.

✔ **Is it okay to recharge a battery when there is some charge remaining?**

If it's a Lithium Ion battery, yes. If it's a NiCad battery, no.

✔ **How do you know when to purchase a new camcorder battery?**

Battery manufacturers generally consider a rechargeable battery to have lived out its useful life when it reaches a point where it can only provide about half of its original consumption. For instance, if your battery could originally provide an hour's power, you should replace it when it can only provide a half-hour's camera use.

You can save yourself a lot of trouble by purchasing an extra battery or two when you buy your camcorder. That way, you always have a backup in case the primary battery runs out of power.

✔ **Camcorder batteries have different specifications on how long they last. How much recording time relates to how much battery power?**

Most professional camcorder operators tell you that the camcorder battery should be rated to operate for a period of time twice that of the tape. Don't assume that the battery provided with your camcorder is the best battery for your circumstances. Usually, a manufacturer provides you with a battery that's good for about an hour of camera usage. Because digital camcorder and Digital8 tape is usually 60 minutes, you may think you've got the correct battery, but chances are you don't. Most people run their camcorders in the non-record mode as much as they do in the record mode, because you can't look through the viewfinder of a camcorder unless it is turned on. So, if you're using a one-hour tape, you'd be wise to use a two-hour battery. Besides, a two-hour battery is good for two hours new. Within a year or so, your two-hour battery will have become a one-hour battery due to normal aging factors. This inevitable aging is accelerated if you don't take proper care of your battery. I discuss battery care in the section "Maintaining your battery," later in this chapter.

✔ **How many camcorder batteries should I own?**

Proper care and feeding of a camcorder battery can make a huge difference to the health of your wallet. Assuming that your batteries work well, and assuming that you occasionally plan to use your camcorder all day, such as on a vacation, you should own as many as four batteries, which means that you begin your day with all the power you most likely need for eight hours of filming. By the way, when you set your camcorder to pause, the battery is still being expended.

✔ **When it comes time to buy a new battery, what type of battery should I consider?**

Always buy batteries that are made for your charger. And, obviously, always buy batteries that are rated for your camcorder. By rated, I mean that your camcorder has a certain power supply; for instance, the Canon GL1 is rated as 7.2 volts DC.

It's theoretically possible to buy the wrong battery and subsequently ruin your charger, the battery itself, or even the camcorder. Stick with batteries made by the company who made your camera and charger. If you want to change chargers and batteries to another manufacturer, I strongly suggest dealing only with a battery company with a good reputation, such as Anton/Bauer.

Maintaining your battery

Caring for your camcorder battery doesn't mean that you have to have an emotional attachment. But you do have to discipline yourself to certain practices or you'll find yourself wasting money and losing valuable shooting opportunities because you'll be tending to your sick batteries.

The numero uno enemy of batteries is heat. Your batteries should never be exposed to elevated temperatures. Anton/Bauer claims that heat can accelerate your battery's aging process by as much as *eighty percent!* Heat can also cause a lithium ion battery to lose its ability to hold a charge.

A good rule of thumb is don't ever store a battery in a place where you wouldn't want to keep a pet dog or cat. Sounds stupid, I know. The age-old taboo about locking your puppy in a hot car also applies to camcorder batteries. If you're shooting video in a very hot place, such as on a beach, keep your extra batteries in a cool place. When you're done using a battery, get it out of the sun right away.

When it comes to long-term storage between uses (as in weeks), Anton/Bauer recommends you keep your batteries with the mayonnaise in your refrigerator. Well, actually, Anton/Bauer doesn't say anything about mayonnaise but recommends storage in a refrigerator. Before you nestle the batteries

between the lettuce and rutabagas, put them (the batteries, that is) in a plastic bag to avoid the rare possibility of the battery seeping and causing food contamination.

Don't ever put a cold battery on a battery charger! If you take a battery out of cold storage or out of a cold environment (such as your car in winter), always allow your battery to reach room temperature. Batteries have been known to explode if placed on a charger while cold. Charging creates heat. If a very cold battery is charged, the radical change can cause the battery to go bananas.

If you have more than one charger, always keep a significant distance between the two chargers if they are being used at the same time.

Last but not least, don't allow your batteries to jostle around while you're carrying them. Jostling directly affects your battery's life and performance. Also, never use a battery that has been physically damaged. The coating on the battery is supposed to keep the battery acid from seeping out; if the batter is damaged, these chemicals (which can be unstable and dangerous) can leak out and cause damage to anything they touch.

Chapter 4

Let There Be Light!

• •

In This Chapter

▶ Familiarizing yourself with light and color

▶ Utilizing additional lighting methods to enhance your video

• •

A camcorder's best friend and worst enemy is light. Light illuminates; adds color, depth, and texture; and provides all the visual information your camcorder needs to acquire beautiful video footage. But light isn't always good. Here's a list of what can happen when light falls on the wrong places:

- ✔ Silhouetting what you want to highlight
- ✔ Casting nasty shadows on noses
- ✔ Causing foreheads to reflect so much light that they look like they're burning (hence the term *burning foreheads*)
- ✔ Making you look like a schnook of a videographer

Believe me, I've experienced the gasps of joy at what I thought was a well-constructed shot, only to find out later that the footage was useless because of my not-so-good decisions about lighting.

Light can even hurt your equipment. Leaving your lens (or viewfinder!) unprotected and pointed at a bright object can cost you hundreds or thousands of dollars to replace it. Unfortunately, I know about that one, too. (Hot sunlight can also destroy your battery.)

In this chapter, you find out how to use lighting to ensure that your audience sees what you *want* them to see. Of course, you could skip this whole chapter and just depend on your camcorder's automatic settings to handle lighting, and most of the time you'd probably be okay. Sooner or later, though, you are going to need to know how to enhance and hide your subject with light. In fact, experience tells me that you will be faced with lighting challenges almost as often as you turn on your camcorder.

Lighting 101

Light and color affect everything you do in video filming and production. Light and color not only illuminate the subject, but also work to create mood and provide insight.

Light

Whether you're recording outdoors with natural light or indoors with artificial light, you'll be wise to remember some simple ideas:

- ✔ Light either satisfies the appetites of all your CCDs' (Charge-Coupled Device) pixels or causes your camcorder to electronically compensate, which lowers the quality of your shot.

 CCDs collect visual images and convert them into either an analog signal or, in the case of your digital camcorder, a digital signal.

- ✔ The way you use light and shadows causes visual hierarchy in your shot — so you and your light source need to agree about the most to least important elements. Light tends to emphasize the most important part of your subject, while shadow tends to hide the less important features.

- ✔ The way you use light and shadows creates an aesthetic or emotional response in the viewer. (I trust that your viewer is laughing because you meant him or her to.)

- ✔ Light sets illusions of relationships in your shot. For instance, something brightly lit infers importance over something dimly lit.

Color

A camcorder's ability to interpret color is based on its ability to interpret hue in a wide variety of light sources, which can be a big problem. Here's an example of what's going on. Have you ever purchased a garment at a clothing store to color coordinate with another garment you already own? You fuss and fuss until you select just the right necktie or scarf. But when you get home, you find the colors don't work together at all. What happened?

In the store, you may have seen the scarf under fluorescent light. In your mind's eye, you interpreted the scarf's color coordination with your garment at home. The problem is that your memory of the garment at home comes from looking at it in incandescent light or daylight. The only foolproof way to color coordinate is to look at both garments in the same kind of light. The misinterpretation of color is due to *color temperature*.

Color temperature

Color temperature is a standardized measurement of how colors appear based on the characteristics of the light in which you see the colors. Your camcorder has to be told how to interpret color based on the color temperature of the light source(s) where you are recording. When you record in the sunlight, your camcorder's interpretation of an object's color is entirely different than its interpretation of that same object indoors.

A typical scenario is when you record video as you follow someone from outdoors to indoors. As you go indoors, your camcorder goes through all kinds of gyrations trying to adjust the iris. (See Chapter 3 for more about irises.) But you may notice that, for a few moments, everything in the room appears to have a bluish cast, and then appears normal again. This transition happens because the camera is trying to adjust to the new color temperature.

White balance

White balancing tells your camcorder how to interpret the color white. As you practice working with manual white balancing, you'll notice your color temperature problems fading away. Avoid *mixed-color* temperatures in the same image whenever possible. The classic mixed-color situation occurs when recording indoors with a window in the shot. If you set white balance for indoor lighting, the outdoor images can have an unpleasant tint. If you can, keep the window out of the shot. But if the shot is important and you don't have control over the lighting, use your automatic white balance and cross your blue-tinted fingers.

White balancing originated with the practice of placing a white object in front of a camera lens and telling the camera that the object is white by adjusting the white balance. Today's camcorders have automatic white balancing capabilities. By using an automatic white balance control, your camcorder reinterprets the color white in order to adjust to a new color temperature. If your camcorder can properly display something that is truly white, then all other colors in the picture will also be correct.

If your camcorder can automatically adjust white balance, why even bother discussing it here? For the very good reason that your camcorder's automatic white balance function is based on an average color temperature in the room. The problem is that sometimes a predominant color in the room can royally mess up other colors, for example, by making someone's skin look eerily tinted.

Manual white balancing is a fairly simple process; just stroll this way to find out how to do it. Although I use the Canon XL1 as the model camcorder throughout this book, the white balance options provided by the Canon XL1 are typical of most digital camcorders. Consult your camcorder owner's manual for the exact location of the controls and follow these steps:

1. **Set your white balance selection to Manual.**

 Using the Canon XL1 as an example, turn the white balance knob toward the white balance button (see Figure 4-1).

2. **Position a piece of white paper at the location where white balance is most critical, such as in front of your subject's face.**

 Doing so ensures that the color temperature at the most important spot is selected as the basis for your white balance.

3. **Press the white balance button on your camcorder.**

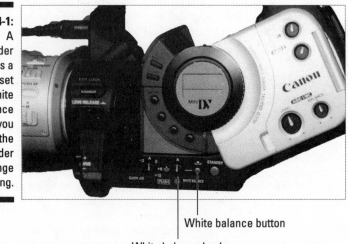

Figure 4-1:
A camcorder utilizes a manually set white balance unless you turn off the camcorder or change the setting.

White balance button

White balance knob

Manufacturers usually provide white balance *presets*. These presets provide you with default white balance settings for recording indoors using artificial light and recording outdoors using daylight. You may be tempted to select one of the presets to nail your white balance, but doing so could result in a disappointing surprise. As helpful as these two little options may be, they can also be easily misused.

Take a look at Table 4-1. The table lists typical color temperatures of various kinds of light sources — from candles to bright sunlight. Presets are intended for one kind of professional lamp (tungsten) and for one time of day. Indoors, presets are intended for studio quality lamps (3,200 degrees Kelvin) and outdoors, they are intended for midday sun (5,600 degrees Kelvin). As you can see, a preset won't help you much if you're using a candle, a standard incandescent bulb, or a fluorescent light indoors. And outdoors, a preset messes up your shoot at sunrise and sunset.

Table 4-1	Approximate Color Temperatures of Light Sources
Light Source	*Typical Color Temperatures (Measured in Kelvin)*
Candle	1,900
60-watt Household lamp	2,800
Professional lamp	3,200
Fluorescent light	3,700*
Sunrise and sunset	2,000-3,500
Cloudless midday sun	5,600
Hazy day	8,000

Fluorescent light color temperature varies according to the age of the lamp, coating, filtering, and other factors.

Lighting Techniques

Unless you have some reason to record video with the lens cover on, you're always either using or being abused by light in your video. If you know just a few simple tricks, you'll be light-years ahead in the quality of your work — particularly with digital video. Although entire books are written about proper video lighting techniques, you can accomplish a lot by knowing the lowdown on three processes:

✓ Setting the hard (preprimary) light

✓ Washing with soft light

✓ Using shadows

Hitting with hard light

Hard light is a term used in film and video for a direct light source that creates sharply defined (high contrast) shadows. Hard light is dominant; it causes the eye to focus on highlights rather than shadows. As a rule, the smaller the diameter of the light source, the sharper the contrast between the light and the shadow. Figure 4-2 illustrates a single hard light source imposed upon a figure. If you're shooting indoors, you can adjust a hard light to be focused and trimmed so that it illuminates exactly what you want. Usually direct sunlight outdoors is hard light.

Figure 4-2:
Hard light
accentuates
dimension
and depth
with
highlights
and
shadows.

Suggesting with soft light

Soft light is more subjective than hard light. Soft light washes an area with light and creates wispy (low contrast) shadows, as shown in Figure 4-3. Indoors, soft light is created by indirect light sources, such as hard light bouncing off a white surface, or hard light covered with a diffusing cloth or filter. Outdoors, soft light can be achieved by shooting on a cloudy day or in the shadow of a structure. Sometimes lighting crews spread silk over an entire scene to cause direct sunlight to diffuse through the silk.

Controlling shadows

Shadows are the places where light is physically blocked by an object. How's that for an objective definition? Shadows can be good (see Figure 4-4), and they can be very bad. The worst shadows are those caused by someone's nose, which can sometimes make a person's nose the focal point of the video. The simplest way to ensure that shadows make your subject look good is to believe what you see in your viewfinder. Your camera "sees" shadows differently than your eyes do because your camera sees in two dimensions instead of three dimensions.

Figure 4-3:
The larger
the diameter
of a light
source is,
the sharper
the contrast
of light and
shadow
created by
the soft
light.

Figure 4-4:
Shadows
add depth
and texture
to a scene
and
establish
the direction
of light
source.

I know you're thinking that you need to spend megabucks for studio lighting
equipment. It's true, lighting equipment can be expensive. But it doesn't have
to be. See the sidebar "Making your living room a studio" for tips on setting
up some very effective lighting by using only three fixtures. But first, take a
look at some basic principles of lighting in traditional cinematography:

> ✔ Key light
> ✔ Fill light
> ✔ Backlight

Key light (making Aunt Bertha a star)

The primary light of a shot is the *key light*. It sets the stage for the shot, establishes texture and depth of a primary figure, and determines the direction of the shadows. The key light typically comes from a single direction, as shown in Figure 4-5, and often is a hard light (see the section "Hitting with hard light," earlier in this chapter). The key light can create problems by overlighting objects and casting ugly shadows.

Key light is especially important when filming someone's face because subtle nuances of light can flatter or distort a facial feature. Correctly filming someone's face takes practice. The great challenge of recording the human face comes from the infinite variety of facial shapes and shades; you can't film everyone in the same manner. Of course, the intent of the shot also can dictate the manner in which you want the face to look. For example, lighting a face for a mysterious, eerie scene is entirely different than lighting the face for a casual interview. The images in Figure 4-6 show how key lighting affects the way people look.

Direction of light

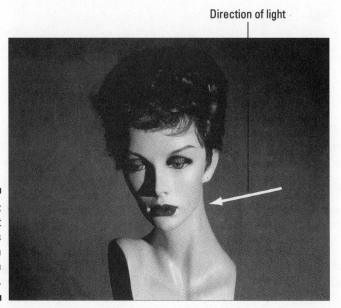

Figure 4-5:
The key light establishes a direction of light in the scene.

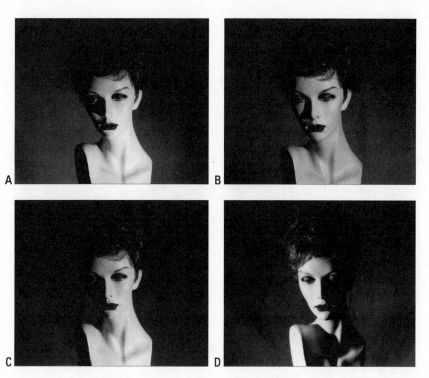

Figure 4-6:
The angle of key lighting changes the effect. (A) is an unusual angle, creating a mysterious look; (B) is natural angle; (C) is also natural but highly shadowed; (D) is overly bright on the forehead.

In Figure 4-6, I adjusted the vertical and horizontal location of the key light in each image to emphasize various features. Using a single facial structure, you can change the angle and the intensity of the key light to create a variety of effects, which creates a dynamic effect.

Set the key light by placing your light source 30 to 45 degrees to the right or left of your camera. A good rule of thumb is to follow the natural light source, so if you are inside and the window is on the right, aim your light in the same direction as the light streaming through the window. I prefer having the light on the left side, but experiment with both sides to determine which side you prefer.

Fill light (making Aunt Bertha a young star)

As important as a key light is, it usually creates too stark and unattractive a scene without the compromising wash of *fill light*. For the most part, fill light casts no shadows and decreases some of the harshness of the key light's shadows (see Figure 4-7). Just as a key light can harshly overlight a subject, too much fill light can destroy the details of an image. For example, using too much fill light causes facial contours to disappear and surfaces to lose their

texture. Place your fill light at a 45-degree angle from your camera on the opposite side from your key light (which is also at a 45-degree angle from the camera).

Fill light comes from different sources such as light coming through a window or from a lamp in a corner. If you're trying to control fill light, you can close the drapes, turn off the room lights, and point bright light at a piece of white poster board so that the light bounces onto your subject in an unfocused (fill) manner.

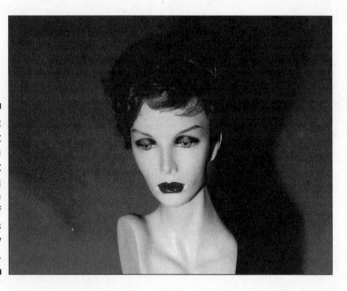

Figure 4-7:
A fill light brightens an overall shot by reducing the darkness of shadows produced by the key light.

Backlight (giving Aunt Bertha depth)

Video creates a two-dimensional illusion of three-dimensional reality. One of the basic challenges when recording video is to avoid giving the impression of pasting the subject against the background. The perception of separation of the subject from the background is a much more visually comfortable illusion. This separation is accomplished by using *backlight*.

Backlight creates a kind of aura around the subject. The highlight lifts the subject from the background (see Figure 4-8). Backlight is accomplished by pointing a light from the back toward but not directly at the camera, illuminating the subject from behind.

To make backlight, aim an incandescent light (such as a utility light from a hardware store) from above and slightly behind the subject onto the subject's head and shoulders.

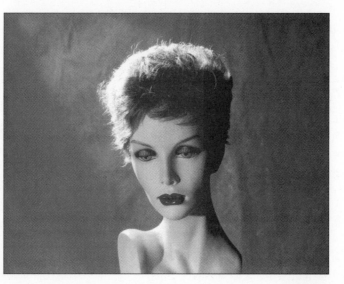

Figure 4-8: Backlight is aimed at the subject so that it does not spill onto the background.

Putting it all together

After you set the key light, backlight, and fill light, turn them all on and check them for white balance. In Figure 4-9, the key light establishes the direction of the light and creates the depth of the shot without giving a stark appearance. The backlight adds a slight aura to the subject. The fill washes the face without destroying the three-dimensional quality of the subject.

You know the combination of light is right when the subject looks natural and attractive in the viewfinder. If the face is too bright, try backing up the key light a little bit. If the shadows are too stark, try making the fill light brighter or closer. If the subject seems pasted against the wall, increase the intensity or change the direction of the backlight.

Making your living room a studio

If you can temporarily prevent outdoor lighting from entering your living room (or any other large room in your house), you've got the makings for a studio.

✔ **Studio light:** Studio lights, such as the Omni Lights I am proud to own, are a valuable investment. However, regular incandescent lights do very well, too. The important issue is that your lights need to be portable and powerful. Just remember some basics:

Lights get very hot. After they've been on a while, use gloves to handle them. Of course, keep the lights away from flammable objects.

(continued)

(continued)

You're likely to need some commercial-quality extension cords so that you can move the lights wherever you want and distribute the power load to more than one circuit in the house. Home-quality extension cords can overheat and pose a serious electrical shock and fire hazard.

✔ **Backdrop:** A nondescript backdrop is essential for studio shots. Here's what I suggest (and, in fact, am using as I write this book — in my living room): Buy some muslin at a fabric store. Paint it a dull, neutral color such as blue-gray. Make a backdrop frame (one that you can easily assemble and break down for carrying in your car). Mine is 8 feet wide by 7 feet high. I simply purchased ¾-inch galvanized pipe at the local hardware store to make the frame.

To construct a backdrop frame, just go to your favorite hardware store and buy the following items:

> Four 4-feet by ¾-inch threaded galvanized pipe
>
> Two 3-feet by ¾-inch threaded galvanized pipe
>
> Three ¾-inch couples (for putting the two 7-feet lengths and the 8-feet length together)

Two 90-degree elbows (for connecting the sides with the top)

Two Ts (for connecting to the bottom of the 7-feet sides)

Four 1-foot by ¾-inch threaded galvanized nipples (for making the backdrop feet)

Four ¾-inch female caps (for making ends to the feet)

Spring clamps (six will probably do) for clamping your backdrop to the frame. These clamps are invaluable in video creation for a multitude of ingenious purposes.

✔ **Foamcore:** At your local craft or office supply store, buy some 2 feet x 4 feet white foamcore (¼-inch or ⅜-inch thickness). This board is great for bouncing light as a soft light. You can also cut out shapes and slots and place them in front of a light to create fascinating background patterns. Last, you can use the foamcore in front of a light to *flag,* a procedure in which you block light to keep it from hitting or spilling into areas of the shot where light isn't wanted.

Figure 4-9:
The balance
of a shot is
seldom
perfect;
your goal
is to
complement
and
highlight the
appearance
of your
subject.

Chapter 5

Sound Is a Big Deal!

· ·

· ·

*T*he audio content in a video is often as important, and sometimes more important, than the visual content. To prove my point, here are two simple tests. This evening turn on your television, select a program, and mute the audio for a few minutes. During those minutes, develop a summary of the information as it's conveyed. When you're done, do just the opposite. Turn on your audio and position yourself so that you can't see the screen. Again, develop a summary of the information. You may be surprised to find that your comprehension was greater with only the audio content than with only the visual content.

If you're an astute observer, you may pick up a lot of very different information in each of the two tests. For example, visually, without interference of sound, you may be more inclined to notice the ambiance of the scene, the framing of the characters, the flow of the edits, and the use of light.

In the audio test, without the seduction of visual images, you are more keenly aware of the development of the story line, the spatial relationship and proximity of characters through comparisons of their voices, the subjective effect of music (soundtrack), and the use of sound effects such as footsteps, wind, and other embellishments.

You don't always have to go through a lot of extra trouble to ensure good audio recording. Sometimes, in places such as your living room, you can just point your camcorder in the right direction and press the record button. High-quality audio production can be amazingly simple. Other times, though, you need to use every bit of ingenuity you can muster just to get a passable audio signal, such as when interviewing someone next to a busy highway.

The physics of sound

Sound is a continuous series of waves traveling through the air. A microphone transforms the waves to electric currents. The waves strike against a vertical surface that is housed within a microphone. The microphone translates the waves into *electrical waves,* similar to the waves that existed in the air. This electrical re-creation of waves results in what is called *analog audio.* The microphone wire then transmits the analog waves to a recording device.

In analog recording, sound waves are processed each time they are moved from one piece of equipment to another. You record the video and audio onto videotape. In so doing, you lay a bunch of wave information onto the tape.

Next, you play the tape on your tape player. In order to see and hear what you're playing, the analog waves are turned into impulses that can be interpreted by your monitor and speakers. This conversion of waves causes them to be somewhat distorted. If you were to take the monitor's signal and pass it onto another tape recorder (a common procedure in editing), you would have further distortion of the waves, and so on. This is called *generational loss.*

Digital audio doesn't reprocess sound like analog audio does. Once you record sound in a digital format, the sound remains precisely the same throughout its digital life and generations — no matter how many kinds of digital equipment you play it on and no matter how many times you re-record it.

In this chapter, I help you make the most of your digital camcorder's audio production features. With a little reading and just a little practice, you can develop good audio production habits. I explain why a good sound recording is so vital, how to choose the best tools and techniques to create the best possible video, and what you can do to use this information to get the best sound recording — even in lousy circumstances.

Recording Good Sound

Sound often makes or breaks a recording. What good is it to record a wedding ceremony if all you can hear is the mother-in-law blowing into her hanky? Your presentations will be more effective, more useable, and definitely more enjoyable if you capture the moment with sound. However, your camcorder cannot perform magic, and it is up to you to understand why sound should be one of your most important concerns.

The human ear makes allowances for imperfections in sound. Even though your mind can fabricate what's missing in a reproduction, your mind rejects what is incorrectly reproduced. People are intolerant of recorded voices that

are unnaturally *sibilant* (hissing sounds) and of sounds with clipped high notes or overly strong deep resonance. The term for such an occurrence in a faulty audio recording is *distortion*.

Two kinds of distortion threaten the quality of audio reproduction — distortions caused by limitations of the recording device and distortions caused by misuse of the recording device. I'll discuss useful equipment and techniques to help you obtain the best-quality recording in the section "Increasing Your Success with Audio."

Choosing the Right Microphone

Imagine that you're going to record a wedding. You get to the church early to set up your equipment. You set up a microphone where the vows are to take place. Everything is ready, so you sit back and wait.

The music begins — beautiful, *loud* organ music. The framing of the shot is beautiful, the light is perfect, everything looks great, but your audio volume meter is going berserk.

Stuff you really don't need to know about digital audio

Digital camcorders usually use Pulse Code Modulation (PCM) 16-bit stereo digital audio recording with a sampling rate of 44,100. In PCM audio recording, audio is converted from analog signals to 16-bit stereo digital. The conversion results in audio of such quality that its dynamic range exceeds the human ear's ability to discern distortion.

Dynamic range refers to the outer ranges of a recording instrument. Every recorder, analog or digital, has its own dynamic range. An audio recorder has minimum and maximum limits in its dynamic range. On some analog recorders, the low range is less sensitive than that of the human ear. As a result, in very quiet scenes, you might pick up a static noise.

Also, some recorders may have an upper range that is unable to record a richness of sound that satisfies your awareness of what the sound should be like. For example, trombones may seem kind of empty rather than full. In either case, it's possible that you're hearing the limitations of the recording device's dynamic range.

A digital camcorder, with its PCM audio recorder, has both a minimum silence range and a maximum amplitude range (dynamic range) that exceed what can be humanly discerned. Some analog recording devices also have excellent dynamic ranges, but these recorders fall short of 16-bit digital video.

Then the music stops, and the minister begins to talk. Then the moment comes: The bride responds to her first vow. That is, you think she answers. But the needle on your camcorder's audiometer doesn't budge.

The minister turns to the groom — and the next crisis hits: The groom nearly shouts his "I do." The needles of the audiometer bury themselves in the red distortion.

This example underscores two common occurrences in video creation: The time needed to prepare a shot is always slightly less than the time available, and you must allot some of that time that you don't have for audio preparation.

So what's a digital videographer to do? The following section provides a number of suggestions, much of it quoted to you from my Ph.D. dissertation from the school of hard knocks, about microphones, acoustics, and other ways to resolve tough recording problems.

One of the crazy inconsistencies of video creation is that a lens is only useful if it remains connected to its camera body, but a microphone is often more useful when it isn't connected to a camera body. Sitting on top of a camcorder, a microphone is susceptible to machine noises and inadvertent sounds made by the camera operator and crew (a crew is defined as anybody who you think will not inadvertently destroy your equipment and who you can blackmail into helping you). Also, especially indoors, a camera-mounted microphone tends to be subject to reflective sounds.

Explanations of microphone types and their proper placement can often be sophisticated and highly technical. In an effort to remain simple and practical, I really only want to describe and recommend a few to you.

Omnidirectional, unidirectional, or shotgun microphones

Here are some classifications of microphones to keep in mind for your videography needs:

- **Omnidirectional — a microphone for all directions:** Omnidirectional microphones pick up sound in all directions. These microphones are typically used when you are confident that all the sound sources within an immediate proximity to the microphone are desirable. Your camcorder's factory-supplied microphone is probably omnidirectional. Omnidirectional microphones can cost as little as $29 and on up to hundreds of dollars.

- **Unidirectional — a one-person-at-a-time microphone:** Just the opposite of omnidirectional, a unidirectional microphone collects sound only from the area directly in front of it. Unidirectional microphones are especially

helpful where you have more than one person wearing a microphone and you need to independently control the volume of each person. They are also useful in situations where you need to isolate one sound from a bunch of unwanted sounds. Unidirectional microphones also can cost as little as $29 and on up to hundreds of dollars.

✔ **Shotgun — a long-range microphone:** The term "shotgun microphone" may imply that it is a roaming and haphazard microphone. A shotgun microphone is just the opposite. You use it for pinpoint isolation of sound. Typically, you use shotgun microphones when you cannot place a microphone directly in front of a person on camera. A crew member stands off-camera and directs the shotgun microphone at the person speaking. The shotgun microphone picks up sound only where it is aimed. Basic shotgun microphones start at around $39 and range up to $1,000 or more.

Take a look at Figure 5-1. Note that the room causes a multiplication of audio sources. That is, the camcorder's audio recorder is faithfully recording what it is receiving from the microphone; however, the omnidirectional camcorder microphone is receiving the sum of all the sounds in the immediate environment — not just the speaker's voice.

One way to put your microphone on a "sound diet" is by modifying or controlling the sound environment around the microphone.

Figure 5-1:
A microphone doesn't know what sound to identify as the correct one, so it collects and assigns equal priority to all sounds.

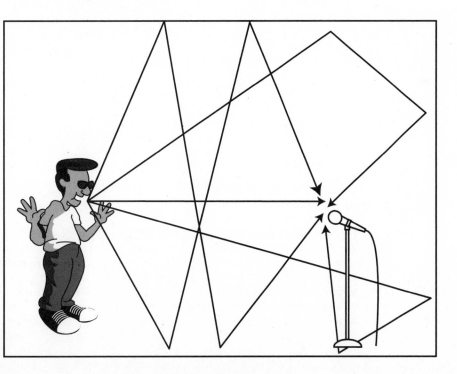

Lavalier or handheld microphones

If recording weddings, training, or any other kind of video where the quality of audio reproduction is important, I suggest that you invest in a decent lavalier microphone. A *lavalier* is a small microphone that can be clipped to a necktie or blouse (see Figure 5-2). Although lavaliers are usually omnidirectional, you can buy unidirectional ones, which are typically used for recording musical instruments.

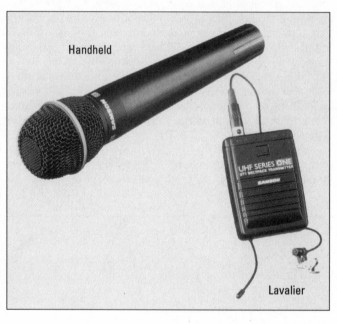

Handheld

UHF SERIES ONE
UT1 BELTPACK TRANSMITTER
SAMSON

Lavalier

Figure 5-2: A lavalier is easier to hide than a handheld microphone, but a handheld microphone is more versatile.

You may also want a handheld microphone. Handheld microphones aren't always handheld (they're often on microphone stands), but that's not really important. Like lavaliers, most handheld microphones are also omnidirectional.

Wired or wireless microphones

Based on your budget and your recording needs, you can use either a wireless microphone, transmitter, and receiver or a hard-wired microphone, which are microphones connected to a long cable. Hard-wired systems are . . . well, you know, *hard-wired.* You see, you have a microphone, and the microphone is connected to the recorder by a long audio cable — in some instances, a very long cable. In Chapter 18, I include information about a basic wireless microphone system costing around $520. You can find wireless microphone systems that cost less than this, but you'll have difficulty finding a system with a receiver small enough to fit on a digital camcorder for less than $500.

When you are buying a camcorder, double-check that it has a connector for an external microphone. And while you are at it, make sure there is a headphone jack, too. Most digital camcorders have external headphone and microphone jacks, but they're good things to confirm nonetheless. The headphone jack is good for listening for sound levels, and I go into this helpful tip in the section "Increasing Your Success with Audio" in this chapter.

Hard-wired systems are inexpensive and dependable. Just plug one end of the cord into the microphone and the other into the recording device. Like wireless systems, wired systems also have limitations:

- Dragging the cord around on the floor causes it to accumulate dirt, which could result in equipment damage or signal distortion.
- Hiding the wiring when recording can be problematic.
- You may pick up a low hum if you inadvertently run audio wiring in a parallel path with electrical wiring.

Wireless systems combat some of those problems, but be aware of their limitations:

- They have a never-ending demand for fresh batteries.
- The transmitter is hard to hide on clothing.
- Radio interference is occasionally possible.

Whenever I have a choice, I use a wired system rather than a wireless one. Experience has proven, though, that Murphy's Law requires having both options (and spare batteries) handy.

Increasing Your Success with Audio

In video creation, overcoming the challenges in the audio environment is one of your biggest jobs. Your goal is to make the audio on the tape sound like what your ears are hearing in real life. This is seldom an easy task.

A cardinal rule is not to *overdrive* your audio recording capability. Overdriving occurs when you place a microphone too close to someone's mouth or place a microphone too close to musical equipment. If you overdrive your recording, you will most likely cause the audio to be distorted. Distorted audio is, in a sense, damaged.

Here are some tips for increasing your success with sound recording. You will make sound goofs — perfection is an unrealistic goal. But you can definitely achieve a high quality on a regular basis by observing some simple rules:

✔ **Rule #1:** Obtain a set of earphones, plug them into the audio monitoring port on your camcorder, and wear them during setup and recording. Once you're sure the sound is okay, you can take off the earphones.

✔ **Rule #2:** Try turning off your *automatic gain control* (AGC) on your camcorder. Really. I'm not kidding. (Trust the Force, Luke.) I usually use the AGC in only two circumstances: when I don't have the time to worry about how the audio turns out, and when the audio situation is out of control, such as at a loud basketball game. Otherwise, I leave the AGC turned off and keep my fingers poised on the volume control. Why do I turn AGC off? Because AGC is very good at what it is designed to do. It looks for sound and then adjusts the dynamic range of the audio recorder to maximize the sound — even sound I don't want maximized. That can be bad.

AGC can do other bad things, too. If you record in an empty office, you may think the room is quiet, but AGC thinks otherwise. It may magnify the sound of the furnace blower, the computer fan, and the copying machine in the next room to a deafening level. The AGC is only doing its job. Believe it or not, I've had to scrap video footage shot in rooms where the only sound was from the ballast of a fluorescent lamp! In playback, the lamp sound just about drove me crazy. In the real room, I had not even noticed the sound. Thanks, AGC.

✔ **Rule #3:** Sound-check your on-camera person (people). I know this isn't always possible. But whenever you can, get your people to talk naturally on-camera in the location they will speak, adjust your sound level, record, and play back. With a little practice, you can perform this procedure in less than one minute. I promise that you will enjoy your time shooting video a lot more if you're confident that the audio is recording properly. As a rule, when I convey my desire to make someone sound and look as good as possible, they usually cheerfully cooperate.

✔ **Rule #4:** Ride the gain. *Riding the gain* is the practice of keeping an eye on the volume meter and a finger on the volume (gain) control. With a little practice, you can learn to anticipate moments when a presenter is about to speak loudly or softly. The intent of riding gain isn't to be constantly adjusting the gain control up and down, but to occasionally, subtly adjust the gain to prevent the presenter's voice from distorting or disappearing.

✔ **Rule #5:** Bring some blankets. Seriously, I mean real blankets. You'll find that some rooms are unalterably hot. In audio recording, *hot* means too reflective. This condition usually occurs in rooms with tile floors and non-acoustical ceilings. If you're getting an audio signal that's too hot, just toss some blankets around the room (off-camera). Doing so can make a major difference in your audio recording quality.

✔ **Rule #6:** Bring lots and lots of batteries. I promise you, there's a direct relationship between proximity of back-up batteries and battery life. If you don't have a back-up battery available, your microphone battery will fail in the middle of an important nonrepeatable scene. If you do have a back-up battery nearby, your microphone battery will last for days. It's a mystery how it works.

Chapter 6

The Basics of Creating Great Video

In This Chapter

▶ Engaging your viewer with well crafted shots

▶ Using storyboarding and scripting to plan your video

I'm going to make a big assumption: You intend to use your digital video camcorder for more than just shooting video. Perhaps you want to impress an individual or group of people with an idea that you would like to translate into film. Maybe you want to motivate people to do, support, or buy something by showing them a touching or powerful film. Or you may want to teach someone a step-by-step process through a training video. Then again, you may want to document an event, such as a wedding or a football game.

With few exceptions, you can't expect to record video that, *unedited,* will meet your goals and expectations. Unedited video is usually boring beyond belief. You've probably sat through some of it (a friend's family vacation, for example) at one time or another, so I won't bother to prove my point. The best way to get good video is to know how to use your camcorder as a persuasion tool and to plan (or *script*) the intended outcome.

Preparing to Shoot Digital Video

You need to become familiar with the vocabulary associated with filmmaking to understand how things are done and how to communicate your ideas effectively. So, always wanting to be helpful, I describe and illustrate some of the terms associated with the different kinds of video shots.

Using the right angle for the right situation

Here's a list of words associated with different types of video shots:

✔ **Extra long shot (ELS):** Shows a person within the fullness of the surrounding area. For example, you tell the viewer what is going on with the person in the video by showing her *and* the big picture around her. Use this shot to effectively establish the environment for opening and closing shots.

✔ **Long shot (LS):** The character in this shot occupies one-half to three-quarters of the screen height. This shot clarifies the relationship between the character and the overall place by showing what's in the subject's immediate proximity. This shot usually shows people from their feet to their head.

✔ **Medium long shot (MLS):** Shows the subject's body plus a little above and below. This shot is often used when the subject is moving.

✔ **Knee shot:** Shows a three-quarter shot from the head to the knee. Use this shot to re-establish the relationship of the character to a location or to another character. That is, after using a close-up shot, you need to show the subject's surroundings again.

✔ **Medium shot (MS):** Shows the top of the head to just below the waist. Use this shot to develop a comfort zone for the viewer: a comfortable, conversational distance between the viewer and character. Overuse this technique, however, and you risk boring the viewer. A basic rule of creating video is to provide timely visual stimulation through changing views. Too much of a comfortable shot can cause the viewer to lose attention.

✔ **Medium close-up (MCU):** Often called a *bust shot,* it cuts from the top of the head to just above the diaphragm. Use the MCU as an attention-getting shot because it violates the comfort zone, thus making the viewers slightly uncomfortable and thereby getting their attention. The shot also implies that the character is significant or has something important to say. For this reason, the MCU, mixed with an occasional Knee shot, is the favorite of the evening news.

✔ **Close-up (CU):** Shows the upper forehead to the upper chest. Use this shot for emphasis, but use it sparingly to hit the important phrase in a statement or to establish strong feeling. It is also used frequently in interviews.

✔ **Big close-up (BCU):** A full-head shot. Use this shot to elicit a laugh or cynicism, but be careful because the shot can appear bizarre.

✔ **Very close-up (VCU):** This face shot shows the middle of the forehead to above the chin. This shot exposes the character's emotions. Reserve it for dramatic moments.

✔ **Extreme close-up (ECU):** Use this shot for a very tight face shot or isolated details, such as a person's eyes widening in fear. This shot is at the edge of the lens's capability to focus. Use the ECU for objects more often than characters.

Figure 6-1 is made up of ten stills that are named according to the type of shot shown. These names indicate the proximity of the lens to the subject (the person, item, or event being recorded).

ELS

LS

MLS

KNEE

MS

MCU

CU

BCU

VCU

ECU

Figure 6-1:
Each shot
causes a
unique
reaction in
the viewer.

Selecting the length of shot

Even though you can use your camcorder to establish environment, bring a character closer to the viewer, or show movement, you need to use good judgment in selecting the correct mixture of shots. The following are two of the main reasons for changing the perspective of a shot:

- ✔ **Storytelling:** The viewer needs to know relationships as well as details. A wide shot establishes the place and the proximity of other characters. A close-up provides necessary visual details, such as a raised eyebrow, a shaking hand, or a flashing smile. Changes of perspective are often as important to a story as spoken words.

- ✔ **Editing:** Changes of perspective are essential to good editing. Transitions are much easier to edit when the character's perspective changes. A good filmmaker provides the editor (even when the two are the same person) with both wide shots and close-ups of the same sequence, which enables the editor to decide when to use the wide shot or the close-up. For example, in an infomercial, the spokesperson talks about the importance of a product's new features. If you have a wide shot of the narrator talking about the feature and close-ups showing the feature's details, you can edit the segment from the wide shot to the close-up whenever necessary to allow the viewer to visually comprehend the significance of the feature.

Be sure to use the right shot at the right moment; otherwise, you may misinform your viewers or make them uncomfortable. At the opening of a scene, the viewer wants to know where the action is taking place. A close-up would not communicate the setting to the viewer. In a scene with an intimate conversation between characters, the viewer wants to be up close with alternating close-ups of one character and then the other. Using a wide shot makes the viewer feel left out or like an eavesdropper. But in conversations that aren't intimate, say, between two business people, the viewer likes alternating medium close-ups of the two. Extreme close-ups in this situation make the viewer uncomfortable.

Off-camera action is something that occurs outside the viewing area that is brought to the attention of the viewer. You want to use dramatic action off-camera (such as a foot snapping a twig when the subject is sitting alone by a campfire) if your intent is to create tension. Off-camera action needs to be used carefully. Off-camera action is counter-productive if the viewer needs the action to understand the story (such as the emergence of the twig snapper from the edge of the woods).

Using focus as a technique

You may have noticed that while using your camcorder, you use the focus mechanism on your lens more than any other camcorder feature. Focusing is

about the most basic function performed by your camcorder (either automatically or manually). With just a little knowledge and practice, you can turn focusing into a powerful technique for getting the most out of every shot. The first thing you probably want to practice is controlling depth of focus (the amount of focused space in front and behind your subject). You adjust f-stop to achieve depth of focus.

Aperture equals focal length divided by the diameter of your lens. The setting of the aperture is referred to as *f-stop*. (If any of these terms are unfamiliar to you, hold your spot here and flip over to Chapter 3 for more information.)

Depth of focus directly relates to f-stop. The higher the f-stop, the greater the depth of focus. At higher f-stops, therefore, the perception of being in focus exists for a substantial distance on either side of the actual plane of focus (*focal plane*). By perception of focus, I mean that only a very thin plane is ever actually in focus. The larger the depth of focus, the more that objects in front and behind the focal plane look like they are in focus. Higher f-stops mean that more of the shot appears to be in focus, but the shot also requires more light.

The opposite is true for depth of focus at lower f-stops. The lower the f-stop, the lower (or shallower) the depth of focus. This means that at lower f-stops, the perception of a shot being in focus is nearly nonexistent on either side of the focal plane. A typical situation in which you use a lower f-stop (for a shallower depth of focus) is when you want to blur out a background for some reason. Using lower f-stops requires less light for the shot.

Take a look at Figure 6-2, which shows two stills. The still on the left (a) was shot at f/11. The still on the right (b) was shot at f/2.8. In 6-2a, objects in the background are in focus. In 6-2b, the background is blurred.

Figure 6-2:
On the left, (a) has large depth of focus while (b), on the right, has a short depth of focus and makes the background irrelevant.

a b

Setting camera height

You can also use the *vertical angle* of a shot to influence a viewer's perception of a character. Take a look at the three stills in Figure 6-3. The first still illustrates the use of a *neutral camera height*, in which the camera's lens is set at chest to eye height. Such shots are objective. That is, they don't influence a viewer's perception of the subject.

In the second shot, the camera height is set above the character's eye height. This angle, which looks down at the character, generally suggests inferiority, weakness, or submission of the character to the viewer or to other characters in the video.

In the third shot, the camera height is set waist-high to the character, which is a subjective shot. This shot suggests strength and dominance of the character over the viewer or over other characters in the video. In *Citizen Kane*, the main character was often shot this way. Orson Welles intentionally did this to establish superiority. The setting of camera height as I've described here applies to a stationary camera.

Moving the camera

You can create energy in an otherwise static shot simply by moving your camera. As with the various perspective shots, videographers bestow specific names on each of these camera movements.

Panning and tilting

Panning and tilting are performed with a camcorder resting on the head of a tripod. *Panning* is moving the camera from left to right, and *tilting* is moving it up and down on the tripod's head.

The two basic kinds of panning are *following pan* and *surveying pan*. In the following pan, the camera operator pans (moves the camera left or right) to follow a character, for example from one spot to another. The surveying pan is used to locate a character or an object, for example, a character searching for and finding another character on a crowded street.

Tilting is often done simply as a matter of course, such as tilting down to follow an action. However, you can also tilt to achieve a particular effect, such as tilting up or down to denote height or depth. The classic tilt is when someone shoots video at the base of a tall building and moves the camera by tilting up to establish that the building is tall.

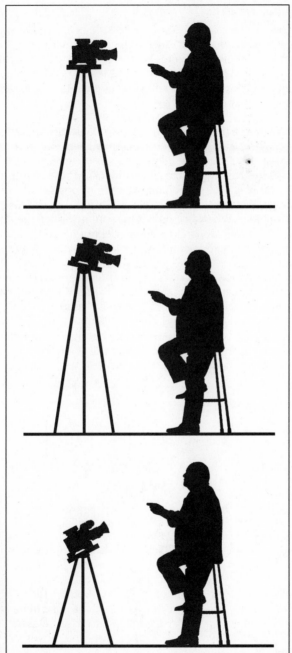

Figure 6-3:
Camera
height
places the
viewer in a
subjective
relationship
with the
character in
a shot.

Craning, dollying, and trucking

In addition to moving the camera from side to side or up and down, you can create even greater dynamic energy by moving the camera over, into, out of, or across the scene. Although moving the camera over a scene, called *craning,* may be too elaborate for your purposes, at least you'll now know the term if and when you hear it. The other two movements — dollying and trucking — are quite easy and effective.

Dollying refers to moving the camera forward or backward in a scene (see Figure 6-4). Although, at first glance, dollying may seem similar to zooming, they are used differently. You dolly by moving the camera forward (in toward the subject) or backwards (away from the subject), whereas you zoom in and out by adjusting the lens. Dollying changes the relationship of the character to his surroundings. When you dolly in, you isolate the character from everything on the left or right. When you dolly out, you introduce the character to her surroundings. Zooming doesn't give the effect of deleting or adding surroundings. Zooming just includes more or fewer details in the picture.

Dollying causes the relationship between the character and the overall scene to change. Generally, you must adjust the focus and tilt the camera while you dolly because you are changing the focal depth by moving the camera toward or away from the subject. Foreground objects disappear or appear as the camera moves in or out. Zooming, on the other hand, does not change the spatial relationship between the character and the scene.

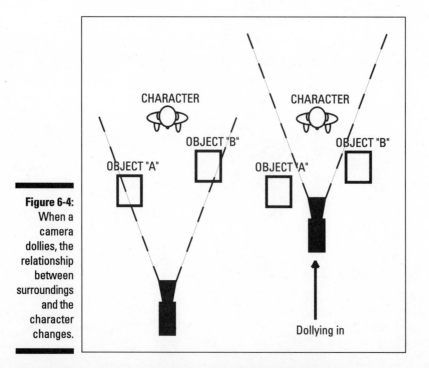

Figure 6-4:
When a camera dollies, the relationship between surroundings and the character changes.

Trucking refers to moving the camera left or right in relationship to a scene, as shown in Figure 6-5. When you truck your camcorder, you change the character's background. This movement makes a dull scene interesting. Trucking is used a lot in commercials where the character stands still, telling you the importance of a product. The camera trucks (moves right or left), keeping the character in the center — the background moves while the character remains stationary. Trucking keeps the viewer engaged visually.

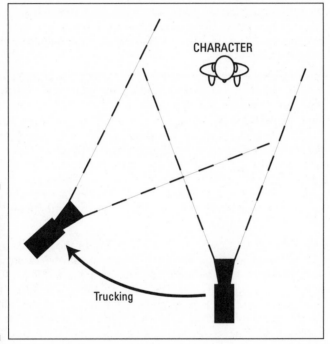

CHARACTER

Trucking

Figure 6-5:
Trucking
provides a
dynamic
effect; as
the camera
moves, the
background
changes.

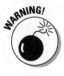

Though trucking can make a scene interesting, it can also cause major changes to the lighting of a character. Sometimes these changes are detrimental, especially when filming indoors. Lighting is usually set based on camera position. To properly light a trucking move, you need to set lights for both ends of the trucking movement. If you don't have enough lights, you may want to reconsider your trucking move.

Composing the picture

One of the fundamental requirements in shooting stimulating video is composing your picture, which is preparing the environment where the shooting takes place. For example, assume that you're shooting on location at someone's

office. You can either make the picture look humdrum (like the workday world), or make it look special. You make the normal special by composing a picture.

Here are some points to consider when preparing the environment:

✔ **Shoot for light.** Lighting has the most obvious impact on the quality of your shot, specifically the location and intensity of the light in relationship to your character. Whether natural or artificial, you want the light to give primary significance to your character's face and secondary significance to the scene. If you can't get the sun to cooperate, close the blinds and use artificial light. Don't forget to white balance your camcorder! (See Chapter 4.)

✔ **Position the character.** Set the character, sitting or standing, in a dignified manner and location. For example, if the character is sitting, secure a posture for the character that is neither stiff nor sloppy. Avoid embarrassing the character by paying attention to how his or her lap is positioned. Also, *always* check out the background. Don't place the character in front of something that inadvertently looks comical. For example, don't let the character sit so that horizontal bookshelves seem to be sprouting out of his or her ears. (This may seem silly, but it's a real problem.) Believe me, many problems of this kind are avoidable; you simply have to be attentive to your shooting environment and use good judgement to prevent them.

✔ **Dress the shot.** This takes only a moment, but in the rush of the moment, you may forget or ignore details of the shot. Not only does this step help ensure a good shot, but it's also an act of kindness to your character. For example, if a desk is in the shot, clean the desk and make it look "professional" (unless, of course, a messy desk is important to the scene). Avoid ultra white or shiny objects in the foreground. Ask the character whether he or she wants family photos in the shot. Also, if possible, dress up the background with a vase of flowers or a book arrangement — anything to avoid a flat background. If you brought along a light kit, throw a colored slash of light across the background (but only after you white balance). If the person is wearing glasses, be sure to check that the glasses don't cause a bad reflection of the light. Be aware, however, that a lot of people don't like to take off their glasses for a video shot.

Framing the shot

Framing the shot is simply a matter of placing the subject properly in the picture. You don't have much to remember to frame a shot correctly. Keep these three things in mind when framing: safety margins, offset versus symmetrical, and proper headroom.

Safety margins

Safety margins are two imaginary rectangles on the outer edges of your picture, as shown in Figure 6-6. Some camcorders actually show these rectangles in their viewfinders. The *outer rectangle* warns you that any images or characters outside the rectangle's boundaries may not appear on some monitors. Obviously, vital parts of a scene, including titles and credits, must be kept inside the outer rectangle. The inner rectangle is the safe area. Within this rectangle, you can safely add images or characters any time during the editing process.

Figure 6-6:
Safety margins around the shot help you ensure that nothing important is cut off at the edge of the screen.

Be sure to keep safety margins in mind while shooting. You don't want to use a shot that's too tight, thereby creating the risk of an editor later putting images or characters on someone's chin or neck rather than across his or her chest. Though you may not have safety margins in your camcorder's viewfinder, you can teach yourself to remember where they are.

Offset versus symmetrical

One of the simplest things you can do to add appeal to a shot is to *offset the frame* — that is, center the character on the third of the frame that is opposite the direction he or she is facing, as shown in Figure 6-7. For example, if the character's shoulders are turned toward the viewer's right, frame the character on the viewer's left. If the character's shoulders are turned toward the viewer's left, frame the character on the viewer's right. If the character's shoulders are square with the camera, use symmetry by centering the character in the screen.

But just how far offset should the subject be? Imagine for a moment that the video you see in your viewfinder is divided into thirds vertically and horizontally. Envision a grid similar to a tic-tac-toe board where the screen area is divided into nine blocks. This is called the Rule of Nines, and you can fill the blocks of this imaginary grid to determine where your subjects should be offset.

Figure 6-7:
Offset framing of your subject makes it easy to add a graphic during editing.

Proper head room

Establishing proper headroom is one of the simplest habits to learn, and after you learn the basic idea, you'll set proper headroom without thinking about it. Simply remember that a person should not look as though he or she has

slipped toward the bottom of the screen (too much headroom). Also, a person shouldn't appear crowded into the frame as though his or her head might scrape the top of the screen (too little headroom).

After you start practicing these techniques, my guess is that you'll like the look you achieve. They are especially helpful if you plan to layer text later on to allow room. Figure 6-7 illustrates the use of offset framing with a graphic added later in the editing process.

Preproducing Your Digital Video

Preproduction refers to the planning and implementation of the many details that will help you produce a successful video. You may find it odd that I bring up the matter of *preproducing* your video *after* telling you how to shoot it. But, trust me, this order is logical. Why? Because of the language. In order for you to preproduce your video, first you need to understand some of the technical vocabulary of creating video. If you haven't read the section "Preparing to Shoot Digital Video" (earlier in this chapter), put a pencil in the margin right here, read through that material, and then come back to this section.

Preproducing a video is literally sitting down and writing out the details of how scenes will look, and what people will say in those scenes. The three main elements of preproduction are:

- **Storyboarding.** This is the process of brainstorming an idea into existence.
- **Scripting.** Scripting is when you decide in advance what characters will say and what the camcorder will do in each scene — such as a wide shot followed by a close-up.
- **Planning the shoot.** This means putting all the necessary plans down on paper so that when the time for shooting arrives, everything and everyone is prepared.

Storyboarding

Storyboarding is the process of planning each scene of your movie on paper (or poster board, chalkboard, or just about anything else you can write on). Most modern films are planned this way. An artist or producer sketches a picture of each scene, and then those scenes are laid out in order on a board or on paper. The crew consults the storyboard to see how each scene relates to the overall story.

The Mickey Mouse history of storyboarding

As the story goes (sorry about that), storyboarding began in the film industry back in the heyday of cartoons, prior to World War II. Animators sketched the actions of the various characters, such as the moment a character turned or was bopped on the head. These pivotal moments, called *key frames,* represented a series of related frames leading up to and away from the action. The key frames were taped or pinned to a board and were the basis for planning a cartoon. In a preproduction meeting, the animation team moved the key frames around on the board, added and subtracted them, and finally arranged the surviving key frames in the order of a cartoon's plot. Thus, the name *storyboard* was coined.

The process was so successful that it eventually became a way for planning most conventional film productions. And, as the years passed, storyboarding found its way into the boardrooms (sorry about that one, too) of corporate America.

If you're making a home movie of your family vacation or even a wedding, creating a storyboard may seem like overkill. Still, you may find it useful to sit down with pen and paper before filming and plan what you want to shoot. You don't even have to sketch drawings if you don't want to, just create a basic outline of the planned shoot.

In the preproduction stage, one of the most exciting parts of storyboarding is visualizing the finished product. In your mind's eye, you follow your character's action from scene to scene. You can almost hear the music playing and see the special graphics and animation you will include during the editing process. Within all this excitement though, you need to ask this question, "Does this storyboard realistically provide the editor (who just might be you) with enough video opportunities to get the job done?" What if a review of your footage during editing reveals that the shot you took didn't turn out very well? Going back and reconstructing the scene for another shot is difficult, if not impossible.

If anything, err toward excess. You may add 15 minutes or an hour to the shooting schedule by taking another shot from a different angle, but, by doing so, you may save yourself a lot of time and headache in the postproduction stage.

Creating the storyboard

So how do you do it? Create your storyboard as quickly and simply as possible. The storyboard is just a set of visual notes that you work from while you are filming your video.

Whatever you use to draw or sketch your storyboards, they should be drawn dark enough to be photocopied, as you will usually need more than one set. To create a storyboard, follow these steps:

1. **On individual sheets, draw the key events and the scene where the events will take place.**

 Don't worry about your artistic abilities (or lack thereof) so long as the drawing illustrates the most important elements of the scene.

2. **On each sheet, include some basic ideas of what is happening and what is being said.**

 Write notes and labels if you feel the need.

3. **Play with the order of the key events by moving them around and adding and deleting the sheets as needed until you are satisfied with the order for the key events in the story line.**

4. **Name the scenes or segments of scenes for each of the key events.**

 Using the segment or scene names, you can develop lists of the elements that need to be prepared prior to video shooting, such as costumes or props.

Planning the shoot

After you develop your storyboard, it's time to plan the shoot. You need to assign camera instructions, such as shots and close-ups for the various key events. Of course, you may modify your plans when the time comes to do the actual shooting. But to prevent chaos during shooting, you're wise to have a shooting plan.

One of the most important steps in preproduction is planning your shooting order. *Shooting order* refers to a chronological list of the segments to be shot. By the way, you don't necessarily want to shoot your video in the order of the plot. Doing so can be a waste of time and resources. (See Chapter 4 for more on producing out of order for the sake of lighting.)

Be sure that you plan more than enough shots for each key event. If your story is complicated or involves a lot of speaking, you may also need to create a script.

Scripting

Scripting is a textual plan of all that will be said and performed in a scene. A shooting script usually includes camera instructions, locations in the scene for sound effects, and general instructions to the editor for editing. For people like myself, scripting is as much fun as the actual filming. For other people, just using a word processor is nearly impossible — let alone writing creatively. I don't claim that writing a script is easy, but I quake to think what might happen in some videos without one.

To understand how a script can help you, first you need to distinguish between two approaches to script writing — subjective and objective.

- **Subjective:** Subjective scripting is storytelling (see Figure 6-8 for an example of a subjective script). The subjective script depends largely on video to establish the environment. (Note the video instructions in the left column in Figure 6-8.) Subjective scripting has characters, a plot, and some kind of dramatic development. In a video where you're primarily communicating a feeling (such as a music video), you present a combination of movements and sounds to elicit an emotional response in your viewer.

- **Objective:** Objective scripting is goal-oriented information or instructions (see Figure 6-9). You want to influence or train your viewer to do or believe what you're presenting. Objective scripts are need-oriented: They exist to resolve a problem or to influence the viewer to agree with you or to buy something.

Subjective scripts are much more complicated than objective scripts. Conversely, objective scripts are subject to a tough test — namely, the success or failure of achieving the objective.

Of course, many scripts are both subjective and objective. A good example is political video advertising. Producers have only 30 seconds to achieve their objective — convincing viewers to vote for a candidate — so they pack the objective message with all kinds of emotion-evoking (subjective), flag-waving tricks to cause viewers to feel positively toward the candidate.

VISUAL	AUDIO
(Scene opens. Camera LS. Martha is seated on the left side of her bed. Bed is frame right. She is in her bathrobe. Her long hair is for the first time untied and lying across her shoulders, slightly unkempt. She is staring camera left at nothing.)	
	(The night table telephone rings.)
(Martha reacts with a start.)	
(Camera MCU. Martha stares down left at the phone.)	
(Camera BCU on phone.)	*(Second ring.)* *(Third ring.)*
(Camera VCU on Martha. The look of worry belies her temptation not to pick up the phone.)	*(Fourth ring interrupted by Martha grabbing the phone from the receiver. Martha speaks softly, barely above a whisper.)*
(Camera MS on Martha and phone. She suddenly reaches out and snatches it up mid-ring.)	*MARTHA: HELLO.* *(Pause. Soft unintelligible voice on phone.)*
(Martha looks down left again.)	*MARTHA: YES, YES IT IS . . . THIS IS SHE.*
(Camera VCU on photograph by the phone. The photo is obviously an old one of a much younger Martha and a much slimmer George.)	*(More soft unintelligible voice on phone.)* *(Music softly fades in - the Scene One wedding reception ballad. This time it has an echoish cast. Behind the music, the sound of laughter.)*
(Tracking left, Camera frame right CU on Martha, still looking down at picture. Tears are forming.)	*MARTHA: DID YOU . . . DID YOU . . . FIND HIM?*

Figure 6-8:
In this example, the storyteller leads the audience through the experience.

VISUAL	AUDIO
(Camera LS on ACME 200HP riding lawn mower. Mower is frame center, visibly rumbling in neutral. Behind the mower is wide swath of mown lawn, smoke still rising from the turf.)	(Trainer's voice off camera.) TRAINER: CAUTION MUST BE USED WHEN APPROACHING THE ACME 200HP LAWN MOWER WHEN IT IS IDLING IN NEUTRAL.
(Surveying pan right to trainer. She is wearing the required flame retardent jump suit and approved safety helmet as described in previous scene.)	TRAINER: IF YOU FOLLOW THESE SIMPLE INSTRUCTIONS, YOU WILL HAVE NO PROBLEM MOUNTING THE UNIT AND PLACING IT BACK IN GEAR.
(Following pan of trainer to mower. Camera MLS. She stops camera right of mowing unit.)	TRAINER: AS I MENTIONED EARLIER, STEEL-TOED SHOES ARE REQUIRED WHEN RIDING THE ACME 200HP RIDING MOWER. THIS IS PARTICULARLY IMPORTANT WHEN APPROACHING THE MOWING UNIT, EVEN IN THE NEUTRAL, UNENGAGED MODE.
(Postproduction. Add dotted line to indicate edge of safety area.)	

Figure 6-9:
The writer of the objective script must equip the viewer with enough information to make a decision or to perform a function.

Chapter 7

Shooting Video on Location

• •

In This Chapter

▶ Producing quality digital video on location

▶ Making your shooting decisions with editing in mind

▶ Creating a two-camera look with one camera

▶ Working with people

• •

*O*ne of my favorite moments in creating a video is the deep feeling of satisfaction I get at the end of a good day of shooting. Using a day productively and safely to tuck away video clips for later editing is the basic goal of every videographer. Some days, you accomplish these things; other days don't quite measure up.

What makes some video projects go well and others poorly? What can you do to ensure success? What problems lurk out there just waiting to grab you when you least suspect them? Answers to these questions aren't always easy or foolproof and nothing about creating quality video is inherently easy. But you can have a satisfying experience. A large part of the enjoyment you derive from successful videography comes from preventing, facing, and overcoming obstacles.

The breakthrough technology of digital video provides you with the opportunity to produce professional-quality video. The emphasis here is on the word "opportunity." You can make beautiful video. Digital video provides you this opportunity, but you still have to work. This chapter is filled with advice for creating a successful video. Some of my suggestions are always true in every kind of project. Others are the good-to-know variety for those times when you face special challenges.

Planning for Success and Preparing for Survival On Location

I tend to be overly optimistic. Life's more fun that way — you know, thinking that I'm just one light lunch away from losing those extra pounds. Optimists like me have to work hard at being realists. One carrot and celery lunch won't undo a paunch I worked years to create. The same is true in creating a video. Optimism is great. Preparing for the unforeseen is better. By knowing and doing certain things, you and others will enjoy the results of your efforts.

You don't have to go far to be on location. It may simply be an office on another floor of the building you're already in. Or it may be out in the parking lot. And, of course, it can be on someone else's property. So what is the difficulty of shooting on location? When you're on location, you're on someone else's turf, subject to someone else's schedule, and using someone else's resources to get your job done. These variables can often prevent you from getting your job done to your satisfaction.

Dangers of on-location filming

On-location shooting is tough — especially on your equipment. Lenses can be ruined from exposure to the sun and camcorders damaged when they are dropped while working in rough terrain. Accidents like these often happen to responsible people making careless mistakes.

Protecting equipment

Of course, sometimes you can't avoid shooting video in places where equipment can be damaged or lost. But you can increase the survival rate of your equipment by insisting that you and others develop some simple habits.

Knowing your legal and safety limitations

Shooting on location is supposed to be fun and interesting. To keep it enjoyable, I suggest refraining from doing things that may put you in jeopardy. Here are a couple of basic rules about using a camcorder on someone else's turf:

✔ Don't take your camcorder anywhere you have to hide it to get it in. For example, don't take your camcorder where signs are posted forbidding use of cameras and recording devices, such as inside art museums or at concerts. You risk the possibility of your equipment being confiscated or worse.

✔ Don't record people on your camcorder without their permission. People can get very upset about this — even to the point of wanting to punch you in the nose. As a basic courtesy, I always ask for permission before I record.

The number one culprit of on-location shooting is grime, so make sure that you do the following:

- ✔ Protect your equipment to and from a shoot by keeping the equipment in cases.

- ✔ Keep plastic covering available for protection against windblown debris.

- ✔ Carry a lens cleaning cloth for your lens and canned air (available at electronics stores) for blowing dust off your equipment.

- ✔ Always wipe your equipment at the conclusion of a shoot. If you have used electrical wiring, take special care to remove grime before storing the wiring with your other equipment.

The number two culprit is theft. I've been victimized a number of times, so I know how it feels. A friend of mine had a very expensive camcorder stolen from the lobby of a hotel. The camcorder was at his side on the floor — and then it was gone! Expensive toys attract attention. Don't ever leave your equipment unguarded — even in seemingly safe locations.

Be aware that your gear is not the only target — purses and bags are targets, too. Unfortunately, my wife has had two purses stolen while shooting on location.

The third culprit is breakage. Breakage happens two ways. The most obvious way is by dropping equipment. But, more often, breakage happens when untrained people use equipment. Very few pieces of equipment can withstand forceful abuse. The most common damage occurs when people try to force a piece of equipment to do something that it's not meant to do.

Be sure to follow these two good rules of thumb:

- ✔ If you don't know how to use equipment, ask.

- ✔ If the equipment doesn't want to do what you are attempting to do, stop. You're probably doing something wrong.

Effects of weather

Weather and temperature can drastically affect video equipment. Simple things can cause big problems. For example, taking a camcorder from a warm environment to a cold one can cause condensation within the equipment — rendering the camcorder unusable for an hour or two. Leaving equipment in the cold can be a problem, too. For example, if you have a fluid-damped tripod, the fluid can become thick in cold temperatures, which can make the tripod unusable until it is warmed.

Here are some suggestions for dealing with weather:

- ✔ Don't take electronic equipment from hot to cold environments (or vice versa) without allowing time for the temperature of the equipment to adjust.

- ✔ Don't leave equipment in your car (including the trunk) overnight in cold climates.

- ✔ Avoid exposing your equipment to extreme heat.

- ✔ Avoid using your equipment in extremely high humidity.

Power

Electrical demands on location are always more complicated than shooting in a studio. The problem is not so much your camcorder, which actually draws a low amount of current, but lighting and other items that use a lot of power. To avoid power catastrophes, keep the following in mind:

- ✔ **AC outlets:** When using electricity on location, always, always, always ask for permission before plugging in. I have witnessed two occasions when people's computers went down while I was plugged into their electrical outlets. In both instances, they immediately blamed me for the outage and lost files! Imagine that. Come to think of it, remind computer users in the building to save their work before you plug in, just in case.

- ✔ **Circuit breakers:** If you plan to use lighting on location, always be prepared to restore a tripped circuit breaker. Find out where the electrical panel is located and, if possible, identify the circuit you'll use. Again, ask whether you may use the circuit and explain that you might possibly cause an outage. And if you're using your own lighting, avoid doing anything that could cause burns to people or equipment.

- ✔ **Batteries:** Using batteries on location can be a shocking experience. Not literally, but almost. The typical problem with batteries is that they run out of power. Many batteries take longer to charge than they do to expend. Bottom line — have two hours of charged batteries for every hour you plan to shoot. And if you expect a lot of shooting time, recharge the batteries on location if possible. I talk in detail about batteries in Chapter 3.

If you plan to take your camcorder out of the country, find out in advance what kind of converter you'll need for running your equipment and for recharging your batteries.

Shipping and travel

Shipping video equipment can cause you anguish because you must trust your equipment to other people who have no idea what they are handling.

Unless your camcorder case is designed for shipping, be sure to take extra precautions when shipping your camcorder. An inexpensive way to ship your camcorder is to wrap it in oodles of bubble packing and put it in oversized boxes. Even so, insure your shipment for its total value. If you're taking your camcorder on a plane, you may want to put the case in cargo, but carry the camcorder on the plane.

If you plan to take your camcorder across international borders, beware! You may not be allowed to take it from one country to another without prior arrangement. I was once prohibited from taking a camcorder into Canada! Before leaving the country, contact your local customs service office a few weeks in advance to find out what you may need to do to take your camera across international borders.

Types of on-location shoots

You typically engage in four kinds of on-location shooting (all these terms are coined by yours truly, but methinks they'll do fine for the purposes of this little discussion):

- ✔ Spontaneous
- ✔ Event style
- ✔ Formal event
- ✔ Made-for-video creation

Spontaneous

Spontaneous shooting is the simplest and the chanciest form of on-location shooting. As the name implies, you turn on your camcorder, point, and shoot. In spontaneous shooting, you have little or no way of predicting how your camera's settings and capabilities will match up with the challenges of the circumstances or the environment. Most people with camcorders are experts at spontaneous shooting because that's all they ever do.

Of course, you can do a few basic things to make your spontaneous shoots more effective. If possible, take a few seconds before pressing the record button to look through the viewfinder and check lighting and background. If you are shooting a dolphin show at the local aquarium, you may not have any control over lighting and background, but in other situations you might be able to reposition your subject for better lighting, or pick up that piece of garbage that's sitting in the background.

Event style

Event style shooting is different than spontaneous shooting in subtle but significant ways. Like spontaneous shooting, event style allows you little or no control of the environment. But in event style shooting, you can manipulate some of the circumstances.

Say that you're asked to videotape a high school football game. Being the "official" videographer gives you license to go places and do things others might not have the freedom to do or explore. Although you have no control over time and events, you do have control over the circumstances.

For example, because you are the videographer, you ask to attend the afternoon pep rally to get some introductory shots for the video. At the rally, you decide to sit across the gym from the students, where you can use your zoom to capture groups of students as they do the berserk things teenagers do at pep rallies.

You could also arrive early to the game and explain to one of the coaches that you are shooting a video for the parents' club. Ask whether you can move about the sidelines during the game. Again, you are controlling the circumstances, as follows:

- ✔ You make conscious decisions about the location of the camera.
- ✔ You position yourself early to wait for shot opportunities.
- ✔ You ensure that your settings are correct.
- ✔ You wear headphones to hear the events as they unfold, because once the game starts, the noise of the crowd makes it difficult to know if you are recording the sounds of the game or not.

In an event style shoot, you have numerous, seemingly unrelated ways to control what is being recorded on tape. You can't tell people what they should wear, and you aren't able to control the elements of the environment, such as weather or time of day. But you do have some control over the subject matter (such as going to the pep rally) and the circumstances (such as selecting where you stand at the rally and the game). Your chances for getting good footage are better with event style shootings than with spontaneous shootings.

Formal events

When shooting formal events, such as weddings and lectures, you have some control over the environment as well as the circumstances. The distinguishing factor of a formal event is that you are expected to provide a relatively high-quality finished product. You may be doing this for free — for example, for relatives or your church. Or you may be shooting the formal event as an employee or a freelance videographer. Whether you're working for free or for

hire, it doesn't matter. You have a customer, and the customer is expecting the video. Though the expectations are higher in formal events, so are the opportunities to deliver a quality video.

In formal events, your customer usually allows you to prepare for the event. Quite often, the customer even allows you to alter event planning in some little ways to accommodate your shooting needs. Prior to a formal event, you usually do the following:

✔ Negotiate with the customer about the location and operation of your video and sound equipment.

✔ Resolve your electrical needs (especially if you're planning to provide lights).

✔ Plan a list of shots with the customer.

Formal events are often more controllable than spontaneous and event style videos. Though the action is unstoppable and occurs for reasons totally unrelated to your project's needs, you still have some leverage in planning the environment and the circumstances.

A simple example of environmental control occurs at a lecture. For example, the lecturer (your *customer*) stands in front of a live audience and makes a PowerPoint presentation using a projector and a screen. Normally, the lecturer will want to lower the room lights to enhance the image on the screen. You will need to do some advance negotiation with the lecturer and figure out a lighting compromise that's best for the screen and the camcorder.

Made-for-video creation

The fourth type of on-location shooting is a made-for-video creation. In this scenario you are shooting events that wouldn't be occurring if you weren't holding a camcorder and recording it all. For instance, if you want to shoot a science fiction epic, or a dramatic masterpiece starring kids from around the neighborhood, you are producing a made-for-video creation. When shooting a video like this, you have the greatest opportunity for producing quality video because you have ultimate control of

✔ Costumes worn by the cast

✔ Set design and background

✔ Camera positioning

✔ Lighting

Of course, there is no such thing as *unlimited* control. The weather may turn bad, your cast may become unhappy, and budgetary constraints can get in the way of your creative vision.

Using Time to Your Advantage

Time is the single most precious resource in creating a video and the hardest to control. So time management is important in order to strike a balance between the amount of time you need and want and the amount of time you actually have.

When all the dust has cleared, the factor determining the failure or success of your project's time management efforts is whether you created appropriate and sufficient materials for editing. During editing, your video is cropped, embellished, and assembled into a coherent and useful message. But if you left something out or created confusing unrelated video clips, your video will suffer, and you'll add many unpleasant hours to the editing process.

Below are some hints for making your editor (even if that editor will eventually be you) a grateful fan and not causing him or her an appreciable loss or graying of hair.

Logging your shots

I'm sure at one time or another you've seen a reenactment of a film or video shoot in which someone holds up a strange looking board with a little board on top of it that says something such as "Scene 14, shot 7, take one. Action." Then the person slams down the little board, making a large clacking sound. What was the person doing? They were sending a message to the editor using a take board.

Take a look at Figure 7-1, which illustrates what's often referred to as a *take board.* Though it may look different from one video to the next, the take board usually includes the name of the video, the date, the scene number, and the take number. The term *scene* refers to a series of shots that, when edited, complete a dramatic action or a portion of a message, such as the famous shower scene in Alfred Hitchcock's movie *Psycho*.

A *shot* is a specific segment of a scene. A *take* is a taping of one of the shots in that segment. Frequently, even in simple videos, a shot is taped many times because a word is misstated by the speaker, the camera is out of focus, a noise occurs on the set, and so on. The tape board is clacked to create a sound that's easy for the editor to hear later while he or she shuttles the video back and forth. While editing, he or she hears the clack and realizes the take has begun. She stops the tape, backs it up, or goes forward until she can read the message on the take board. The take board is only one-fourth of the conventional record-keeping process.

The other three parts are as follows:

- **The script.** The actual plan of the video, including descriptions of action, camera instructions, instructions to the actors, and any dialogue in the scene.

- **The time code.** A particular kind of identifying information recorded by the camcorder onto the videotape. Time code makes frame-accurate editing possible. It is the frame-by-frame permanent identification of the video information on the tape. You can usually see the current time code in the camcorder's viewfinder.

- **The log.** Someone logs information about each of the takes, as shown in Figure 7-2. If you have comments about a specific take or scene, this is where you record them. For example, if you have taken several different shots of your child posing in front of trees in the neighborhood park, keeping a log of where you shot the film helps you later when you find that the light wasn't right at that time of day, but the location was perfect. The log provides the perfect way to remember.

Figure 7-2 shows the number of the scene and take, and information about the take. By keeping an accurate log during shooting, you ensure that all the planned shots have been taped and that you've written all the information the editor will need to find the good footage. One of the important functions of logging details is to ensure continuity.

DATE: 5/19/99

LOCATION:

TAPE	SCENE	SHOT	TAKE	COMMENT
001	02	4	1	Bad focus
"	"	"	2	Stumbled words
"	"	"	3	Good !!
"	02	5	1	Good !!
002	02	5	2	Confidence shot (use #1)
"	"	6	1	Sound of airplane
"	"	"	2	Good !!

Figure 7-2:
The log always contains details about the segment.

Continuity

One time-consuming problem editors face is reconciling missing or visually unrelated sequences. Figure 7-3 illustrates a common mistake. Say that in one of your scenes, the presenter points to an object, requiring a close-up. After pointing, the presenter goes on with the narration.

According to the script, you need to shoot a close-up of that object. You do the wide shot showing the presenter and the object, and then reposition the camera to set up for the close-up. While shooting the close-up of the object, you have the presenter's hand come into the picture and out again. Later on, the editor puts the wide shot of the pointing hand and the close-up of the pointing hand together — only to discover that the hand in the wide shot is the left hand and the hand in the close-up is the right hand.

Aaargh! This little situation is called a *break in continuity.* Basically you have the following two options:

✔ Assemble the movie without correcting the break in continuity and hope that your audience doesn't notice.

✔ Go back and reshoot the scene.

Figure 7-3:
The middle
image (the
close-up
shot) isn't
continuous
with the
preceding
shot
because the
person has
switched
pointing
hands.

Neither of these options is very desirable, and reshooting the scene will waste a lot of time. It could even result in further continuity breaks if something about the original shooting location has changed since your first shoot.

The very *best* solution is to maintain continuity in the first place. Pay attention to even the minor details of your shot and don't be afraid to shoot extra takes if those details aren't exactly right.

Creating editing options

One of the simplest ways to cover yourself in the event of unnoticed goofs (and you will have many) is to give your editor lots of alternatives.

Here are a couple of tips that will help you avoid video goofs:

- ✔ **When a person is looking directly into the camera:** What do you do if you discover while editing that you need to take something out of the speech? A straight cut of video footage will look apparent and bad. You can anticipate this problem and give yourself more editing options by shooting the speech twice from different angles or zoom perspectives. Then, if some of the speech must be cut, the editor can switch between takes at the editing point. To the viewer this will look like a simple changing of camera angles, similar to what you often see during the evening news on TV.

- ✔ **When a person is looking directly at someone off camera:** Imagine that you're shooting an ordinary interview in which the interviewer is sitting off camera and directly next to it. The person on camera isn't looking into the lens, but is looking directly at the interviewer. This may be disorienting to the audience unless you also record some *reaction shots* of the interviewer. After the interview, shoot the interviewer asking questions, nodding, shaking his or her head, or otherwise reacting to things the interviewee said during the interview. The editor can splice these reaction shots periodically with the video of the interviewee so that it looks like there were two cameras in the room during the interview, and the video simply switches back and forth between the cameras as questions are asked and answered.

Record a long track of some *ambient sound*. Ambient sound is silence in the environment where you are shooting. Silence is very different from one location to the next. For example, ambient sound at a computer workstation is filled with the sound of the computer's fan motor. Outdoor ambient sound may include as background the sound of cars on a nearby street. An editor needs a continuous track of ambient sound to play in the background of the interview to cover up the inconsistent, broken ambient sound that will occur as the editor splices interview and reaction shots. Don't forget to note ambient sound in your log.

Working with People on and off Camera

Creating a video on location can involve as few as one crew member (that would be you) or as many as a dozen or so. But no matter the number, if you

have a crew at all, two of the most important principles of successful on-location shooting are knowing that the director is the boss and that the director allows the crew members to do their jobs. In order for a crew to work efficiently, everyone should be clear about his or her role.

The following section provides a classic description of crew roles. These roles are not necessarily held by one person. And one person can have more than one role. The director needs to make sure that people understand their roles.

Roles that people play

First, an important clarification: A video shoot is not a democracy. Clear-cut roles are as essential in video as they are on a football team or in an army platoon. Second, pecking orders don't exist in creating a video. There isn't a concept of greatest and least. Everyone simply has a job to do. Following is a formal description of roles. In real life, the interaction is probably much looser than I describe here.

Producer

The *producer* (probably you) is the person responsible for the overall completion of the project. Frequently, the producer gets involved before anyone else on the crew. The producer negotiates with the customer, sets the budget, signs the contracts (if this a commercial project), and stays involved with the project long after the crew dissolves. The producer also works with the editor, arranges for distribution, oversees general administration, and sees the project to its conclusion. Additionally, if a representative of the customer is at the shoot, the producer is responsible for interacting with the customer and communicating concerns to the director.

On location, the producer does all that is necessary to keep the director focused on the video.

Director

The *director* is the leader and must understand everyone's role and guide the overall movement of the video. But even more important, the director is the person with the vision. The director knows what the project is supposed to be like and what it is intended to accomplish. The director's first and foremost job is to hold the vision together throughout the video. A good crew keeps the director focused on leading, not problem solving.

Customer/technical consultant

In some videos, especially training videos, the customer will provide a *technical consultant,* also known as a subject matter expert (SME). The SME is often ultimately responsible for the technical accuracy of what is said and done in front of the camera. The director and the producer frequently depend on the

instructions of the SME, but the SME instructs the crew only at the request of the director and only in the specific instances where such action is needed. Otherwise, the video can become a chaotic mess. Also, the SME cannot appear on camera. If he or she does, you need another SME — because once a person appears on camera, you can't depend on his or her objectivity.

Subject matter experts are often present even in your spontaneous, home videos. For example, if you are shooting a video of your infant granddaughter taking her first steps, her parents may be off camera giving you instructions on when to start recording. Or if you are filming your child's soccer game, the coach may be able to tell you what part of the field your child will be playing in most.

Videographer (photographer)

A *videographer* is the camcorder operator. In the world of television news, such people are called photographers. A good videographer is a humble but confident person. The videographer must follow the director's orders but must also be able to tell the director if there's a better way to do the job. Usually, directors and videographers develop close professional relationships and learn to read each other's subtle or implied meanings and moods. One important rule that's seldom, if ever, broken is that no one other than the director ever directs the videographer.

Sometimes the videographer, depending strictly on the preference of the director, is a kind of assistant director, giving instructions to the other crew members. A director may choose this route when he or she has to give full attention to the person in front of the camera.

Sound technician

Sound technicians have a bit of an odd role: They listen to the audio with earphones without actually watching the action that is being filmed. I've never been able to figure out whether they're sleeping or concentrating on the sound. Sound technicians keep their fingers poised on a field mixer, anticipating fluctuations of volume in order to maximize the recorder's dynamic range. The sound technician must call for a retake whenever an alien sound or a speaking glitch is heard through the earphones. The sound tech usually works with the videographer.

Gaffer

The *gaffer* is the crew member responsible for anything having to do with light and electricity. Typically, the gaffer works directly with the videographer in framing the shot and setting light levels.

Grip

On a small crew a *grip* is primarily an assistant to the gaffer. The grip is responsible for setting up lighting for a shot. Normally, the grip also helps move the camera and tripod and any other gear.

Production assistant

The *production assistant,* affectionately referred to as the PA, is the do-every-thing-else person on the crew. Usually, PAs are the ones who keep the shooting log up to date and typically handle the take board. PAs also assist in moving equipment as needed. On your own crew, the PA might simply be one of your kids who refills your coffee cup. (Hey, this is important stuff!) One important note about PAs: They are usually eager to help — sometimes to a fault. Be sure that they know how to use equipment before allowing them to handle it.

Professionals and amateurs

Two kinds of people appear on camera in videos: professionals and amateurs. Professionals have usually logged many hours in front of a camera. They are (usually) fun to direct because they (usually) know exactly how to do whatever you ask them. But, unfortunately, there's a cost for such skill. If you have something important to shoot and if the video is message heavy, try to find the money to hire professionals. Because they are so good at what they do, you can cut your shooting time in half.

In videography, amateurs are not trained to speak or perform in front of a camera. Some amateurs are astonishingly effective — most aren't. The director's biggest job with amateurs is to set them at ease during filming. If an amateur is not nervous, he or she will usually look good in front of the camera. The viewers of video aren't turned off by people who lack beauty. They're turned off by people who act incompetently in front of the camera.

Choosing effective clothing

Whether you are making a video of a story filled with fictional characters or you are shooting your family's summer vacation, you should carefully consider what the people on camera are wearing. The following are a few basic tips for choosing effective clothing:

- Avoid dark clothing, particularly in dark rooms or locations. The audience will get a better view of subjects who wear light colored clothing.

- Avoid patterned dresses that may blend into backgrounds.

- Avoid low necklines in close-ups, because they make it look like the person forgot to wear anything at all.

- Avoid white and red clothing. White interferes with the aperture (the light that reaches the focal plane in your camcorder — see Chapter 3 for more about aperture and focal plane). Red duplicates poorly on film and in video and tends to bleed into adjacent, non-red portions of the video.

- Avoid tight stripes and herringbone patterns because camera and video player technologies can't handle these designs. The result on-screen is called *moire* — an unpleasant wavy or shimmering effect on the fabric.

Part III
Editing Digital Video with Your Computer

"Of course graphics are important to your project, Eddy, but I think it would've been better to scan a picture of your worm collection."

In this part . . .

A computer is basically unintelligent — complicated but unintelligent. You have to tell it what you want, and you have to arrange it to accomplish the job correctly. After you've correctly arranged everything on the computer, it accomplishes amazing feats. You can't "train" your computer to bring you your newspaper and slippers, but you can get it to capture and edit video. In this part, you find out what's required to ensure that your computer rolls over and does video editing tricks.

Seldom does a human being have an excuse for having as much fun as you're about to experience. Imagine learning a software program and loudly exclaiming "Wow!" at the same time. Doesn't seem possible, does it? If you're of the opinion that learning a software program and being excited are mutually exclusive, you're about to change your mind.

This part has chapters that introduce you to Adobe Premiere 5.1, Microsoft Movie Maker, iMovie, and Epson Film Factory. But, ahem, remember: You're not supposed to be having fun here, you're supposed to be acquiring knowledge about some computer software programs. Well, maybe just to be on the safe side, you should keep a pillow nearby in case you need to stifle an occasional "Wow!"

Chapter 8

Getting Your Computer Ready for Making Movies

· ·

In This Chapter

▶ Determining your video editing needs

▶ Selecting video editing components

▶ Ensuring compatibility of hardware and software

▶ Completing the setup

· ·

*P*eople approach digital video in different ways. Some people are more familiar with cameras than they are with computers, so they start with a camera and make their way to the computer side of digital video production. Other people are more familiar with computers, so they start at the opposite end. Well, just so you'll know where you are in relation to this book, you're at the nexus between shooting video with your camcorder and editing that video on your computer. In this chapter, you see how the digital video recorded on the tape in your camcorder migrates into your computer where it can be easily edited.

Your existing computer may be almost all the hardware you need for editing digital video; then again, it might not fill the bill at all. How can you know? And if you're considering plunking down some serious money for a computer, how can you be sure you'll get the right one for editing digital video? This chapter provides you with many of the answers. And the chapter explains a number of things you may not have thought to ask about. As a long term, multi-PC owner, I have to swallow a couple of times before I can say this: If you don't own a computer and are going to purchase one for video editing and other home use, get a Mac. Specifically, get an iMac. The Macintosh is a pioneer in digital video capture and in digital video editing. The iMac is way ahead of PCs when it comes to simplicity of installation. PCs will definitely do the job, but you need to do your homework to prevent a costly disappointment. You need to ensure that your computer, your video capture card, and your editing software are compatible with one another and that together they can perform the tasks you expect.

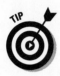

If you own an iMac, you can skip this chapter and jump to Chapter 9, which is about Adobe Premiere, or Chapter 11, which is about iMovie, and start capturing and editing. If you own a PC or are planning to purchase one, I suggest that you continue reading this chapter.

In the rest of this chapter, you see how your camera, software, and computer all come together and how you can join the digital flock.

Defining Your Video Editing Needs

To determine your video editing needs, the place to begin is with *you* — not, as you might think, with computers or software programs or capture cards or any of that stuff. Begin by determining what you already know about using a computer.

Digital video enthusiasts come in all ages and have an endless range of reasons why they want to get into digital video editing. The striking difference among them, though, is that:

- Some know little about either video production or computers.
- Others are familiar with computers but don't know how to create and edit video.
- Some have been creating video for years but know little about computers.
- And, of course, a few know a lot about both.

Which of these three categories describes you?

- You are a virtual novice to creating videos.
- You are a raw recruit at using a computer.

 Do you have no idea what a mouse (computer mouse) is? Do you want to ask what Windows is but are afraid somebody might laugh? If you answered yes to these questions, I suggest you read Dan Gookin's excellent book, *PCs For Dummies,* 7th Edition, published by IDG Books Worldwide, Inc. Reading it will enable you to march right into this chapter.

- You have a little working knowledge about computers.

 Do you know how to open a program and save a file and stuff like that? If so, you are probably ready to launch into digital video editing. Honest! You could be making art in just a little while.

Preparing for Video Editing

Editing video on a computer is called *nonlinear editing.* (You'll probably find it no big surprise that you can use a computer to do things like edit video — after all, you can do almost anything else with a PC. But, the truth is, I'm still amazed.)

I introduce nonlinear editing in Chapters 1 and 2, but the short story is that nonlinear editing is based on computer software programs that enable you to shorten, combine, and modify video clips. When I say editing in this chapter, I am referring to nonlinear editing. Editing equipment includes the software tools you need for adding music, sound effects, special visual effects, and more. Editing enables you to do all these things without overwriting the original video clip.

Selecting digital video software

What kind of software do *you* want for your digital video editing? This book introduces you to three very good suggestions — two for the Mac and two for a PC:

- ✔ **Adobe Premiere 5.1 (for Macs and PCs).** One of the best digital video editing programs for home computers is covered in Chapter 9.

- ✔ **Windows Movie Maker (for PCs).** A good beginner digital video editing program that works especially well with e-mail.

- ✔ **iMovie (for Macs).** A very nice video editing program that has a full range of neat options that makes video editing simple.

What is a video editor?

Adobe Premiere 5.1, Apple's iMovie, and Microsoft's Windows Movie Maker are all types of video editing application software. These editing applications are called nonlinear because they allow you to edit video in any way you want; you can squeeze in a scene here and cut a scene there without having to reedit or reshoot everything after that point in the video. In *linear editing* you have to do all of your edits in order, from the beginning of the movie to the end. Thankfully, the power and adaptability of modern computers makes video editing easy.

A video editing *system* is the combination of software and hardware (computer, boards, monitors, and so on) that are required to do the work as commanded by the software. Just think of the software as the brains and the hardware as the body. The video *editor* is you (or soon you will be)!

I have also included some other video editing programs on the CD located at the back of this book. Some of these programs are not as common as the video editing programs I've listed, but I think that they are worth a look — especially if you don't want to spend tons of money to do basic video editing.

Sometimes, the driest information is the most important. A perfect example is product specifications. Reading product specifications definitely can be boring, but even so, you need to know what the manufacturer says about the product without the marketing hoopla that you'll find in their advertisements. The product specifications tell you what the computer system requirements are for the software, the video formats the program uses, and a list of editing tools and features that come with the application.

If you don't have the product specifications lying around, go to the software manufacturer's Web site. The Web sites for the software applications mentioned in this book are located at

- **Premiere 5.1:** www.adobe.com/prodindex/premiere/prodinfo.html
- **Windows Movie Maker:** www.microsoft.com/windowsme/guide/ digitalmedia/moviemaker.asp
- **iMovie:** www.apple.com/imovie/

If no documentation is available on a product that you're interested in, be aware that you're gambling with your money.

Sizing up your computer

Minimum and recommended system requirements are important. Your computer must meet or exceed the hardware specifications listed by the software or you will have all kinds of ugly problems that you don't even want to think about. For example, having a lot of RAM (random access memory) is *vital* to good editing. If a manufacturer tells you that you need at least 128MB of RAM, consider this an absolute minimum. Otherwise, you may find yourself spending hours making a movie that you could have made in minutes.

As an example of manufacturer's requirements, at the Adobe site, you see the Premiere requirements. The requirements listed are for both Windows-based and Power Macintosh computers. Remember that you have a "Minimum" and a "Recommended" choice. Here's where the fun starts.

Minimum components

To varying degrees, the term *minimum* may be a cause for caution. In my opinion, a minimum requirement is like low-octane gasoline — your car is able to make it up hills, but, once in a while, your vehicle starts making that knocking sound that you know isn't good. With that said, allow me to walk you through the following specifications:

- **Intel Pentium processor:** Sorry, but your old 486 processor isn't going to cut it. It really won't work for modern video editing tasks. Pentium II, Pentium III, and Celeron processors perform better than a basic Pentium.

- **Microsoft Windows 95, 98, or NT 4.0, or later operating system:** Sorry, but Windows 3.1 won't work for editing purposes. You'll find that Windows 2000 is more robust (less prone to crashing), but of course only Windows Me comes with Windows Movie Maker.

- **32MB RAM:** These days, you can hardly play Solitaire with 32MB RAM. (*RAM* is the memory on an operating system.) The amount of RAM that you have directly affects your graphics and video-playing capabilities. For minimums, let's talk 128MB RAM. Maybe 32MB would work, but I doubt you'd have much fun.

- **60MB hard disk space for installation (30MB for storage):** Sixty megabytes is sufficient only if you're creating tiny (postage stamp size) multimedia files. If you intend to use your computer for digital video, remember that 30MB is approximately 12 seconds of digital video. Again, in my opinion, the *true* minimum should be in the order of 200MB to 300MB (and that is only a minimalistically minimal minimum). 300MB of quality digital video equals about two minutes. 18GB equals a little over 80 minutes of video.

- **2GB hard drive (1 gigabyte equals 1,000 megabytes):** This is storage for all your audio and video files: Fortunately, hard drives that hold 30 GB or more are now common and affordable.

- **256 color video card (also known as a display adapter):** Although the software manufacturer lists this as a minimum, it's not really enough for digital video editing. A VGA 256-color video card is for people who might be developing something for multimedia applications. You need a full-fledged graphics card with its own built-in memory. Matrox Millennium G200 is a good one. It offers you true color (necessary for a digital video editor) and speed. For more information, check out the Matrox Web site at www.matrox.com/mga.

✔ **Sound card:** No particular sound card is needed. You simply need one. (Acceptable sound cards are available for as little as $20.)

✔ **CD-ROM drive:** You need a CD-ROM drive to install the video editing software because it comes on a CD-ROM.

Recommended components

Now we're getting into some stuff that ranges from *absolutely necessary to wouldn't it be nice?*

✔ **Pentium III processor with 300 or more MHz:** The faster the processor, the more likely that you can successfully work with resource-demanding digital editing software programs. By the way, if you prefer AMD products instead of Intel, an AMD Athlon processor is sufficient for digital video editing as well.

✔ **Microsoft Windows NT 4.0, Me, or 2000:** Windows Me comes with Windows Movie Maker and NT and 2000 are just less prone to crashes.

✔ **18GB hard drive:** 18GB provides storage for roughly 86 minutes of digital video. If possible, use a separate hard drive (from the one your software is installed on) for capturing and storing digital video. This prevents you from inadvertently using up vital free space on your main hard drive with digital video. Many computers on the market are now offering hard drives in excess of 40GB.

✔ **Video card with 8MB RAM:** Many good, inexpensive video cards are available that are in the $60-$80 range.

✔ **Video capture card:** This is the part of your computer that your camcorder actually connects to. For digital video you need a FireWire (IEEE 1394) capture card. See the "Selecting the capture card" section later in this chapter for specific requirements that a FireWire card must meet.

✔ **Modem:** If you want to post videos online, you need to have at least a 28.8K modem internal or external. However, because of the large size of most digital videos, you'll find that uploading them through a 28.8K modem feels a little like shoving a watermelon through a straw. If you plan to publish videos online regularly, try to get a faster connection, such as an ISDN (integrated services digital network) modem, cable modem, or DSL (digital subscriber line) service.

✔ **8x speed CD-ROM:** An 8x speed or faster CD-ROM is helpful. Other speeds you see advertised are 20x, 32x, and even 40x.

System requirements for Mac users

Most of what I discuss in the previous section is also true for the Mac version of Premiere. If you want to use Premiere on a Mac, you need these elements:

- ✔ **Processor:** PowerPC processor.
- ✔ **Operating system:** MacOS 7.5.5 or later.
- ✔ **FireWire capture capability for digital video.**

Choosing the hardware

A few of the major PC manufacturers sell computers with FireWire ports already installed. Purchasing one of these systems may seem like a no-brainer if you're interested in digital video editing with your computer, but this is not necessarily so. Some computers' already-installed capturing capabilities are proprietary in nature. That means that you can capture and play digital video only with the editing software provided with the computer. For some people, this is okay. For people who want to be able to use other editing software, such as Adobe Premiere or Windows Movie Maker, a proprietary hardware/software package won't be acceptable. When purchasing a PC with built-in digital video capturing capability, be sure to check that the editing software that serves that capture card is to your liking. Or, better yet, check to see that the built-in capturing capability is compatible with other digital video editing software programs.

If you buy a PC that doesn't have a built-in FireWire adapter, you need to add one. See the "Selecting the capture card" section, later in this chapter.

If you purchase a new Macintosh, make sure that you get one with a FireWire port. Most have them, but you should double-check anyway. All FireWire adapters that come with Macs support third-party editing software, such as Adobe Premiere.

The digital video editing software is the brains of the operation. For that reason, you have to look to the software specifications for guidance about acceptable capture cards (the hardware that captures and plays video). The reasoning for this may seem obscure at first, but you'll quickly get the idea. Here's how it works:

1. The computer listens to the brains (the digital video editing software).

2. The digital video editing software tells the capture card that it's time to capture some video from the FireWire input.

3. The capture card has its own software that obeys digital video editing software and operates the card and the recorder/player.

4. The video is captured and turned into a computer file.

5. The digital video editing software closes the capture card's software and goes back to the editing process.

Obviously, the digital video editing software and the capture card need to have a chummy relationship. For that reason, Adobe lists the cards that are certified to work with the digital video editing software, such as Premiere 5.1. I cover capture cards in the "Connecting Digital Video Devices" section later in this chapter. For an example of a compatibility listing, go to www.adobe. com/products/premiere/cards.html. This Web page lists all the capture cards that are certified to work with Adobe Premiere 5.1.

The relationship between the digital video editing software program and the capture card is critical. If the relationship works well, you're going to have a blast. If it doesn't, well . . . let's just say you won't be very happy.

Connecting Digital Video Devices

One of the amazing aspects of preparing your computer for digital video is that you aren't dedicating your computer to an exclusive function. On the same computer, you can do word processing, surf the Internet, and balance your checkbook. For editing digital video, you just need to load some software, add a simple piece of hardware, and follow some straightforward instructions to prepare for capturing digital video.

Throughout this book I show you the basics for using digital video editing software, but here I need to share some basic information about connecting the devices that make digital video work and help you create wonderful video.

The capture card

After you shoot some video, you must import that video into your computer if you hope to edit it. This is the function of the capture card. Digital video requires a FireWire capture card. FireWire ports are extremely fast — capable of transferring up to 400 million bits of data per second. This makes FireWire

perfectly suited for capturing digital video. Some hardware manufacturers now offer other FireWire devices, including printers, scanners, and external hard drives.

Unless your computer came with a built-in FireWire adapter, you need to add one before you can capture digital video. FireWire cards cost as little as $50 to as much as hundreds of dollars. Generally speaking, if you pay more than $150 for a FireWire card, you're paying for some fancy software that comes with it rather than a better card. The following sections describe how to choose and configure a FireWire card in a PC.

The iMac computer doesn't need capture card setup, but most PCs do.

Selecting the capture card

Any FireWire capture card that you select must be OHCI- (Open Host Controller Interface) compliant. This should be clearly identified on the specifications sheet for the card. Be careful because not all FireWire cards are OHCI-compliant. You should also check the system requirements for the card to make sure that your computer can support it.

If you're interested in editing with Microsoft's Windows Movie Maker (part of Millennium Me), be aware that successfully capturing video with your capture card and playing it in Movie Maker are two different things. If you plan to use Movie Maker as your digital video editing software program, be sure to use a capture card that's certified for compatibility with Movie Maker. Don't assume that by installing Windows Me on your computer that Movie Maker will work with your capture card. I discuss capture cards in depth in the "The capture card" section later in this chapter.

If knowledge of technical specifications is more than you want to bother with, don't worry. You just need to ask your computer dealer's technical support staff to make sure that the capture card's minimum requirements are met or exceeded by your computer.

Here are the issues that you or your computer store staff need to check when selecting a capture card for your computer.

- ✔ **Your computer's speed — 233 MHz Pentium processor or faster.** Make sure your computer's processor is fast enough. Most FireWire cards require at least a Pentium-233, but a Pentium II-300 or faster is better suited to the rigors of digital video editing.

- ✔ **Capture card slot — 32-bit PCI slot.** Virtually all FireWire cards use a PCI (Peripheral Component Interconnect) bus. Make sure your computer has an unobstructed PCI slot available. You can usually identify the PCI slots by their ivory or white color.

✓ **64MB RAM (more recommended).** This is the minimum RAM recommended by most capture card manufacturers. However, I recommend at least 128MB RAM for your digital video software and capture card.

✓ **50MB free hard disk space (approximate) for software.** Your system's hard drive (normally the C drive on your computer) must be capable of storing the capture cards' capturing software programs.

✓ **2GB video hard disk space (minimum).** Although 2GB (gigabytes — 2GB is 2,000 megabytes) sounds like a lot, it isn't. At least for digital video, it's not much space. Two gigabytes stores only 9½ minutes of video. A reasonable amount of audio video storage is 18GB, which can hold more than 80 minutes of digital video.

As you can see from the minimum requirements, you must know a bit about your computer before choosing your capture card. You may also have to upgrade your computer's power, memory, and storage capacity to meet these requirements. Remember, help is as close as your computer dealer's technical service department.

You also need to be sure the editing software you plan to use supports the capture card that you buy. Table 8-1 provides information on supported capture cards for each of the three digital video editing programs covered in this book.

Table 8-1	Supported DV Capture Cards
Program	*Supported Cards*
Adobe Premiere	A list of supported devices is available online at www.adobe.com/products/premiere/cards.html.
Windows Movie Maker	All OHCI-compliant IEEE 1394 cards, Intel and Philips USB (Universal Serial Bus) capture devices
iMovie	A FireWire port is built in to all Macs that come with iMovie.

Installing a capture card

Properly installing a capture card into your PC is relatively easy *if* you're an experienced computer user; however, it may be a little intimidating if you're a novice. Here's my recommendation: If you have added expansion cards, additional hard drives, or any other internal component to your PC, you probably know enough to install the capture card yourself. Otherwise, save yourself

some stress-related headaches and ask someone with technical know-how to do it for you. Some computer stores install the card for you at no charge if you buy their card. If all else fails, pay your local computer repair store to install the card. *Beware:* PC components are delicate, and the slightest goof while installing a new capture card could ruin your whole computer.

If you intend to install your own capture card, do the most important thing first. Read the installation instructions that come with the capture card and its software. You'll find that capture card manufacturers write installation instructions for people who have never installed a card or driver. If you have problems, the manufacturer almost always provides a Web site and a telephone number to assist you.

Video editing software programs are *nonproprietary,* which means that they can operate on and (perhaps) share video clips with other software programs on the same computer. After you install the digital video software, the capture card, and the capture card software, you're ready to connect and check out your digital video system. You can hook up your camcorder and monitor and find out what this digital video hoopla is all about.

The IEEE 1394 cable (FireWire or i-LINK)

Connecting your digital camcorder to your computer is simply a matter of connecting one end of an IEEE 1394 FireWire cable (also called an i-LINK cable by some manufacturers) into the connector on your FireWire adapter card and the other to the digital video output connector on your camcorder. I wish it were more highfalutin' than that, but it's not. Figure 8-1 shows you how to connect the IEEE 1394 cable to the digital video connection on your camcorder.

Lossy and lossless

Lossy means that some data is lost in transmission. *Lossless* means the digital video signal is virtually the same in the computer as it was on the digital videotape. Because of the innovation of low-cost, professional-quality digital camcorders and their *lossless* connectivity to computers via the IEEE 1394 (FireWire) cable, you can now affordably record and capture high-quality video.

IEEE 1394 connection

MiniDV camcorder

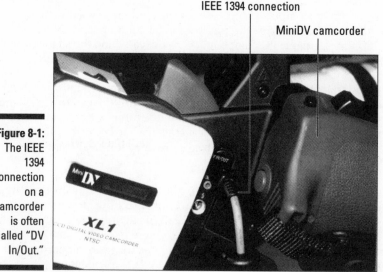

Figure 8-1:
The IEEE
1394
connection
on a
camcorder
is often
called "DV
In/Out."

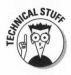

IEEE stands for the Institute for Electrical and Electronics Engineers, who sets the standards for electrical and electronic devices and systems. IEEE 1394 is a low-cost digital interface that integrates cameras, recorders, and computers. By connecting the IEEE 1394 cable to your camcorder and your computer's IEEE 1394 card, you can transmit digital video images from your camcorder's cassette through the card to your computer's hard drive.

Preparing to Play and View Video

Now that your capture card and its software are installed and the IEEE 1394 connection to your camcorder is connected to your computer, you're ready to boogie. All you have to do now is find out how to operate the capture software and use the computer monitor to view the playback. Fortunately, both items are pretty simple.

Begin by launching the capture software that came with your capture card. When you open the capture software, the first thing you probably notice is the program's interface (see Figure 8-2). Although each manufacturer's software differs, the software shares common features. It provides a way for you to control your camcorder, play your video on the computer, and record your video to your hard drive.

Scanning a digital videotape

Most DV capture card software programs provide a way for you to log all the video clips on your tape (refer to Figure 8-2). This procedure, called *scanning,* doesn't capture your video, but it does something equally amazing. When you click the tool, the capture software takes over the operation of your camcorder and searches the entire tape loaded in your video tape recorder. The scanning utility of the capture software creates and saves a library of thumbnails showing the first frame of each clip (see Figure 8-3). Each thumbnail displays the opening frame of a clip and its time code. This library is a useful way of logging all your shots on a tape.

Scan DV Tape

Capture

Figure 8-2: The capture card's software program is the control center for connecting your digital camcorder and your computer.

Edit

Print to DV Tape

Running the digital video device control

The bread and butter of the DV capture card software is its DV device control. Digital video device control handles the video tape recorder on your camcorder. The digital video device control automatically advances or rewinds the tape in your camcorder if you're directly controlling your camcorder controls. Figure 8-4 shows a monitor playing the digital video tape recorder clip.

Time code

Figure 8-3:
Most digital
video
capture
card
software
programs
create a
thumbnail
library of all
the
recorded
segments
residing on
your digital
videotape.

Figure 8-4:
The digital
video device
control runs
your video
tape
recorder via
the IEEE
1394 cable.

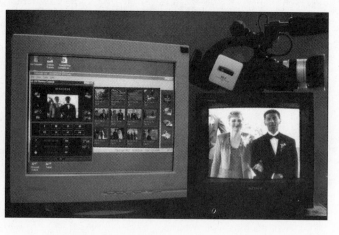

Capturing video clips to your computer

Capturing video to your computer is usually easy with DV capture card software. In most capturing software programs, you simply play the video with the digital video device controls. When you're satisfied with your choice of video, just press the Capture (Record) tool. Depending on the capture card, the video plays either on your computer monitor or in the viewfinder of your camcorder during capturing. This way you'll know when you want to stop the capture process. Again, depending on the capture card, you press Escape on your keyboard or click a button to stop recording.

Monitoring playback

Many digital video camcorders have composite (VHS) and S-VHS outputs. Figure 8-5 shows an example of composite and S-VHS outputs. Depending on the inputs of your monitor, you can use either of the outputs for viewing your video. After you connect your monitor, just turn your camcorder to VTR mode (the setting for using your camcorder as a video tape recorder) and play your recorded digital videotape.

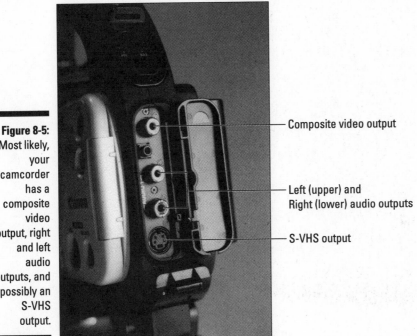

Figure 8-5: Most likely, your camcorder has a composite video output, right and left audio outputs, and possibly an S-VHS output.

Composite video output

Left (upper) and Right (lower) audio outputs

S-VHS output

The IEEE 1394 serial bus cable provides full control of your camcorder's videotape recorder from your computer through the cable to your computer. From your computer, you can play your camcorder and watch the tape play on your monitor. Not only that, you can edit in Premiere 5.1 and watch a full-screen video playback of your edited piece — just as though the camcorder's videotape recorder were part of the computer.

Chapter 9

Video Editing with Adobe Premiere

In This Chapter

▶ Introducing Adobe Premiere

▶ Editing video with Adobe Premiere

▶ Mixing your audio and video

Selecting an editing program to meet all your current needs is important, but you also want a system that can continue to meet your needs as you become more experienced. That's why I like Adobe Premiere 5.1. Premiere is one of the top editing programs in its price range.

Many professional editors, as well as serious home moviemakers, use Premiere 5.1 because the program is easy to use but wide open in its potential. With this program, you can make movies with

✔ Luxurious titles (text on the image)

✔ More than 70 types of transitions

✔ More than 70 types of special effects

✔ Picture in picture (one smaller video on top of another)

✔ An almost unlimited number of audio and video layers

In this chapter, I introduce you to Adobe Premiere 5.1. A trial version (available in both PC and Mac) is located on the CD at the back of this book. The trial version of Premiere 5.1 is the same size as the full-size version — about 30MB. For more information on how to load the materials from the CD and what system requirements your machine needs to run this program, see Appendix A. Adobe Premiere is the video editing software that is most used by professional videographers, so you can imagine that it offers all the bells and whistles that you could want. I use this chapter to introduce you to Premiere; how to import, place, edit, and delete a clip; as well as how to add sound to your video.

Introducing Adobe Premiere

Before jumping in, install the tryout version of Premiere 5.1 on the CD located in the back of this book (unless you already have Premiere installed on your computer). For steps on installing Premiere, turn to Appendix A.

You can also download some sample files for Chapter 9 that I've included on the CD-ROM at the back of this book. These sample files are stored in CLIPS/CHAP09. Turn to Appendix A for steps on copying the Chapter 9 sample files to your hard drive.

Starting Premiere for the first time

When you start the program, you see a little box that offers you the opportunity to buy the program (be prepared for a price tag of about $450). On PCs, some of the default settings are different from one computer to the next, depending on the capture card you purchased. For example, if you purchased a Canopus DvRaptor capture card, your initial settings default to that card's settings. You can use Premiere without having to purchase a capture card for the time being, although if you want to edit some of your own video that you recorded with your camcorder, a capture card becomes important. See Chapter 8 for more on capture cards.

To use the sample video files on the CD, you need to select General Settings in the New Project Settings dialog box, as shown in Figure 9-1. Before you begin working in the Premiere window, change a couple of settings so that you can use the sample files on this book's CD-ROM. Your Current Settings information may be different from what you see in the figure, but don't worry about that. Here's what you need to do:

Timebase

Figure 9-1: Use these settings to begin editing your video.	

New Project Settings

General Settings

Editing Mode: Video for Windows
Timebase: 30
Time Display: 30 fps Non Drop-Frame Timecode

Current Settings:
Video Settings
Compressor: Microsoft Video 1
Frame Size: 640 x 480, Frame Rate: 29.97,
Depth: Thousands, Quality: 1%

Audio Settings
Rate: 44100, Format: 16 - Stereo

OK
Cancel
Load
Save
Prev
Next

1. **In the General Settings category (the default), click the Timebase drop-down box and select 30.**

2. **Click the Next button.**

 You now see the Video Settings category selected (see Figure 9-2). You see Frame Size and Frame Rate.

3. **Click in the Frame Size width box (v) and change the width to 240.**

 If the 4:3 Aspect button is checked, the height automatically changes to 180. The 4:3 aspect ratio is the width-to-height ratio of a television set or video monitor. By checking this box, you're instructing Premiere to keep the ratio.

4. **Click the arrow inside the Frame Rate drop-down box and change the Frame Rate to 15.**

 Fifteen is the common frame rate for multimedia files.

5. **Click OK.**

Width

Height

Figure 9-2:
Use these settings to set the frame width, height, and frame rate.

New Project Settings

Video Settings

Compressor:
Microsoft Video 1 | Configure

Depth:
Thousands | Palette

Frame Size: 240 h 180 v ☑ 4:3 Aspect
Frame Rate: 15

Quality
Low 1 % High

Data Rate
☐ Limit data rate to 1000 K/sec
☐ Recompress Always

OK
Cancel
Load
Save
Prev
Next

Frame rate

The numbers in the Frame Size boxes are pixel counts. The word *pixel* is short for picture element, which is the smallest unit of a picture on a monitor's screen. You make the frame size smaller when you reduce the pixels. Leave Aspect checked because a television monitor and a computer monitor have 4:3 aspect ratios. Even though you make the frames smaller than full-screen size, you want to maintain the width and height ratio for the examples in this chapter.

The Adobe Premiere window can be set up any way you like, just make sure that you have access to the Monitor, Timeline, and Project windows. In this section, you find out how to prepare your screen for editing.

Touring Adobe Premiere

If your monitor's resolution is set at 800 x 600 or 640 x 480, you find the Premiere window a little crowded because Adobe Premiere packs a lot on the screen (see Figure 9-3). Now is a good time to briefly introduce, or perhaps reintroduce, you to the windows on the Premiere screen (see Figures 9-3 and 9-4). At the top is the Monitor window. Farther down is the Timeline window.

You can do the following in Windows and Mac to "clean up" the window:

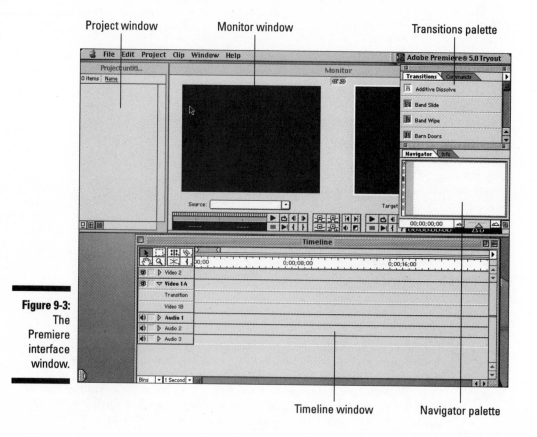

Figure 9-3:
The Premiere interface window.

Project window Monitor window Transitions palette

Timeline window Navigator palette

1. **In Adobe Premiere, select Window⇨Hide Transitions and Window⇨ Hide Navigator.**

 These actions temporarily hide a couple of windows.

2. **Click the lower-right corner of the Project window and, while holding down the mouse button, drag the window up until you shorten the window to about half its original length.**

3. **Click the highlighted portion of the window and drag the window to the lower-right corner of the screen.**

4. **Click anywhere in the Timeline window to highlight it. Drag the Timeline window up until you can see the lower-right corner.**

5. **Click the lower-right corner of the Timeline window and, while holding down the mouse button, drag and reduce the Timeline window vertically until its bottom is just below the Audio 2 channel.**

6. **Select the top of the Timeline window and drag the resized window down until it borders the lower-left side of the screen.**

 Your screen should now look something like the one in Figure 9-4.

Monitor window

Figure 9-4: When you set up your Premiere window, make sure that you have easy access to the Monitor, Timeline, and Project windows.

Timeline window

Project window

Editing Video with Premiere

Watch out! You're about to become infatuated with the editing program Adobe Premiere and you'll love what you can do with it. You'll want to show everybody — your friends and neighbors, your boss and your cat — what you can make. The only hitch with the tryout program that you installed from this book's CD-ROM is that it doesn't allow you to save the finished product (after all, Adobe wants you to buy the full program). Ah love! So passionate, and yet so fleeting.

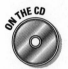

Now it's time to edit your video. Of course, if this were a real-life project, you would have already shot and captured your video. But for the sake of this introductory project, you can use clips that I provid on the CD.

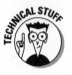

To accommodate your computer's memory and hard drive, I turned some full-screen video into smaller-sized versions. I shot the original clips using a Canon XL1 camcorder and captured the video into my computer using an IEEE 1394 capture card, thereby turning the video into computer files. Then I imported the files into Premiere and reduced their pixel size and frames per second. I also compressed the video files so that they could play more easily from a hard drive or a CD-ROM.

Importing clips

In the crazy world of editing, video clips, audio files, graphics, and animation are affectionately referred to as *assets*. Such warmth. Some people also call video clips *media*. I refer to them as *clips*.

In order to edit clips in Premiere, they must be available in the Project window. Begin this process by importing some clips:

1. **Double-click the Project window.**

 The Import dialog box appears, as shown in Figure 9-5.

2. **Find the media clips that you want to use.**

 If you haven't had the opportunity to create some files of your own material, feel free to pull up some files located in CLIPS/CHAP9 on this book's CD-ROM.

3. **Highlight the files that you want to edit.**

 For example, I selected girl1.avi, jars1.avi, and natural1.wav (Mac users highlight girl1.mov, jars1.mov, and natural1.aiff files).

4. **Press the Shift key to highlight the files you want to edit.**

5. Click Open.

These two clip files now appear in the Project window (see Figure 9-6).

Figure 9-5:
The Import
window
indicates
the movie
files
available for
importing.

Figure 9-6:
The Project
window lets
you import,
organize,
and store
references
to clips.

Placing clips

As is true of most good editing programs, Premiere offers you more ways
than one to do your work. After you get the hang of working with your film,
you find that you will work almost exclusively in the Monitor window. If
you're just beginning, you may find it more comfortable to move back and
forth between the Timeline window and the Monitor window. To be able to
work with a file in Premiere, you must first pull the video file from the project
window into the video editing monitors. To place the imported video clips
into the editing monitor, do the following:

**1. Go to the Project window and highlight the files you imported. To
 highlight both files, click the first file, press and hold the Shift key,
 and then press the Down arrow key.**

For example, in Figure 9-5 I highlighted girl1.mov and jars1.mov to
import.

2. **Place your cursor over the highlighted files. (The arrow cursor becomes a hand.) Click and drag the two files into the Timeline window and drop them in the Video 1A row. Release the mouse.**

 The two clips appear in the Timeline in the track Video 1A, and the opening frame of the first clip appears on the right side of the Monitor window (in the Program monitor). Your screen should look something like the one in Figure 9-7.

Premiere lets you layer multiple video tracks on the Timeline. That's why you see tracks called Video 1A, Video 1B, Video 2, and so on. Video 1A is the main video track, so that's where you should place the first clip in your project. You can place all of your clips in track 1A if you want, but that's no fun. See "Preparing to Add Audio" later in this chapter to see what you can use the other tracks for.

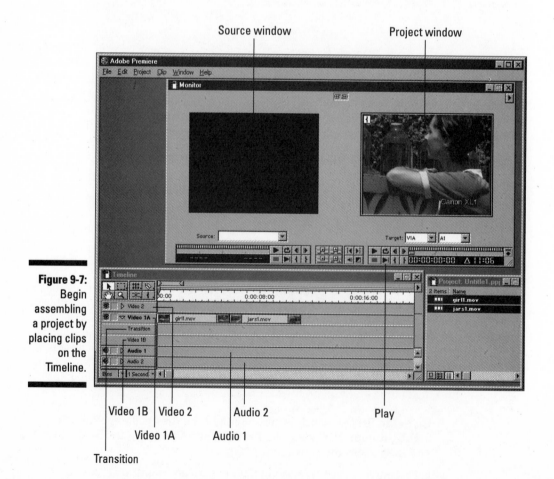

Figure 9-7: Begin assembling a project by placing clips on the Timeline.

The default Timeline has three video tracks, two audio tracks, and a transitions track.

- ✔ **Video tracks:** Video 1A, Video 1B, and Video 2. Video 1A and Video 1B are for normal video clips. If the clips have sound associated with them, the sound appears in Audio 1 and Audio 2 respectively.

- ✔ **Audio 1 and Audio 2:** Used for holding audio from Video 1A and Video 1B or the audio tracks can be used for other audio that you lay on the Timeline.

- ✔ **Video 2:** Used for superimposing text (titles) with transparent background. Video 2 is also for video with special effects, such as laying a smaller picture in Video 2 on top of a full-screen picture in Video 1A or Video 1B.

- ✔ **Transition:** The place where you lay in a transition from the Transitions Palette (see "Transitioning clips" later in this chapter).

Playing clips

One of the most common things that you want to do with clips on the Timeline is play them. Playing a clip is easy in Windows and on a Mac. Follow these steps:

1. **Click anywhere in the Timeline window and highlight it.**

2. **Press the spacebar to begin playing the clip in the Program monitor. Or, you can click the Program Monitor Play button.**

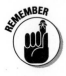

Toggle between stop and restart in the project by pressing the spacebar. If you want to go back to the opening frame, simply press the letter **A** on your keyboard. You're starting to become an editor!

Deleting clips

When clips are imported into Premiere, nothing is done to the original clip. By this, I mean that you can make a zillion changes to a clip in Premiere, but you're not modifying the original. When you import the clip from your hard drive into Premiere, you are actually importing a copy, not the actual clip itself. So if you delete a clip from the Timeline or Project windows, you still have the original on your hard drive.

1. **Highlight the clip in the Timeline window.**

2. **Press Delete.**

 The clip is no longer in the Timeline window, but it's still available in the Project window.

Editing clips

Your two-clip project is, so far, unedited. Say you have a clip of your dog and a separate clip of your cat. With the "magic" of video editing, you can make them appear to be in the same clip and look like they love each other (yeah, I know, in your dreams right?). Editing involves cropping clips so that they are shorter. Sometimes, you may want to start a clip at a later point. This is called adding an *in* point. If you want to shorten a clip, this is called adding an *out* point. You can edit in and out points either on the Timeline or in the source window.

Using the Timeline to edit clips

For my project, I use the sample files from the CD. I want to create a simple segment in which the young lady looks down at the row of jars. I also edit the clip to show all the jars. Here's some step-by-step instructions on how you can use the Timeline to edit clips:

1. **Import the clip you want to edit into the Project window.**

 If you need more information on how to import a clip to the Project window, turn to the section "Importing clips," earlier in this chapter.

2. **Place your clip onto the Timeline.**

 The section "Placing clips" gives you more information on how to get your clip onto the Premiere Timeline.

3. **Double-click your clip in the Timeline window.**

 In my example, the clip now appears in the Source monitor (see Figure 9-8). The "girl1.mov 0:00:00:00," shows up in the Source clip information box, identifying the clip and its place on the Timeline. The zeroes indicate that the clip is resting at the beginning of the hour, at the beginning of the first minute, at the beginning of the first second, at the beginning of the first frame of the project.

4. **Click in the Source monitor.**

5. **Type the letter A to set the clip at the opening frame.**

 The time unit at the bottom of your monitor should now read 00:00:00:00. Following the time unit is a triangle followed by the number

5:20, which indicates that the next edit will be at 5 seconds 20 frames. Unless you edit the clip, Premiere assigns the last frame of the clip as the final frame in the Timeline.

6. **Click and drag the slider (scrubber) just above the time code until you reach the time you want to create the new out point for the clip.**

In my example, I chose the time unit reading to be 00:00:03:20.

7. **Click the out point button at the bottom of the Source monitor (see Figure 9-8).**

This will be the new out point for the clip. An out point represents the last frame of an edited clip. Setting a new out point doesn't delete any video from your actual clip. Premiere is using your new edit point as a reference point in your clip. As a matter of fact, Premiere lets you use the same clip as many times as you want in a movie. Each time you use the clip, you can set whatever edit points you choose.

8. **Click Apply at the top of the Source monitor.**

The clip is now 3 seconds 20 frames long. Note that changing the out point of the clip in the Source monitor also changes the out point in the Timeline window.

You've trimmed one of the clips. You can play it if you want by clicking anywhere in the Timeline window to highlight the window and pressing the spacebar.

Using the Project window to edit clips

You can also use the Project window to edit clips before you place it on the Timeline.

1. **Click on your clip, hold down the mouse button, and drag the clip to the Source monitor.**

If you had a clip already loaded onto the Source monitor, this clip replaces it.

2. **Click and drag the slider just above the time unit until the time reading is at a place you want to end the clip.**

With my example, I stopped the time unit reading at 00:00:03:20.

3. **Click the in point button at the bottom of the Source monitor.**

You have just edited a clip before it is dragged into the Timeline window (see Figure 9-8). As you can see, an in point appears in the upper-left corner of the Source monitor. An in point represents the first frame of an edited clip.

Scrubber In point

Time Source monitor Out point Program monitor

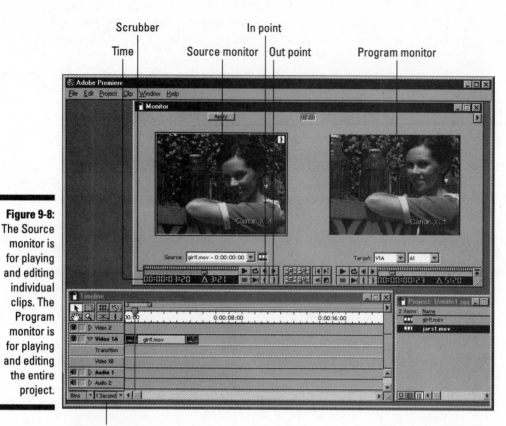

Figure 9-8:
The Source
monitor is
for playing
and editing
individual
clips. The
Program
monitor is
for playing
and editing
the entire
project.

Time unit button

Adjusting units of time

Sometimes you want to see your whole movie on the Timeline. Other times you want to look closely at individual frames. A clip can have up to 30 frames in a second. So, if you're looking up close, you don't see much of the movie. Moving in and out in units of time is important so that you can alter your perspective from a "big picture" view to a detailed view. You can do this by adjusting units of time on the Timeline.

The next thing you need to do requires a little more accuracy in time than the Timeline currently allows. So you must change the scale of time measurement to 8 frames from the current 1 second.

1. **Click the Time Unit button in the lower-left corner of the Timeline window.**

 The Time Unit menu appears (see Figure 9-9).

2. **Select 8 Frames from the drop-down menu.**

 The Timeline changes to an eight-frame unit measurement. Note that changing the Timeline window scale of time doesn't change the length of clips on the Timeline.

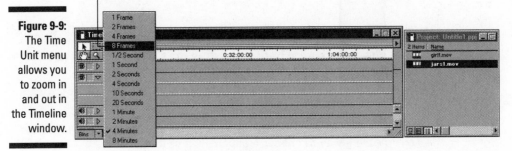

Figure 9-9:
The Time
Unit menu
allows you
to zoom in
and out in
the Timeline
window.

Transitioning clips

Rather than bumping two clips side by side and getting a choppy project, you make what's called a *transition*. By transition, you merge the end of the one clip with the beginning of another clip to create a smooth and continuous flow. Here's where Premiere really starts being fun. Follow these steps to merge clips in Windows or on a Mac.

1. **Import the clips you want to turn into a project.**

2. **Drag one clip onto the Timeline window and lay it in the Video 1A row.**

3. **Drag a second clip onto the Timeline window and lay it in the Video 1B row, overlapping your first clip about a second (see Figure 9-10).**

4. **Open the Transitions window by selecting Window⇨Show Transitions from the Premiere main menu.**

 The Transitions window appears.

Overlap

Figure 9-10:
Figure 9-10:
The overlap
of clips on
the Timeline
represents
how long
the
transition
will take.

5. **Scroll down the Transitions window until you come to Cross Dissolve.**

6. **Hold down the mouse button and drag the Cross Dissolve transition to the Transition track in the Timeline window.**

7. **Position the transition so that it fills the overlap between Video 1A and Video 1B and release the mouse button.**

 You just set a transition (see Figure 9-11). The transition provides a visually pleasing way to change from one clip to the next.

Figure 9-11:
The
transition
automati-
cally fills the
space of the
overlap
between the
two clips.

Transition

Previewing clips

Want to see the fruits of your work? To preview the work area of the project, you have to adjust the work area slider (see Figure 9-12):

1. **Using the Time Unit menu, change the time units from 8 frames to one-half second.**

2. **Click and drag the blue work area slider over the area of the transition.**

3. **Drag the left and right edges of the work area until it covers all the clips.**

4. **Press Enter.**

 Premiere builds the preview and then runs it in your Program monitor (see Figure 9-12).

Congratulations! You've created a segment of two edited clips with a transition.

Work area slider

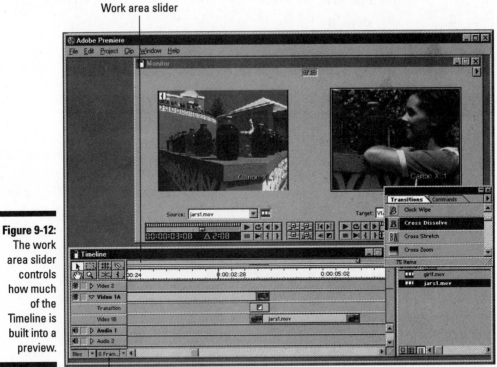

Figure 9-12: The work area slider controls how much of the Timeline is built into a preview.

Time unit

Combining Audio and Video

Audio can completely change the energy and the message of video. Well produced audio is the least expensive and most versatile tool of video. Premiere provides the canvas and paintbrush for you take pieces of video and graphics and turn them into a connected whole — largely because of your use of sound. You do a couple of intricate procedures with a song in your heart and on the computer's speakers. This section focuses on adding audio to video.

You have two major categories of audio, as follows:

- Audio that is recorded at the time of video recording
- Audio that is added later after you have finished video recording

Preparing to add audio

Audio tracks are at the bottom of the Timeline window, so you need to vertically enlarge the Timeline window a little. This gives you some space to work as you adjust the audio attributes of your project.

To vertically enlarge the Timeline window, follow these steps:

1. **Click anywhere in the Timeline window to highlight it.**

2. **Drag the Timeline window up a little and then click the bottom border of the Timeline window and drag it down until the bottom of the window touches the bottom of the screen.**

Adding sound to video

Adobe Premiere enables you to combine up to 99 audio and video tracks, giving you the opportunity to create some fascinating combinations of video clips and audio files. For the example shown in Figure 9-13, I use natural1.wav (Mac format natural1.aiff), which you can find on the CD that comes with this book in the folder Chap09. If you haven't loaded the file yet, see the section, "Importing clips." Here's how to attach background sound to your video and play your masterpiece:

1. **After you have imported your audio file from your hard drive, drag your audio clip from the Project window to an empty audio track on the Timeline.**

 If you have video already on the Timeline and if the video has audio connected to it, that audio occupies one of the audio tracks, as shown in Figure 9-13.

2. **Highlight the Timeline window and press the spacebar to see and hear the video with the audio.**

 The audio track in the video is not affected by the addition of other audio tracks.

Figure 9-13:
The audio track in the video does not replace the background audio track.

Audio track in video

Playing audio

Not sure whether you inserted the right audio track into the Timeline? What if you just want to make sure that the audio track plays properly? Premiere lets you play audio tracks easily. Follow these steps:

1. **Import your audio file from your hard drive.**

 If you need a refresher on how to import a file from the hard drive into Premiere, swing back to the section "Importing a clip." Although a clip is different from an audio file, the steps are the same for importing into Premiere.

2. **Add an audio track to the Timeline.**

 See the section "Adding sound to video" if you're not sure how to add audio tracks to the Timeline.

3. **Highlight the Timeline window and press the spacebar.**

 Audio files play just like video files.

Chapter 10

Making Movies with Windows Movie Maker

*I*n September 2000, Microsoft released Windows Millennium Edition (Windows Me). Windows Me features a new program called Movie Maker, especially for people interested in digital video. Movie Maker is Microsoft's answer to Apple iMovie (covered in Chapter 11), and it is ideally suited to people who are just getting into digital video or who want to publish videos online. This chapter helps you figure out how to create your first movie project in this exciting new program.

Windows Movie Maker is easy to use, but there is a lot more to this surprisingly versatile program than I can cover here. If you plan to use Movie Maker a lot, check out *Microsoft Windows Movie Maker For Dummies* (published by IDG Books Worldwide, Inc.) by Keith Underdahl.

Introducing Windows Movie Maker

As with any program, Windows Movie Maker has strengths, as well as a few weaknesses. Strong points of this program include the following:

 ✔ It's free (with Windows Me).

 ✔ It's easy to use.

 ✔ It can produce extraordinarily small video files, which are ideal for sharing online.

Movie Maker system requirements

As with all good software producers, Microsoft has published system requirements for using Windows Movie Maker. According to Microsoft, you should have at least a Pentium II-300, 64 MB (megabytes) of RAM (random access memory), and 2 GB (gigabytes) of hard drive space.

These requirements, I have found, are rather arbitrary. The program actually runs and performs video editing on much slower systems; however, I have found that a Pentium II-300 is not quite fast enough if you want to record video from a digital camcorder. Videos produced by Movie Maker have extremely small file sizes. The program achieves this small file size by compressing video "on the fly" as it is captured from your camcorder. If you are recording video

directly from your digital camcorder through your FireWire adapter, your computer's CPU (central processing unit) is forced to work really, really hard.

If your CPU can't handle the load that Movie Maker puts on it, your video drops frames and has very poor sound. To ensure you get the most out of this program, here are the *real* system requirements:

✔ Pentium II-500 or faster CPU

✔ 64 MB RAM (128 MB is better)

✔ As much hard drive space as you can afford, but at least 1GB

Weaknesses include the following:

✔ Movies produced by Windows Movie Maker can only be viewed using Windows Media Player 6 or higher.

✔ The program lacks many built-in special effects features, such as *compositing* (the combination of two or more pieces of film into a single scene), titles, and advanced transitions between scenes.

✔ Video quality is not as good as Adobe Premiere or Apple iMovie.

If you have Windows Me and you just bought your first digital camcorder, Movie Maker is a great way to plunge into the art of video editing. If you want to produce videos exclusively for online use, the small file sizes produced by Movie Maker are hard to beat. But if you want to get a bit more advanced, or you want to produce higher quality video that can be viewed full-screen on a computer or on a regular TV from a video tape, you should try a different program, such as iMovie or Premiere.

Touring Movie Maker

The Windows Movie Maker interface is very simple, as you can see in Figure 10-1. To launch the program, choose Start⇨Programs⇨Accessories⇨ Windows Movie Maker. Movie Maker has the following important areas:

- ✔ **Collections area.** Your collections are organized in a treelike structure on the left, similar to folders on a hard drive. The middle of the Movie Maker screen shows individual clips within a collection you select.

- ✔ **Collections toolbar.** These tools help you manage your collections. Collections are like folders on a hard drive because they help you store and organize clips.

- ✔ **Location toolbar.** This toolbar tells you which collection you are currently browsing.

- ✔ **Monitor.** Preview clips or your whole movie project here.

- ✔ **Project toolbar.** Three key functions of Movie Maker are here: Save, Send, and Record. Click Save Movie when you are done with your project and ready to save it as a video file. Click Send when you want to send the movie via e-mail or post it on the Web. Click Record when you want to record audio or video.

- ✔ **Standard toolbar.** Tools here include New, Open, Save, Cut, Copy, Paste, Delete, and Toggle Clip Properties. The Toggle Clip Properties tool displays properties of a clip.

- ✔ **Workspace.** This is where you assemble clips to create your movie. You can toggle between the Timeline and Storyboard workspaces.

Create a new collection folder for each portion of video that you record or import. You can also create separate collections just for audio clips and still graphics. Name collections descriptively so that you can easily identify them.

Determining who can play Movie Maker movies

Windows Movie Maker videos can be saved in one of two formats: .WMV or .ASF. The two formats are virtually identical, and as of this writing the only program that can play them is Windows Media Player version 6 or higher. You can download Windows Media Player 6 or 7 for free from Microsoft at `http://microsoft.com/windows/mediaplayer/download/default.asp`.

Collections toolbar Project toolbar

Standard toolbar Location toolbar Monitor

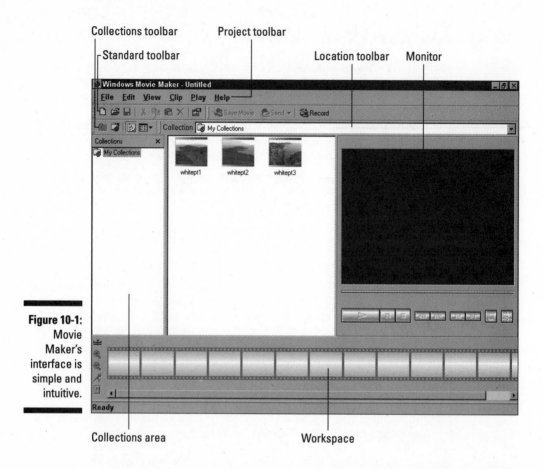

Figure 10-1:
Movie
Maker's
interface is
simple and
intuitive.

Collections area Workspace

Your audience does not have to use Windows to use Windows Media Player. A version is available for most Macintosh systems, as well as Windows 3.1 or higher. Table 10-1 lists system requirements for Windows Media Player.

Table 10-1:	Windows Media Player System Requirements	
Windows 3.1	*Windows 95 and Higher*	*Macintosh*
Pentium 90	Pentium 120	PowerPC 180
16MB RAM	32MB RAM	32MB RAM, 10MB free for Media Player

Windows 3.1	Windows 95 and Higher	Macintosh
16-bit sound card	16-bit sound card	Mac OS 8
256-color video card	256-color video card	16-bit display adapter
Video for Windows		

Currently, no .wmv or .asf player is available for UNIX-based operating systems, such as Linux, although the innovative nature of the UNIX community means this situation may change soon.

Moving Content into Movie Maker

If you want to edit movies with Movie Maker, you must first have something to edit. Then, you can place content (audio, video, or still graphics) into Movie Maker in two ways:

- ✔ **Record.** If you have a camera connected to your computer, such as a small Web cam or a digital camcorder connected to a FireWire port, Movie Maker can record directly from that device. Movie Maker also records audio from a microphone attached to your sound card.

- ✔ **Import.** Movie Maker lets you import multimedia files into the program. For instance, if you have MPEG video or MP3 music saved on your hard drive, Windows Movie Maker can import those files.

What about CD Audio?

Although many of the most common multimedia file formats can be imported into Windows Movie Maker, one significant format missing from the list is CD Audio (.CDA). This is the format of audio on music CDs, and although you can play music CDs on your computer, Movie Maker cannot import music directly from CDs.

But wait! There is an easy solution. Windows Media Player 7, which also comes free with Windows Me, allows you to record music from audio CDs onto your hard drive in .WMA format. This format is so compact that it requires only about 1MB of disk space to store one minute of music. And, of course, .WMA audio files can easily be imported into Movie Maker. To record music from a CD onto your hard drive, launch Windows Media Player, place a music CD in your CD-ROM drive, click CD Audio, and use the Copy Music button to copy the desired songs.

Table 10-2 lists the types of files that can be imported into Windows Movie Maker. If you have any multimedia files with a file extension shown in Table 10-2, they can be imported. If the file extension isn't listed here, you are (sadly) out of luck.

Table 10-2:	Multimedia File Types Supported by Movie Maker
Media Format	**Supported File Types**
Audio	.AIF, .AIFC, .AIFF, .AU, .MP3, .SND, .WAV, .WMA
Video	.ASF, .AVI, .M1V, .MP2, .MPA, .MPE, .MPEG, .MPG, .WMV
Stills	.BMP, .DIB, .GIF, .JFIF, .JPE, .JPEG, .JPG

Importing multimedia

Importing audio, video, or still graphics into Movie Maker is easy. If you are importing a video file, Movie Maker automatically breaks it into clips, which can then be inserted into your own movie projects. Movie Maker imports audio files and still graphics as single clips. To import a multimedia file, follow these steps:

1. **Launch Windows Media Player and open the collection that you want to import the files into.**

 If you aren't sure which collection you want the file saved in, just choose My Collections at the top of the Collections list.

2. **Choose File⇨Import.**

 The Select the File to Import dialog box appears, as shown in Figure 10-2.

3. **Navigate to the folder or disk containing the file that you want to import.**

4. **Choose the file that you want to import and click Open.**

 The file is imported. If you are importing a video file, Movie Maker automatically creates a new collection for it and names the collection based on the name of the file you imported.

Select the File to Import

Look in: My Videos

Easter.ASF	sts-96-launch.mpeg
easter.WMV	toymart.mpg
easter2.WMV	toymart.WMV
hometour.wav	train.WMV
kthwrk.WMV	Windows Movie Maker Sample Fil
LongIslandCrash.mpeg	XtreemeMotorSports-ChrisR-R6-Cr.
MapleLawn.WMV	zoo1.WMV
Presidents2.WMA	zoo2.WMV
Rushmore.ASF	
Rushmore.WMV	
shatter.mpeg	

History / Desktop / My Documents / My Computer / My Network Pl...

File name: sts-96-launch.mpeg — Open

Files of type: Media files [all types] — Cancel

Import options: ☑ Create clips for video files

Figure 10-2:
Choose a
file that you
want to
import and
click Open.

When you import a file, all you are really doing is updating Movie Maker's internal database to point to the original source file. This means that if you delete or move the source file, Movie Maker will lose connection to it and you will have to re-import the file.

Recording video

If you have a digital camcorder or another type of camera connected to your computer, Movie Maker streamlines the process of recording video from that device. The easiest way to record video is to connect your digital camcorder to your FireWire (IEEE 1394) adapter.

You can also record video from an analog VCR or camcorder using a video capture card. Of course, Movie Maker isn't able to automatically control the analog device, meaning you have to press the Play button manually.

To record video from a digital camcorder, follow these steps:

1. **Connect the camcorder to your FireWire adapter and turn on the camcorder.**

2. **Launch Movie Maker and click Record.**

 The Record dialog box appears, as shown in Figure 10-3.

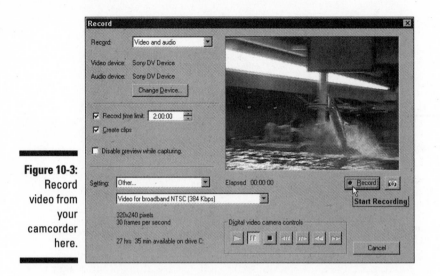

Figure 10-3:
Record
video from
your
camcorder
here.

3. **Fast forward or rewind the tape in the camcorder to the place where you want to begin recording.**

4. **Choose a recording quality in the lower-left portion of the dialog box.**

 Higher quality video requires more disk storage space. However, I recommend that you choose the highest quality setting possible (one of the "Video for broadband" options in the drop-down menu is best) in the Record dialog box. Remember, you can always shrink the file size when you finish your project.

5. **Click Record in the Record dialog box.**

 Movie Maker automatically starts playing the tape in your camcorder and records the video from it.

6. **Click Stop when you're done recording.**

 The camcorder stops automatically, and the Save Windows Media File dialog box appears.

7. **Name and save the video.**

 Movie Maker imports the video and breaks it into clips.

If the quality of video and sound is very poor, place a check mark next to the Disable Preview While Capturing option in the Record dialog box. This reduces the load on your CPU and improves recording quality.

Working with clips

What in the Wide World of Sports is a clip, anyway? A *clip* is the basic unit of measurement in Windows Movie Maker. When you record or import video into Movie Maker (see earlier sections in this chapter for more on recording and importing), the program automatically breaks the video into clips. Every time Movie Maker detects what it believes is a new scene — say, you stopped recording, repositioned the camera, and then started recording again — it creates a new clip.

Likewise, if you import an audio file (such as an MP3 song) or a still graphic (such as a JPEG picture), Movie Maker treats each individual file as a clip. Figure 10-4 shows each of the three kinds of clips you use in Movie Maker. Notice that video clip icons have a filmstrip along the top and bottom of a preview; stills have gray strips and a preview; and audio clips have music symbols (but no preview, for obvious reasons).

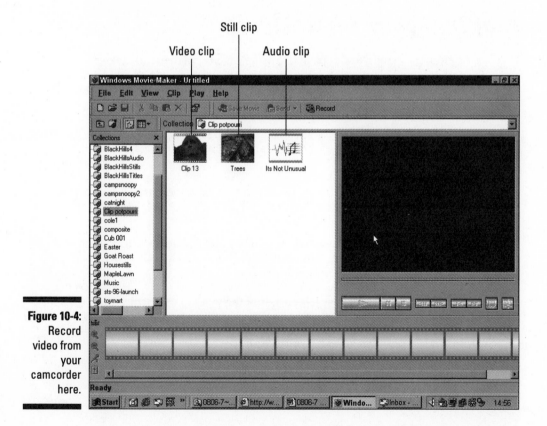

Figure 10-4: Record video from your camcorder here.

Organizing clips into collections

The best way to organize your clips is to place them into *collections*. Collections are similar to folders on your hard drive and are arranged in a treelike structure. You can see in Figure 10-4 that I have created quite a few collections to place my clips into. To create a new Collection, click the New Collection button on the Collections toolbar or choose File⇨New⇨Collection.

You can create *subcollections* within collections just as you create subfolders on your hard drive. Simply open the collection you want to create the subcollection in and follow the instructions for creating a new collection.

Moving clips into new collections is easy. Simply drag and drop a clip to a different collection to move it. And don't worry; this doesn't have any effect on the actual video files on your hard drive.

Making Your First Movie

After you have a few clips in the program, you're ready to make a movie of your own. You can make a movie using only video clips or add a unique soundtrack using audio clips. You can add still clips or even use Movie Maker to create a slide show using nothing but stills.

You assemble movie projects in the workspace area of Movie Maker, which is located at the bottom of the program window and toggles between two modes:

- ✔ **Storyboard.** The Storyboard is shown when you first launch Movie Maker. It looks like a filmstrip and only shows the basic order of clips in your project.
- ✔ **Timeline.** The Timeline lets you see and control how long each clip plays. Here you control transitions between clips, as well as add a soundtrack or narration to the project.

The button in the upper-left corner of the workspace toggles the workspace between the Storyboard and Timeline. You can also choose the Storyboard or Timeline from the View menu.

Adding clips to the Storyboard

Professional filmmakers use storyboards to plan their movies. Artists sketch a view of each scene in the movie, and these scenes are assembled — storyboarded, in Hollywood-speak — in order on a board. This enables the film crew to see how the order of the story should come together. Movie Maker's Storyboard works in much the same way, except that you plan your movie with actual clips instead of sketches.

Adding a clip to the Storyboard couldn't be easier. Locate a clip you want to add, and then drag and drop it to the Storyboard. Five clips have been dragged to the Storyboard shown in Figure 10-5. The order of clips on the Storyboard dictates the order of the movie.

You can only add video clips and still graphics to the Storyboard. If you try to add an audio clip, the workspace automatically switches over to the Timeline.

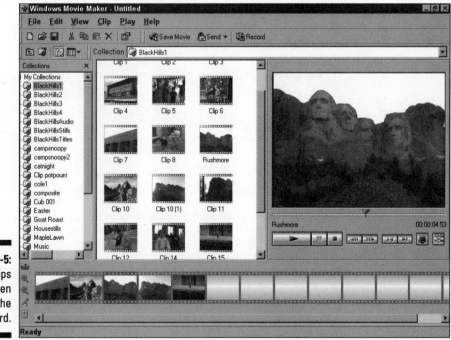

Figure 10-5:
Five clips have been added to the Storyboard.

If you want to change the order of the clips, simply drag and drop clips to new locations along the Storyboard. To remove a clip from the Storyboard, right-click it and choose Delete. Don't worry; clicking Delete here only removes it from the Storyboard. The clip remains in its original collection.

Working with the Timeline

When it comes to working out the order of scenes in your movie, the Storyboard works best. But the Timeline gives you a bit more control over the project, enabling you to adjust the playing time for individual clips, control transitions between clips, or add narration or a soundtrack. To switch to the Timeline, choose View⇨Timeline. Your Timeline may look something like Figure 10-6.

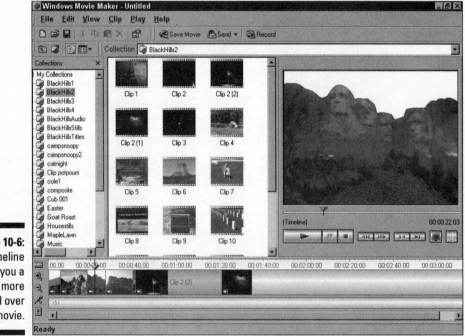

Figure 10-6: The Timeline gives you a bit more control over your movie.

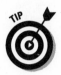

Are some of your clips so narrow on the Timeline that they look like mere slivers? Click the Zoom In button on the left side of the workspace to zoom in on the Timeline. Right below that is the Zoom Out button, which zooms (surprise) out from the Timeline.

One of the differences you'll notice between the Storyboard and the Timeline is that while the Storyboard gives an equal amount of space to each clip, the size of each clip on the Timeline varies. The width of each clip on the Timeline is representative of the playing time for that clip. If the clip is very short, it shows a thin sliver on the Timeline, and if the clip is really long, it is shown as being very wide.

The Timeline gives you several important editing options for your project:

- **Control transitions between clips.** If you leave the clips adjacent to each other on the Timeline, a clip disappears as it ends and, in the blink of an eye, is replaced by the next clip. This is called a *straight cut transition*. Instead, try dragging a clip slightly left to make it overlap the adjacent clip. The overlap area represents a *cross fade transition* or *dissolve*, where one clip fades out as the next clip fades in. Control the speed of the cross fade by adjusting the size of these overlaps.

- **Trim clips.** The Timeline enables you to trim portions off the beginning or end of a clip. Click once on a clip on the Timeline to select it. Trim points will appear above the clip, which you can drag back and forth with the mouse to trim the clip.

- **Adjust how long still clips play.** By default, still graphics that you import into Movie Maker are set to appear for five seconds. You can adjust the playing time of a still graphic by moving the trim points for it on the Timeline.

Figure 10-7 shows what trim points and a good cross fade transition (pointed out with the callout Overlap) look like on the Timeline.

Figure 10-7:
Trim clips or create transitions by using the Timeline.

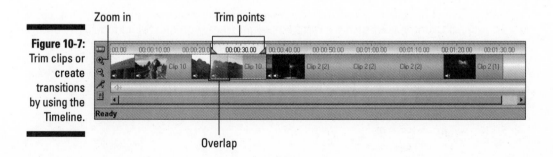

Adding a soundtrack to your movie

Most of the video you record probably already has sound with it. But sometimes you may want to add a soundtrack of your own to the movie, which Movie Maker enables you to do. You can add a prerecorded audio file (such as music) to the audio track of the Timeline, or you can record narration directly.

To add an audio clip to the Timeline, simply drag and drop it to the audio portion of the Timeline, just as you would drag in a video clip to the video portion. In Figure 10-8, you see that an audio file called "America" has been added to the project's audio track. If you would rather record some narration for your movie, click Record Narration and use the Record Narration dialog box to record narration using the microphone attached to your PC. If you don't have a microphone yet, swing over to Chapter 5 where I provide the low-down on available microphones.

Record narration

Figure 10-8:
Play audio
tracks and
record
narration
using the
Timeline.

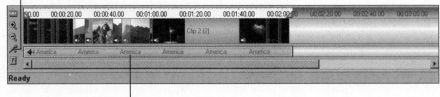

Audio track

You can move audio clips can be moved back and forth on the Timeline simply by dragging them. You can trim them by using trim points (just like video clips), and you can create transitions between audio clips by overlapping them (just like . . . well, you get the idea).

Most of your video probably already has audio recorded along with it. If you are adding your own narration or soundtrack, you must decide which audio source (the audio that came with the video or the audio track that you added to the Timeline) should be more prominent. You make that decision by clicking the Set Audio Levels button in the bottom left corner of the workspace. The Audio Levels dialog box appears, as shown in Figure 10-9. Move the slider back and forth to give prominence to one source or the other. To completely silence the video track's audio, move the slider all the way to the right.

Figure 10-9:
Use the
slider to set
audio levels
for your
movie.

Previewing your movie

I probably don't need to tell you the importance of previewing your movie before distributing it; you'll probably go through it dozens of times on your own. But previewing the whole movie — start to finish — is a little tricky in Windows Movie Maker. The two methods for previewing your movie are:

- Choose Play⇨Play Entire Storyboard/Timeline.

- Click in the very top strip (the one with the time marks) of the Timeline so that the whole strip turns yellow. Then click Play in the Monitor screen.

The first option is by far the easiest. If you keep trying to illuminate the whole Timeline in yellow using the second method, inevitably you'll end up trimming a clip or doing some other kind of unintended damage. Don't ask me how I know this.

The movie may play perfectly in Movie Maker, but that's still not the best indication of how your audience will see it. To be sure, preview it in Windows Media Player after you have saved the movie.

Saving your movie

When you are done editing, you are ready to save your movie. But first, you need to save the project. The *project* consists of all the edits you've made, all the clip trimmings, all the audio tracks, and all the transitions. If you want to go back later and re-edit the movie (and you will) you must save the project. It's easy:

1. **Click Save on the Standard toolbar.**

 The Save Project dialog box appears.

2. **Name your project, navigate to a new hard drive location if you want, and click Save.**

 The movie is saved in a format that only Windows Movie Maker can use. The file extension for this format is .MSWMM.

After you have saved the project, you should save the movie. This is the actual file that others will view and enjoy. Even if you only plan to e-mail the movie or send it directly to a Web server, I recommend that you save a copy of it to your hard drive by following these steps:

1. **Click Save Movie on the Project toolbar or choose File➪Save Movie.**

 The Save Movie dialog box appears.

2. **Choose a quality setting.**

 A higher quality setting is more enjoyable to watch, but you must carefully consider if your online audience is able to download it within a reasonable amount of time. For any quality setting you choose, the file size and estimated download times at various Internet connection speeds are listed.

3. **Add a movie title, author, and other information, if you want.**

 This information appears at the bottom of the Windows Media Player program window when the movie plays.

4. **Choose a location to save the movie, name it, and click Save.**

 By default, the movie is saved in WMV format. When the Save dialog box disappears, you see a dialog box telling you that your movie is being created.

 Although .WMV appears to be the only file format offered in the Save dialog box, it is a not-so-secret secret that you can also save movies in .ASF format simply by manually typing the .ASF extension at the end of the movie's filename. Normally, you have no good reason to do this, unless you have a stubborn Web server that accepts .ASF files but not .WMV.

Sending Your Movie to the Online World

The best audio and video quality offered by Windows Movie Maker is a far cry from the broadcast-quality video produced by programs such as Adobe

Premiere. But when it comes to producing really small files that are ideally suited to sharing online, Movie Maker is hard to beat. The medium quality setting, for instance, uses an average of about 760KB (kilobytes) of disk space per minute of video. That same one minute can be shrunk down to as little as 150KB, or expanded to 4.75MB (megabytes), depending on your quality preferences.

Before sending your movie online, make sure that you have saved a copy of it on your hard drive. See the section "Saving your movie" earlier in this chapter if you haven't done this yet.

Because Movie Maker is so well suited for producing video for online use, it should come as no surprise that the program can help you get your videos onto the Internet. It can help you in two ways — by using e-mail or by using a Web server.

Sending your movie via e-mail

To e-mail a movie to a friend follow these steps:

1. **Choose File⇨Send Movie To⇨E-mail.**

2. **Choose a quality setting.**

 Pay close attention to the file size. You want the file to be small enough to send to any of your friends and relatives. Some folks might have attachment restrictions that do not allow them to accept large attachments.

3. **Enter the title information.**

4. **Click OK.**

 Because the movie is sent as a file attachment using your e-mail program, you are asked to name that file. An e-mail message is automatically generated using your default e-mail program.

 Never, ever e-mail a large movie file to people without warning them first and getting their approval. Large e-mail attachments clog mail servers, hog download time, and cause people to worry about viruses.

5. **Click Send.**

Sharing your movie via a Web server

The best way to share movies online is to place them on a Web server. Anyone with Internet access can visit the Web server and download your movies at their own convenience. Many Internet service providers (ISPs) provide Web server space, which you can use to host your movies.

But what if your ISP doesn't provide enough free space for your movies? What if the ISP doesn't provide any space at all? Many other Web servers are ready to offer you huge amounts of storage space free of charge, and all they ask in return is that you allow them to show advertisements to people who view the files you place on the server.

If you have a lot of server space, you can even offer the same movie at various quality levels, allowing your audience to choose their own balance between quality and download time.

Movie Maker gives you quick access to several "free" Web servers. You can set up an account with one at the same time you upload your movie by following these steps:

1. **Choose File⇨Send Movie To⇨Web Server.**

2. **Choose a quality setting, type the title information, and click OK.**

3. **Give your movie a filename and click OK.**

 Make sure the file name is eight characters or less. Some Web servers cannot accept longer file names. After you name the file and click OK, Movie Maker creates the movie.

4. **If you need to sign up for a new Web server account, click Sign Me Up in the Send to Web dialog box; otherwise, type your login name and password for your Web server account and click OK to upload the movie.**

 When you first sign up for a Web server account, your Web browser will launch and connect to the Internet (if necessary). The Windows Movie Maker Partners Web site opens and guides you through the process of setting up a server account.

For more on uploading movies to Web servers, see Chapter 14.

To place a movie on your ISP's Web server, you must follow the ISP's instructions for uploading files. Movie Maker has a built-in tool for uploading files to Web servers that only works with servers that are Windows Movie Maker Partners.

Chapter 11

Making Movies with iMovie

*I*f you're interested in a powerful, dependable computer that's simple to use and capable of producing beautiful graphics and video, give serious consideration to an iMac computer. You may be thinking that I'm one of those crazies who carries a big chip on his shoulder about PCs. In fact, the opposite is true. I've owned many PCs over the past sixteen years. I've never owned a Mac until recently. What I have quickly discovered is that the iMac computer makes video editing fun. The Mac and the iMac are the computers of the artist's world. Digital video was born on the Mac, and that's where it still struts its stuff the best.

In this chapter, I introduce you to iMovie — the video editing program designed for the iMac computer. In Chapter 10, I investigate Microsoft's new program called Windows Movie Maker, a part of the new Microsoft Windows Me operating system.

Introducing iMovie

When you open iMovie, you see a rather bland screen (Figure 11-1), called the iMovie interface. However, you can't tell a book by its cover. As you'll see, you can accomplish a lot with a minimal number of steps or commands. The interface has the following five sections:

 ✔ **Menu bar:** Each menu contains options and tools for using iMovie.

 ✔ **iMovie Monitor:** The Monitor is where you preview clips.

 ✔ **Shelf:** Clips are stored in the Shelf.

 ✔ **Editing buttons:** These buttons let you edit your movie projects.

 ✔ **Viewers section:** This section lets you view your clips in one of two ways.

Menu bar

iMovie has only four rather limited menus:

 ✔ File

 ✔ Edit

 ✔ Advanced

 ✔ Help

Menu Bar iMovie monitor Shelf

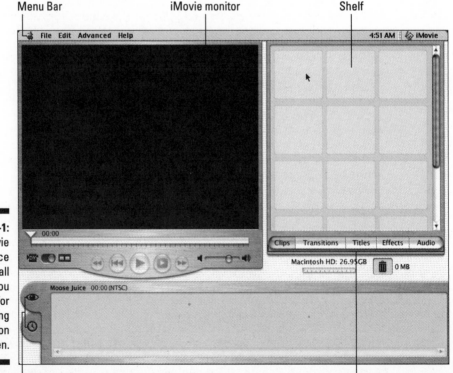

Figure 11-1:
The iMovie
interface
contains all
that you
need for
making
movies on
one screen.

Viewers Editing buttons

If you don't like to use menus, you can always use the hot keys that so many seasoned Mac users know and love. *Hot keys* are keyboard commands that perform the same function that would occur if you were to click a button or select something from a menu. For instance, if you want to quit iMovie, type ⌘+Q. In this chapter, I highlight some of the iMovie hot keys in parentheses as I describe various functions.

The File menu contains commands for starting a new Project (⌘+N) and opening an existing Project (⌘+O). A *Project* is a compilation of clips, time-lines, and transitions. I describe clips, timelines, and transitions later in this chapter. You can store as many Projects as you like on your hard drive and open them whenever you want to add or change something as you build a movie.

I describe clips in the "Opening Projects and Importing Clips" section and Timelines in the "Playing and Loading Clips in the Clip Viewer" section. And you can read about transitions in the "Making Transitions" section.

When you first open the Edit and Advanced menus, they're almost com-pletely grayed out. That's because iMovie is waiting for you to begin a project by first importing clips.

The Help menu provides you general help for getting around in your iMac computer and specific help for using iMovie. Included in the Help menu is the command to run a nifty little tutorial about the making of an iMovie.

iMovie Monitor

The iMovie Monitor provides a playback of your movie as you edit it. The Monitor has a horizontal bar, called the *Playhead,* indicated by an upside down triangle and hash marks. When you play a movie, the movie appears on the Monitor and the Playhead moves to tell you where you are at in the movie.

Shelf

The Shelf is where you store clips. A c*lip* is anything you record or import into iMovie. Clips can be video, audio, video with audio, and still frames. You select clips and drag them into the Viewers to edit the clips into a movie. I explain clips and the Viewers later in "Playing and Loading Clips in the Clip Viewer" later in this chapter.

Editing buttons

Editing buttons, such as the Transitions button, and the Titles button, allow you put the finishing touches on your project. By clicking the Transitions button, for example, you are shown a bevy of ways to create beautiful and exciting changes (transitions) from one clip to the next in your movie. For instance, if you would like to make an edit in a movie where one scene slowly changes into another, click the Transitions button and select Cross Dissolve. I discuss Transitions and other editing tools later in "Making Transitions," "Making a Title," and "Adding Audio."

Viewers

The Viewers section provides two ways of seeing your clips. The Viewer with the eye (see Figure 11-1) is called the *Clip Viewer*. The Clip Viewer is where you drag your clips to include them in your movie and edit them. The Timeline Viewer (the one with the clock) is used mostly for editing audio. I discuss the Viewers later in this chapter.

Connecting the Digital Camcorder

In the lower-left corner of the Monitor area is a DV symbol, and just to its right is a blue circle inside a cylinder. On the right of the blue circle is a symbol representing film (see Figure 11-2). Together, these three symbols are the controls for switching from previewing video from your camcorder to movie clips within iMovie. If you click the DV symbol before connecting your digital camcorder to your FireWire port, a message appears saying Camera Disconnected.

It's best to connect your camcorder to the iMac with your FireWire cable before you open iMovie. By first connecting the camcorder, you're informing iMovie that you are making a movie that conforms to digital video standards.

If your camcorder is connected and turned on, you are ready to capture video as clips into iMovie.

1. **Press the DV symbol.**

 The Monitor becomes a playback controller and recorder. An Import button appears.

2. **Using the Monitor controls, shuttle your camcorder to the places where you want to import video.**

3. **When you're ready to record, click the Import button.**

4. **When you're ready to stop recording, click the Stop button.**

 Your recording turns into a clip on the Shelf.

Opening Projects and Importing Clips

I've created a little Project called "Moose Juice." If you have an iMac with iMovie, you can follow along with my example by opening the Chapter 11 subfolder in the Samples folder on the CD-ROM. To do so, select File➪ Open Project (⌘+O). The Project opens, as shown in Figure 11-2. Notice that when you open a Project, your clips are automatically loaded onto the Shelf. Each clip is a thumbnail showing the clip's first frame. At the top of each clip are numbers designating the length of the clip in seconds and frames (30 frames per second).

You can easily change the label name for a clip by clicking on the clip label and typing a new name.

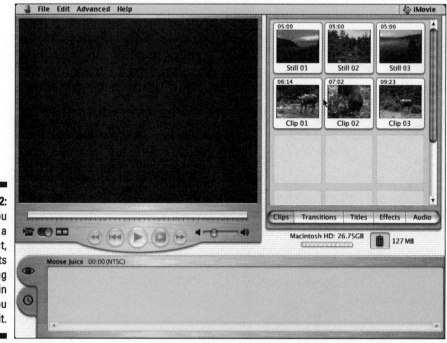

Figure 11-2:
When you open a Project, iMovie puts everything back in place as you last saved it.

To import additional clips into your project, select File⇨Import (⌘+I). If you're building a Project with digital video files, you can import Mac PICT, AIFF audio, Compuserve Gif, JPEG, Adobe Photoshop, BMP files, and DV Stream files.

Playing and Loading Clips in the Clip Viewer

After you load clips onto the Shelf, you're ready to start building a movie. To familiarize yourself with a clip, follow these steps:

1. **Select a clip by clicking it.**

 The clip appears in the Monitor.

2. **Press the controls to rewind, return to the clip beginning, play, and fast forward.**

3. **Click the button to the immediate right of the play button to make your movie full screen. When you're ready to see the editing interface again, click the mouse.**

 You can also drag the Playhead right and left to scrub the clip. *Scrubbing* is the process of manually moving the Playhead around the clip until you find a specific frame that you are looking for. In Figure 11-3, I have scrubbed Clip 02 to four seconds and 23 frames (04:23).

To get to a specific frame, try using the back and forward keyboard keys — it's a lot easier and more accurate than scrubbing.

You can read important information about a clip in the top border of the Viewer. For example, this Clip 02 is seven seconds and two frames (07:02) long and was recorded on August 9, 2000, at 8:57 a.m. MBT (Moose Breakfast Time). The numbers next to the Playhead inform you of your exact location in a movie in timecode. The horizontal bar is the Scrubber bar, which allows you to move around in your movie while you edit. The hash marks are measurements of time — similar to the hash marks on a ruler. Below the horizontal bar are a number of recording and playback controls.

To begin building a movie by putting clips into the Clip Viewer, follow these steps:

1. **Click a clip to highlight it.**

2. **Drag the clip into the Viewer area and release.**

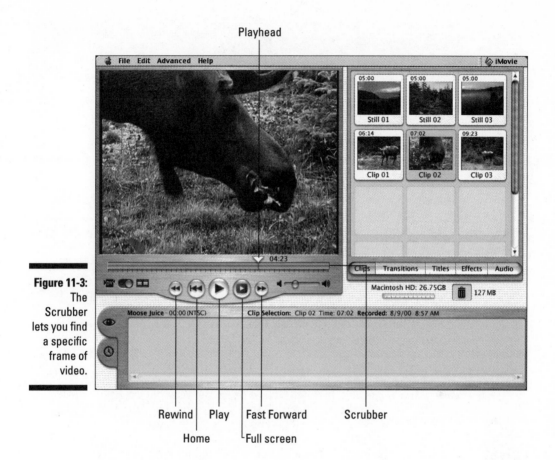

Figure 11-3:
The
Scrubber
lets you find
a specific
frame of
video.

You can drag multiple clips into the Viewer all at one time by following these steps:

1. **Hold down the Shift key and individually click each clip you want until all the clips are highlighted.**

2. **Drag them as a group into the Viewer.**

 Don't worry about the order in which they arrive. You can change the order after they are loaded into the Viewer.

After you have loaded clips into the Clip Viewer, you can rearrange them in any manner you see fit. In this example, I've arranged the clips in the following order to make a story: Still 01; Still 02; Still 03; Clip 01; Clip 02; and Clip 03 (Figure 11-4).

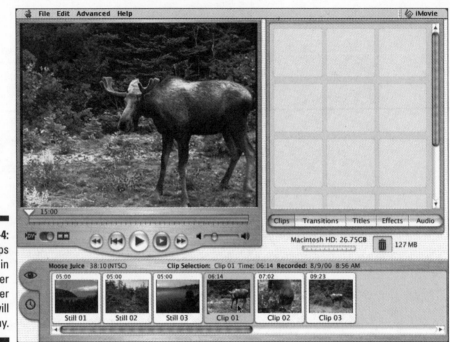

To watch a single clip, highlight it and press the Play button below the Monitor. To watch the entire movie at any time, just click the Viewer in a space where there is no clip. If no clip is highlighted, the entire movie plays.

You can also play and pause a clip or an entire movie by pressing the space-bar on your keyboard. To start from the beginning, press the Home key. Go to the end by pressing the End key.

Cropping Clips

One of the most important parts of video editing is getting rid of unnecessary video. In iMovie, you can easily shorten (crop) stills and video clips. Notice in this example that each of the stills is five seconds in length — that's because the default setting for stills duration is five seconds. These clips would probably be more enjoyable to watch if they were shorter.

To change a still's length, follow these steps:

1. **Highlight the clip by clicking it.**

2. **Change the clip's time by clicking the Time setting in the border at the top of the Viewer area.**

3. **Enter the new time in minutes, seconds, and frames. The maximum number of frames is 30.**

 In this example, I change all the stills to an even three seconds (00:03:00).

4. **Complete the time change by clicking outside the Time box or by pressing the Return key.**

You can change the default setting for stills by selecting Edit⇨Preferences. Click the Import tab if it isn't already on top. This tab lets you change the default from five seconds to any length (seconds and frames) that you wish. The new default affects any new still that you create but doesn't change existing stills.

You crop video clips in the Monitor. In this example, the close-up of the moose chewing is probably a little too long. To crop a chew or two, highlight the clip to show it in the Monitor. If you play or scrub the clip, you'll notice that the time shown next to the Playhead is the time within the movie, not the clip. In this example, a good place to crop is nineteen seconds and sixteen frames (19:16) from the beginning of the clip. The actual time of the clip appears on the border at the top of the Viewer (04:09). To crop follow these steps:

1. **Click just below the Scrubber.**

2. **Drag to the right or left.**

 In this example, drag to the left all the way to the beginning of the clip. The cropped area should look like Figure 11-5.

 You're cropping the part you want to keep — not the part you want to get rid of.

3. **After you have marked a portion of a clip for cropping, select Edit⇨Crop (⌘+K).**

 The clip crops to the length and in the frames you designated.

If you think you've made a mistake, you can undo your change by selecting Edit⇨Undo (⌘+Z).

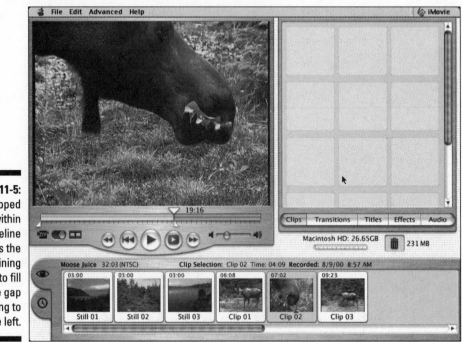

Figure 11-5:
A cropped clip within the Timeline causes the remaining clips to fill the time gap by moving to the left.

Making Transitions

Without a transition, clips simply cut from one to another. In some instances, this is exactly what you want. Other times, a transition can greatly add to the visual appeal of your movie. In this example, the cut from Clip 01 to Clip 02 makes sense: The movie is simply going from a wide shot to a close-up of the moose chewing. The beginning stills and the ending clip need some help, though; the particularly need transitions. To begin working on transitions, follow these steps:

1. **Click the Transitions button.**

 The Transitions controls appear, as shown in Figure 11-6.

 The Transitions controls are made up of three areas: Preview, Speed, and the Transitions menu. The Preview monitor shows a sample of how the transition will look. Speed sets the duration of the transition. And, you can select how you want one clip to change to another clip from the transition menu.

Figure 11-6:
iMovie gives
you a
choice of six
transitions.

2. **Select a transition.**

 In this example, select Still 01 and then select the Fade In transition. Still 01 has a duration of three seconds (03:00). A good fade in is two seconds (02:00).

 A good way to begin a movie is with a fade in, and a good way to end is with a fade out.

3. **Set the duration of the transition.**

 For instance, set the two-second duration by dragging the Speed bar to 02:00.

4. **Watch your Preview to decide if the type of transition and its duration are what you want.**

 In this example, because you've selected a clip, the Preview appears in the large Monitor.

5. **When you like the way the transition looks, drag it into the Viewer.**

 In this example, drag the Fade In transition into the Viewer to the left of Still 01.

6. **Release the mouse button.**

 When you release the mouse button, your iMac begins rendering the transition. *Rendering* is a compositing process in which the computer figures out how each successive frame should look. The rendering time is very short; you know it's done when the red line disappears from under the transition in the Viewer.

The Fade Out transition works in an identical but reverse fashion than Fade In. In this example, you try laying a two-second fade-out transition at the end of the movie. Also, try putting a Cross Dissolve between Clips 02 and 03 and a Push between Stills 02 and 03. When you're done, the Viewer should look like Figure 11-7.

Figure 11-7:
Transitions
don't add
time to a
movie
because
they use
existing
frames.

Making a Title

Titles are used to introduce a movie, add credits to the end, or to identify
things in the middle. iMovie provides a pretty snazzy titling feature. Here's an
example of how to use the Titles function:

1. **Click the Titles button.**

 The Title menu provides you with a Preview monitor, Speed and Pause
 controls, a Title menu, font selector, font sizing, and the place to type
 the title (Figure 11-8).

2. **Choose a transition type.**

 In this example, Centered Title probably works best.

3. **Set a speed for the title. Speed is the time you choose for the transi-
 tion to take place.**

 In this example, you're creating a movie title. Try setting the Speed to
 02:00. Some transitions have a Pause option. Pause is how long the tran-
 sition will remain on the screen. In this example, try using a pause of
 01:00.

Title Menu

Preview

Speed and Pause
controls

Figure 11-8:
iMovie
provides
extensive
titling
options.

Font selector

Text box

4. **Choose a font and font size.**

This example shows Times New Roman.

5. **Type in the text.**

You can type any text that you want. In this example, the text is
"Moments with a Moose" in the first line and "Cape Breton, Nova Scotia"
in the second line.

6. **When you're done preparing and previewing, drag the transition to
the clip where you want to place it.**

In this example, try dragging and placing the transition at the beginning
of the movie.

Adding Audio

You may want to add some interesting audio to your movie. Fortunately, iMovie gives you an assortment of sound effects. Click the Audio button and you'll see a selection of sound effects. Plus, if you have an external mic, you can record your own voice or other external audio (such as moose calls).

Modifying audio in your movie requires you to switch to the Timeline Viewer (the one with the clock). One of the tricks you may want to try is making your audio repeat throughout the video. In the case of the moose video on this book's CD-ROM, the cricket sound effect (provided by iMovie) can be repeated over and over to help the viewers feel as if they are "out in the field" with the moose. To use sound effects, follow these steps:

1. **Drag a sound effect to the approximate place where you want it to begin.**

 In this example, a good place to start is where the moose first appears. You can move a sound effect around by clicking and dragging its left barbell.

2. **Drag additional sound effects onto a soundtrack until you have covered the area where you want to have sound.**

 In this example, try putting cricket sounds over the entire visit by the moose.

3. **Modify the sound effect's volume by clicking the left dumbbell and then sliding the audio volume slider to the left or the right.**

 In this example, try setting the same volume for all three audio clips.

4. **Set fade in and fade out as needed.**

 In this example, you probably would need to click the Fade In check box for the first audio clip and the Fade Out check box for the last audio clip. When you're done, the audio track appears as in Figure 11-9.

Making a Movie for Distribution

After you save your project, you're ready to make a movie and distribute it. iMovie provides you a wide variety of formats — from broadcast-quality digital video to small, easy-to-send e-mail.

Make a movie from a project you have been working on by selecting File➪Export Movie (cmd+E). When you make this selection, you immediately hit a crossroads. Do you want to send your movie back out to your camcorder as a fully edited video movie? Or do you want to make a QuickTime file? If you select Camera, iMovie takes you through a simple procedure for laying your movie on digital camcorder tape.

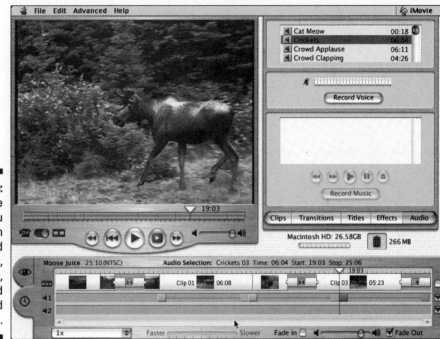

Figure 11-9:
iMovie
allows you
to lay in
sound
effects,
narration,
and
recorded
music.

If you select the QuickTime export option, you're offered a wide array of possibilities for saving the movie on your hard drive. You can make a video for attaching to e-mail, Web distribution, CD-ROM distribution, and a full-sized television copy (watch out, these files can be huge!). Choose an option based on the distribution method you plan to use.

The great thing about a program such as iMovie is that you can do all of the above. After you've saved your project you can export it in as many ways as you would like. Chapter 14 tells you about all your movie distribution options and how to perform them.

Part IV
Jazzing Up Your Video with Photos

The 5th Wave By Rich Tennant

"I found these two in the multimedia lab morphing faculty members into farm animals."

In this part . . .

This part shows you how to add some nice touches to your video using Adobe Photoshop. Adding still photos to your videos makes them more dynamic and interesting; this section is perfect for the budding videographer. This section also goes into detail on how to export your movies to the Web and through e-mail. Don't you just love technology?

Chapter 12

Manipulating Digital Photos with Film Factory

Digital camcorders are great for making still photos. You probably use your digital camcorder a lot for shooting video, but most digital camcorders can also be used to take still photos. (Check the documentation for your camcorder to figure out if and how you can shoot still photos.) When you are editing video on your computer with Premiere, Movie Maker, or iMovie, you can also snap digital still photos of video that you have imported. Digital photos can be stunningly beautiful — both in clarity and texture. Many of my digital photos have been framed by my friends and hung on their living room walls or have appeared on their Web pages.

Digital camcorders are so good at making still photos that they can create a problem: Where do you store all those wonderful photos? Printed photos piled in a box are cumbersome to sort through. Photos that are spread all over your computer can become an unmanageable mess.

In this chapter, I introduce you to a nifty little program called Epson Software Film Factory that is available for both Macs and PCs. Film Factory is an unpretentious application that helps you touch up photos, organize your photos into electronic albums, and export your photos to print or send as e-mail attachments. Put on your working clothes; we're headed for the factory.

You must have the Film Factory Trial Version installed on your computer to do many of the things that I describe in this chapter. For information on installing Film Factory from the CD-ROM that comes with this book, turn to Appendix A.

Opening Film Factory

Epson Software Film Factory included on this book's CD-ROM is a fully operational 30-day free trial version. When you open Film Factory, you see a selection screen (Figure 12-1). Click the Try button to begin the program. Later on, if you like Film Factory, you can buy it by clicking the Buy button and following the directions. You can also download a copy of Film Factory from Epson's Web site at `www.epson.com/cgi_bin/Store/Redirect.jsp?link=esff`.

Introducing the interface

When you open Film Factory, you'll notice its "factory" atmosphere. (See Figure 12-2.) The application interface is ready to work and waiting for you to guide the operation. At first, the screen may even seem a little intimidating — as if it's a little impatient to get the job done.

Figure 12-1: Film Factory enables you to edit photographs used in your digital video projects.

Print wizards

The left side of the screen is populated with a column of print-related wizards. Each of the wizards provides a series of steps to help you make standard prints, index photos, multiple prints, a photo album, greeting cards, and stickers. Read more about print wizards later in the "Using the Print Wizards" section.

Photo roll

Between the Print Options and the *thumbnails,* which are small representations of photos, is something that looks like a roll of film, called a *roll*. This may seem a little cutesy, but it's definitely forgivable considering the quality of this program. A roll is a term used in Film Factory to refer to a virtual grouping of photos. To carry the roll metaphor one step further, you put a bunch of rolls . . . you guessed it — in a case. A drop-down list box resembling a carrying case appears in the lower-left corner of the screen. I further investigate rolls and cases in the "Making a Case" section.

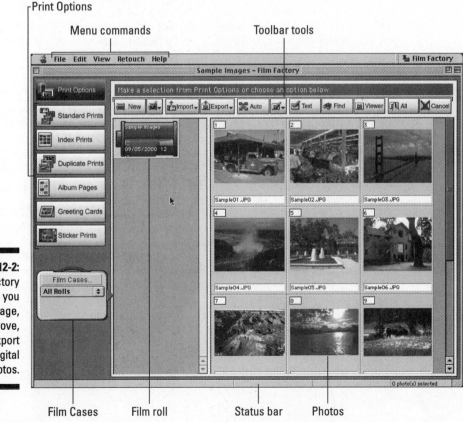

Figure 12-2:
Film Factory
helps you
manage,
improve,
and export
digital
photos.

Toolbar tools

Directly above the photos is a series of buttons. Film Factory calls these buttons toolbar tools. *Toolbar tools* are a series of options for

- Making and editing a roll
- Adding photos to a roll
- Deleting photos from a roll
- Tweaking individual and groups of photos within a roll

If you move your cursor over a toolbar tool and click and hold down the mouse button, the status bar explains the functions of the tool.

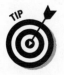

By dragging the pointer away before releasing your mouse, you avoid opening the toolbar tool.

Status bar

At the bottom of the screen is a *status bar.* The status bar is sort of a chameleon — it changes its function based upon what you are doing or about to do. For instance, if you hover your mouse over a photo, the status bar tells you the size of your actual photo in kilobytes, the size of your photo in pixels, and the day and date.

Menu commands

At the very top of the screen are the Menu commands. The File menu contains commands that (for the most part) can be performed by clicking toolbar tools — with one notable exception: *Preferences*. The Preferences command, which I explain later in the "Setting preferences" section, is important for maintaining your sanity. The Edit menu contains commands that you may more easily perform by selecting toolbar tools.

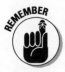

The View menu (Figure 12-3) has some important commands not found in the toolbar tools. For instance, by clicking Status Bar, Photo Number, View Filename, and View Comment, you activate the toolbar in the editing window, or you can select the toolbar again and hide it from view. I often hide some of the toolbars when I need more room to edit the photograph. For instance, selecting Status Bar turns on the status bar at the bottom of the interface. Selecting it again turns the status bar off. Selecting Sort Rolls and Sort Photos gives you a choice of the order in which you can sort your roll or photos. You can sort your photos by their name or by the date you imported them into the program.

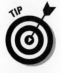

As you work within Film Factory, you'll find that occasionally you need to select Refresh Screen [F5] (Mac: ⌘ + R) to update the screen with your latest changes.

Figure 12-3:
The <u>V</u>iew
menu
provides
commands
for showing
or hiding
and resizing
information
and photos.

Setting preferences

One of the more important features offered by Film Factory is that the program allows the user to customize the preferences. Film Factory allows you to choose between four kinds of preferences: General, Image, Mail, and Import. To set General, Image, and Mail preferences, select <u>F</u>ile⇨<u>P</u>references. The Preferences dialog box appears (Figure 12-4).

The preferences you can set are as follows:

✔ **General.** This tab contains default folder selection boxes. These boxes permit you to choose where film rolls, thumbnails, album pages, greeting cards, and sticker print files will be stored. This tab is important when you want to use Film Factory on another computer and makes it possible for you to copy your project folders and retain the original structure no matter where you move it.

✔ **Image Calibration.** This tab walks you through the process of balancing the appearance of the photos on the monitor with the appearance of printed photos. This is an important process because it keeps you from worrying about whether a bright image on the monitor will be equally bright when printed. (Not to mention that it can save ink and paper.)

Images on a monitor are backlit by a consistent light source. Printed images are lit by whatever light source you happen to be in. Though your calibration may be accurate, you may still find that your photos don't appear the same as they did before you printed them. Practice and a little patience will help you optimize settings for your printer and personal preferences. After you have printed a few images, you'll have the settings the way you want them.

✔ **Mail.** This tab allows you to specify which e-mail program you would like to use for sending photo attachments to e-mail.

✔ **Import.** To import a picture from a scanner or another TWAIN-compliant device (*TWAIN*, which is not an acronym for anything, is the most common type of scanner interface that helps it work with your computer), you must set your import preferences. To set Import preferences, you need to close the Preferences dialog box, select the Import button on the toolbar, and set import file options.

Figure 12-4:
Folder
preferences
help you
have better
organization
and control
of your
projects.

Digitizing Old Photos

Film Factory gets two thumbs up for its ability to manage your boxes of old photos. But before you can manage your photos, you first need to digitize them. You can digitize your photos in three ways:

✔ **Scan them yourself.** The best and most direct way to get old photos into your computer is to scan the photos yourself. Good digital scanners are relatively cheap these days — less than a hundred dollars gets you a perfectly acceptable flatbed scanner.

Before you buy, you may want to get some advice from the experts at your computer store about whether or not your computer can handle a scanner and how complicated it is to install it. Computers manufactured in the past couple of years have USB ports that make hookup painless. Computers that are more than about three years old usually don't have USB ports, meaning that you'll have to connect a scanner to a SCSI or parallel port (but if your computer is that old, it probably won't work with digital video very well, either). Scanners are very handy, but you may decide that you can afford to live without one.

✔ **Pay someone else.** Take your photos to a photo store and pay to have them put onto a CD-ROM. This approach often becomes more expensive than owning your own scanner.

✔ **Reshoot with your digital camcorder.** If you already own a digital camcorder, you've got all you need to do the job. Using your camcorder's LCD viewfinder, white balance, zoom, and focus controls, you can quickly shoot digital copies of your photos. This takes a little practice, and the image quality doesn't match what you can produce from a scanner, but you might find the procedure to be a workable alternative to a scanner.

Owning a tripod can be very helpful when shooting still photos, but it's not absolutely necessary. I also recommend that you put your camcorder on a flat surface, such as your kitchen or dining room table. To enhance the appearance of the photos, use a piece of black poster board as a background for your photos. The black background is important. If you use a white or other light-colored background, you're bound to have your camcorder compensate for the background with its iris (see Chapter 3 for using your camcorder's iris). The camcorder averages your light background with the image — causing your photo to have poor contrast quality.

Creating Rolls

You begin using Film Factory when you put images on a roll of film. In the vernacular of Film Factory, a film roll is equivalent to a folder or a bin in other programs. In order to put images on a roll, you have to first create the roll. You can make an empty roll before importing photos, and you can make one for storing existing photos.

To make a new roll for your future photos follow these steps:

1. **Click the New button on the toolbar.**

 The New Roll dialog box appears (Figure 12-5).

2. **Type the name you want to call your roll in the Name text box.**

 In my example, I'm typing in the words Graduation Photos. The name of the roll is limited to 34 characters, but a name that long would look silly anyway. Some special characters that you can't use include / : \ * ? < > | .

3. **Enter a date related to the images in the roll.**

 You can also use the default computer date or any date that you choose. In my example, I typed the date of the graduation.

4. **Add comments.**

 Comments are helpful when you have lots of photos. You can use comments to help you search for a particular roll or photo. I've added more about how you can add comments to photos already in your roll later in the "Working with Thumbnails" section.

5. **Press the Add button.**

 The new roll appears above or below existing rolls based on alphabetical order. The roll displays its name and the date that you selected. If you click the new roll, the photos on the screen disappear. The pictures aren't deleted; they are merely hidden. By clicking the new roll, you're telling Film Factory that you want to see the new roll's contents. Because you haven't put any photos into the roll yet, the photo area is blank.

To create a roll for existing photos, you

1. **Click the New button on the toolbar.**

2. **Click the Use Existing Folder check box.**

3. **Click Browse to find the folder of photos on your hard drive or other storage media that you want to import into your new roll.**

 If you want to use a sample folder to practice importing, select the Chapter 12 folder in the Practice files from the CD-ROM that came with this book. (The Chapter 12 folder contains all the examples in this chapter.)

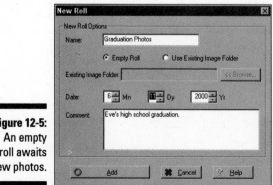

Figure 12-5:
An empty
roll awaits
new photos.

4. **Click the Add button.**

 The new roll is added to the interface.

5. **Click on the new roll.**

 The photos appear (Figure 12-6).

Organizing Rolls

Film Factory comes alive after you have imported the contents of a folder into a roll. You are ready to manage your photos. If you're like me, you've got a box or two of photos in a closet somewhere in your house. The photos are precious to you, but they're also a pain because you have trouble establishing order, keeping order, and changing the order of the photos after you have established it. Film Factory allows you to share copies of your photos between rolls easily without the fear that these precious keepsakes may be damaged or lost. Photos can easily be moved from roll to roll, or you can copy a photo so that it appears in several different rolls.

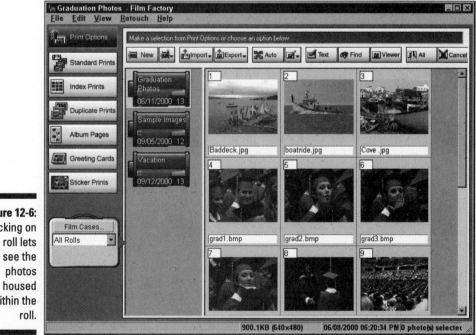

Figure 12-6: Clicking on a roll lets you see the photos housed within the roll.

Moving photos

One of the most useful things that you can do in Film Factory is shuffle your photos from one roll to another — a simple procedure to perform. Film Factory offers you the option of moving or copying photos. To move a photo, follow these steps:

1. **Click on the photo or photos that you want to move or copy.**

 You can select multiple photos by clicking on the first photo, holding down your shift key, and clicking on the last photo. Film Factory highlights all intervening rows of photos.

2. **Select Edit⇨Move/Copy Photo.**

 The Move/Copy Photo dialog box appears, as shown in Figure 12-7.

3. **Click Browse and indicate where you want to place the photographs.**

4. **Click either Move (to remove the file from the current roll and place in the file folder) or Copy (to duplicate the image in the file location).**

5. **Click the Move/Copy button.**

Figure 12-7:
Put your highlighted photos in a new folder to move them to a new roll.

Move/Copy Photo
Destination
Folder: 🗀 << Browse...
● Move ○ Copy
Move/Copy ✖ Cancel ？ Help

Copying photos

In Film Factory, copying photos is a little easier than moving them. To copy a photo or photos to another roll, simply

1. **Highlight the photos you want to copy.**

2. **Drag the photos to the other roll.**

Deleting photos

Deleting a photo from a roll is a little scary. Be aware that when you hit the Delete key and click the Yes button to the question about really wanting to delete the photo, you are deleting the photo from your computer without a chance of changing your mind. So, delete cautiously.

Working with Thumbnails

Those pictures that you've been looking at on-screen are thumbnail versions of the actual photos, which are stored on your hard drive or another disk drive. Thumbnails allow you to identify each photo with unique names, and they give you a graphical way of seeing how Film Factory is managing your photos.

Sorting thumbnails

Each thumbnail within a roll has a number in its upper-left corner. Don't be misled by this number. It is not a permanent assignment to a particular photo. The number designates the order that your thumbnails currently happen to be in at the moment. The permanent identification of the photo is its file name.

You can change the order of the thumbnails. To do so, select View⇨Sort Photos. You can sort your photos by name or by date.

Adding comments to thumbnails

You can add a comment to an individual thumbnail or any number of thumbnails within a roll. These comments stay with the thumbnail and offer a good way to store important information about each picture. To add a comment to a picture:

1. **Click on the thumbnail that you wish to add comments to.**

 Or highlight any number of thumbnails.

2. **Click the text button on the toolbar.**

 The Change Photo Comments/Dates dialog box appears.

3. **Type any comment you want.**

 You can also change the date and time designation for the photo at this time.

4. **Click the Make Edit button.**

 If you highlight more than one photo, the dialog box shows the next highlighted thumbnail. By clicking the appropriate button, you can put new information or dates into the dialog box, copy the previous comment, or skip to another highlighted photo.

Utilizing Cases

Film Factory is great for managing large quantities of photos. But what happens when you start accumulating large quantities of rolls? Simple. You put them into manageable larger containers called *cases*. You can have as many cases as you want.

You can even put the same roll into multiple cases. This can be handy when you have a favorite photo that you want to distribute to a group of people. You can assign a case to each person and put whatever combination of photos that you want in each case. When you put the same roll in different cases, Film Factory creates shortcuts to the photos on your hard drive, eliminating the waste of storage space. After you make a case, you can select it from the drop-down list to bring out the rolls you want to view.

Creating a case

When you create a case and assign rolls to it, the film carrying case adds your new case to its drop-down list. To create a case:

1. **Click Film Cases in the lower-left corner of the screen.**

 The Film Cases dialog box appears (Figure 12-8).

2. **Click the Add Case button.**

 The Add Film Case dialog box appears.

3. **Type a name for your case and click OK.**

 Your new case is added to the Film Cases list.

4. **In the Rolls of Film column, click on the rolls you want to add to the new case.**

5. **When you're satisfied with your selection, click the Close button.**

 Your new case is added to the list of other cases that may be selected and displayed.

Figure 12-8:
Film cases
hold any
number of
film rolls.

Deleting a Case

Film Factory allows you to get rid of film cases just as easily as you can create them. When a case is empty and no longer needed, you can easily delete it. If you ever want to delete a case, perform the following:

1. **Open the Film Case's dialog box.**
2. **Highlight the case you want to remove.**
3. **Click the Delete Case button.**

 The case is deleted, but your rolls and their photos will remain.

Retouching Photos

Film Factory offers an advanced system for retouching your photos. Film Factory makes numerous modifications to your printable image without changing the original photograph by putting all of your photo enhancements into a database system. The value of this database system is that you can tweak a photo any way that you want while still maintaining your original photo. This is helpful when you find that you have made a photo too bright, trimmed too much, or added too much color. Film Factory offers two ways to retouch photos — automatically and manually.

Retouching photos automatically

A quick way to enhance your photos is to use the Automatic retouching tool. Automatic retouching changes your photo's color balance, hue, saturation, sharpness, and focus. The nice thing about the feature is that it lets you see

what your change will look like and offers you a good improvement to your photo. The bad thing is that it often doesn't work as well as retouching your photo manually. To use Auto retouching, follow these steps:

1. **Highlight the photo or photos you want to retouch.**

 Don't worry about not liking the way the photo will look; you have the option to decline retouching after you see the result.

2. **Click the Auto button.**

 The Auto Retouch with PhotoFair dialog box appears, as shown in Figure 12-9. The Auto Retouch system shows your original photo and what Film Factory suggests to improve your photo.

3. **If you like Film Factory's suggestion, highlight the retouched photo, or leave the original image highlighted, if you prefer.**

4. **If you chose the retouched photo, click the Overwrite Original Image check box.**

 The Auto Retouch setting is applied to the original photo on your hard drive. If you leave the box unchecked, your retouch settings are stored in the database record for that photo without making changes to the original photo.

5. **If you kept the retouched photo, click the Make Changes button. If you kept the original photo, click Cancel to exit the Automatic Retouch tool.**

You can change the automatic settings for the Auto Retouch tool by selecting Retouch⇨Auto Retouch Settings on the Menu bar. The Auto Retouch Settings dialog box allows you to increase, decrease, or turn off automatic settings for color balance, hue, saturation, and sharpness and noise. The new settings are saved by Auto Retouch and are used until you change them again.

Retouching photos manually

Film Factory offers a bevy of manual retouching tools. These features allow you to manually change brightness, trim your photo, change your color photo to black and white or *sepia* (brown, old-looking prints), soften focus, and correct red eye.

Manually changing brightness

To change a photo's brightness or contrast using the Manual Retouch dialog box, follow these steps:

1. **Highlight the photo and select Retouch⇨Manual Retouch on the Menu bar.**

 The Manual Retouch dialog box appears (Figure 12-10).

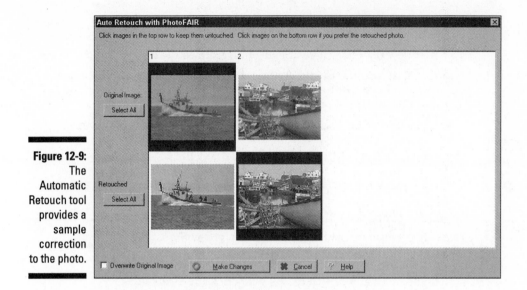

Figure 12-9:
The
Automatic
Retouch tool
provides a
sample
correction
to the photo.

2. **Press the Brightness tab.**

You are shown a choice of nine versions of your photo. The center photo is your current selection. The other photos represent different levels of contrast and brightness that are available.

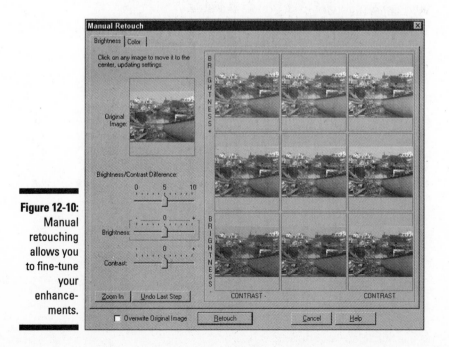

Figure 12-10:
Manual
retouching
allows you
to fine-tune
your
enhance-
ments.

3. **If one of the nine photos is closer to your desired brightness or contrast, click on that particular version.**

 Your new selection (if you made one) assumes the center photo position.

4. **To adjust brightness and contrast together or to individually adjust brightness or contrast, select the appropriate slider on the left and move accordingly to increase or decrease each item.**

5. **If you don't like your decision, click the Undo Last Step button.**

The Undo Last Step button works only on what you see in the Manual Retouch dialog box. After you click the Retouch button to commit the changes, you cannot reopen the Manual Retouch dialog and try to undo your last action.

Manually changing color

To easily perform manual color changes to your photos, perform the following steps:

1. **In the Manual Retouch dialog box, click the Color tab.**

 The manual color options appear. The photo in the middle represents what your photo will look like with the color change.

2. **Click photos around the middle photo to make your color selection.**

 The photo you click becomes your selection.

3. **Select the appropriate slider on the left and move accordingly to increase or decrease red, green, and blue.**

4. **Click the Retouch or Cancel button when you are done.**

Removing red eye

Film Factory makes it easy to remove nasty old red eye from a photo. To fix red eye, do the following:

1. **On the Menu bar, highlight the photo and select Retouch⇨ Manual Retouch⇨Red Eye Correction.**

 The Red Eye Correction dialog box appears.

2. **Using the Zoom slider, magnify the photo until you can easily see the details of the subjects' eyes.**

 After magnifying the photo, use the horizontal and vertical scroll bars on the bottom and side of the photo to center the eye.

3. **Click and drag your mouse to create an oval that's equal to the red eye area.**

 After you have created the oval, you can resize it or move it by dragging the dumbbells on the sides of the ellipse.

4. **Using the Brightness and Hue sliders, adjust the ellipse until the red eye is sufficiently reduced.**

Taking the red eye

When talking about photographs, the term *red eye* has nothing to do with taking late-night airline flights. Red eye occurs when using a still camera's flash unit to photograph people in a dimly lit area. In this dim environment, a human's iris is dilated to take in more light, similar to the iris in the camera's lens. When the photographer snaps the picture, the flash from the camera causes a reflection in the large, dilated pupil of people looking towards the flash. This reflection shows up as an ugly red dot in the pupil of everyone in the picture.

Many newer, more advanced cameras have a red eye reduction feature that briefly strobes the flash, causing those wide-open pupils to contract slightly before the actual picture is taken. As the name implies, red eye reduction only reduces red eye; it can't eliminate red eye completely. But it can reduce red eye considerably, lessening the amount of editing you have to do after the photo is imported into Film Factory. Of course, if the people in your photos just got off the 4:00 a.m. flight from Vegas, the redness in their eyes may have nothing to do with tricky reflections, and Film Factory may not be able to reduce the red eye effect either.

Making other manual changes

Film Factory offers a similar manual process for rotating and trimming your photos, changing your photos to black and white or sepia, and changing focus. Each of these manual changes is easy to perform. In each case Film Factory shows you a *before* and *after* version of the photo. You merely need to approve or reject the manual change.

Using the Print Wizards

Film Factory offers step-by-step print wizards to help you in the photo printing process. The wizards help you make standard prints, index prints (small versions of prints), duplicate prints, album pages, and greeting cards. Though each of the wizards is for a unique purpose, they all work in basically the same manner. To begin:

1. **Click a Print Options wizard.**

 In this example, I selected the Duplicate Prints wizard. The term Print Options is replaced by the name of the wizard you selected. Below the wizard name are steps. Above the photo area, wizard-related buttons replace the toolbar tools.

2. **Click either 1 Copy of each or 0 Deselect All.**

 Clicking 1 Copy of each begins the process by highlighting each photo. Clicking 0 Deselect All allows you to individually select a photo or photos.

3. **Click on a photo that you want to edit.**

 When you click a photo, a plus or minus selector allows you to increase how many copies you want to make of that photo.

4. **When you're satisfied with your choices, click the Next Step button above the photos or press the next step below the currently high-lighted step on the left.**

 In the Duplicate Prints wizard, the next step opens the Print Preview, layout, and print options. You can determine how many pages you would like, position the photos on the page, and see a close-up preview of your prints before sending them to the printer. The wizard you choose is slightly different for each of those functions, but they all are straightforward from here on out.

5. **When you are ready, either click the Print button or click the Print Options button to cancel the wizard.**

Print quality is affected by the quality of your photo and its resolution. The higher the resolution, the more pixels per inch in your photo (the more detail). Print quality is a direct result of the quality of your printer and the paper you use for printing. Fortunately, high-quality color printers are not as expensive as they used to be (starting around $150). You can print professional-quality photos using an ink-jet printer on glossy paper — yielding prints that approach professional photo development.

Chapter 13

Adding Graphics to Video with Adobe Photoshop

*W*hen you make a video, you can easily lose your audience by ineffective use of images and sound. Although you may think that constantly moving, quick-action video is the best way to keep your audience's attention, it's not always true. Sometimes, your viewer needs to dwell on a picture or text to internalize the significance of a message. Sometimes, nothing gets the job done better than a well-developed graphic image.

In this chapter, I help you figure out how to create graphics and text for video using Adobe Photoshop. You also see how to add still graphics to a video in Adobe Premiere. If you want to add graphics to a Movie Maker video or iMovie video, you are out of luck because neither Movie Maker nor iMovie allows you to insert graphics.

Windows Movie Maker and iMovie do not allow you to add still graphics over actual video clips. However, they do allow you to add still graphics clips to your movies. In fact, you could create a "movie" consisting of nothing but still graphics, which would have the effect of a slide show. Even if you use Movie Maker or iMovie, the information in this chapter may still be useful.

Introducing Adobe Photoshop

Adobe Photoshop is an image-editing program used to change existing images or create new ones. Adobe Photoshop is a great tool for creating or editing still graphics that you can use in a video editing program such as Adobe Premiere, Windows Movie Maker, or iMovie.

When you open Photoshop, you see the Adobe Photoshop title bar at the top of the window, as shown in Figure 13-1. The main menu is under the title bar, and the toolbox is at the far left. At the right are four palettes — Navigator\Info\Options, Colors\Swatches\Brushes, History\Actions, and Layers\Channels\ Paths. I discuss the functions of many of these palettes throughout the chapter.

You can move the toolbox around by clicking the top border and dragging it. In addition to dragging, you can also minimize or close any of the palettes by clicking the maximize/minimize or close buttons in upper corners of the palettes. You can also hide palettes by selecting Window⊅Hide in the Menu bar.

Toolbox Title bar Menu bar Palettes

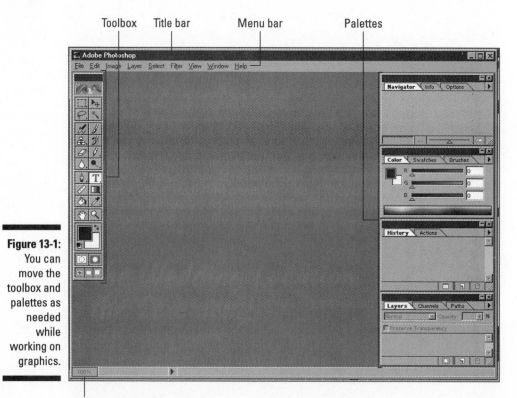

Figure 13-1:
You can move the toolbox and palettes as needed while working on graphics.

Zoom percentage box

Which version of Photoshop is right for you?

The full version of Adobe Photoshop 6 is a remarkable program; when it comes to working with graphics there is little it can't do. But all of Photoshop's amazing capabilities come at a price: $609 is the price for the full version, although discounts are available to registered owners of previous versions. If you're a graphics professional, you need this program. But if all you want to do is retouch and resize graphics and convert them into different formats, $609 may be more than you're willing to spend.

Fortunately, Adobe offers a more affordable alternative. Photoshop LE (Limited Edition) offers all the capabilities that I describe in this chapter and costs just $95. If you're just getting started with graphics editing, I suggest that you start with this more affordable alternative. You can always upgrade to the full version later, and then you will qualify for the substantial upgrade discount.

Perfecting Images

Though you can create graphics from scratch using Adobe Photoshop, the program's greatest strength is improving existing photos. This feature is important because inevitably you will want to include some still graphics in your video projects, such as historical photographs of your subjects, wedding portraits, or title screens that give credit to people involved in the movie. Photoshop's graphics capabilities are seemingly endless, but here are just a few of the things you can do to improve your photos:

- ✔ Import and export a large variety of graphic files (such as BMP, PICT, TIF, TGA, GIF, JPEG and others)

- ✔ Resize or crop images to best fit your needs (such as changing the shape or orientation of a graphic so that it is the same size and shape as the rest of your video)

- ✔ Use simple, yet powerful tools to enhance or repair images (such as faded colors or red eye)

- ✔ Create beautiful image text for titles and add effects to the text such as 3-D shading

- ✔ Add filters to your image for special effects

The two most common editing tasks you will do in Photoshop are touching up imperfect photos and resizing them to fit in video.

Photoshop restricts each file to its own window, which enables you to make changes to an image without affecting the others.

Fixing imperfections on your photos

Photoshop is a great tool for cleaning up imperfections in photos. Two handy tools for removing nasty imperfections are the Zoom and Rubber Stamp tools. (Adobe *has* to come up with more romantic-sounding names.) Figure 13-2 reveals the basic Photoshop interface.

If you want to follow along but don't have any photos of your own to edit, check out the sample files in the Chap13 folder on this book's CD-ROM.

You can fix an imperfection by applying color and brightness using the Photoshop Rubber Stamp tool. The Rubber Stamp tool helps you match the blend of colors near the imperfection you want to edit. This skin doctoring is a total cure — not a bandage. Just follow these steps:

1. **After opening the image that you want to edit, zoom in on the area that needs work by using the Zoom tool from the toolbox until you reach the level of magnification you need.**

2. **Click the Rubber Stamp tool in the toolbox (fourth row, left column).**

 You can tell which tool you're picking by holding your mouse over a tool without clicking. After a moment, a text box appears telling you the name of the tool.

Figure 13-2:
The magnification reveals a grid of individual picture elements (pixels), each with its own color and level of brightness.

As you pass the cursor over the image, its shape becomes a rubber stamp. Before you use the Rubber Stamp tool, you need to select the right brush size for your work. For small imperfections, such as this scratch, you need a small brush.

3. **Click the Brushes tab in the Colors\Swatches\Brushes palette on the right.**

 A selection of brush sizes appears (see Figure 13-3).

4. **Click the appropriate brush size.**

 In this example, the brush in the top row, third from the left, is probably the best one. The brush you select directly affects the size of the cursor's action.

Figure 13-3: Various brush sizes are available for your painting needs.

5. **Position the cursor over the area you want to use to mask the imperfection.**

6. **Press and hold down the Alt key while clicking and releasing your mouse.**

 Like a rubber stamp, you have just picked up the ink you want to use.

7. **Position the cursor over the imperfection and click your mouse to deposit color and shading.**

8. **Zoom out by clicking the zoom percentage box (refer to Figure 13-1), and type 50 in the box, then press Enter or the Ctrl key and the – sign.**

 The photo returns to 50 percent of the full image. The scratch is gone. Nice job, Doctor.

Cropping images

Photoshop enables you to isolate parts of photos — someone's face, for example. Use the Crop tool to perform this trick.

Another important use of the Crop tool is making pictures fit on the video screen. Televisions and computer monitors have a 4:3 aspect ratio, meaning that the size of the screen is four units wide and three high. In other words, if you have a graphic that is exactly 800 x 600 pixels, or 640 x 480 pixels, it fits perfectly in with your video. But if the graphic is, say, 800 x 500 pixels, you end up with black space at the top and bottom of the screen because the graphic does not have a 4:3 aspect ratio. The cropping tool helps you trim down pictures so that they conform to the 4:3 ratio. For more on sizing pictures for video, see the section "Preparing Images to Fit into Video," later in this chapter.

If you want, you can grab and drag the photo to the middle of the screen by clicking, holding, and dragging in the photo's blue title bar.

To crop a picture, follow these steps:

1. **Open the file that you want to edit.**

 Select colo2.tif if you need an image for practice. Notice that the file has some white at the bottom of the photo. Nasty little problem, huh? This is a job for the Crop tool.

2. **Select the tiny down arrow located in the bottom-right corner of the Rectangular Marquee tool (first row, left column of the toolbox).**

 A selection of tools appears.

3. **Drag the cursor to the right to the Crop tool; release your mouse to select it.**

 The toolbox now reveals the Crop tool, replacing the Rectangular Marquee tool, as shown in Figure 13-4.

Figure 13-4:
Adobe
Photoshop
removes
unwanted
portions
from a
photo.

4. **Starting in any corner of the photo, click and hold down your mouse. Drag the mouse to create a rectangle.**

 It doesn't matter where you draw it.

5. **Release the mouse to reveal a dotted rectangle.**

6. **Click and drag the nodes (little boxes) of the rectangle to increase the rectangle size to select only the part of the image that you want to keep.**

 In this example, drag the box to the edge of the white area in the graphics file.

7. **Press Enter.**

 The new area excludes the extraneous white.

Not happy with the crop you made? You can undo it by selecting Undo on the Edit menu. You can also select the last action in the Actions palette and click the trash can button at the bottom of the palette to undo that action.

If you save your image file after making a crop, the parts of the picture you cropped out will be lost forever. To be on the safe side, choose File⇨Save As and give your cropped image a new file name. That way, the original copy of the photo remains unchanged for future use.

Adjusting images

Photoshop seems to have endless features. Even so, some of them are used more often than others. Two bread-and-butter features offered by Photoshop are rotating canvas and color and brightness correction.

Reversing an image

Sometimes, although your photo is great, your subject might be looking in the wrong direction. Suppose that you have a video you want to add a picture to — your child looking to the right, for example. In the photo that you want to use, however, he or she is looking to the left. No problem. In Photoshop, you can flip the image using the rotating canvas feature. To reverse an image, select Image⇨Rotate Canvas⇨Flip Horizontal. That's all!

You won't, however, be able to reverse an image containing numbers or letters because they will appear backwards.

Adjusting hue

Sometimes, a photo is fine by itself, but when compared to other photos in the group, it has a different hue (a balance of colors). For example, if have a great father-and-son shot, but it has too much red to blend well with the other photos, you need to tone it down just a little:

1. **To correct the hue, select Image⇨Adjust⇨Selective Color.**

 The Selective Color dialog box appears (see Figure 13-5). You adjust the colors in this dialog box to shift the hue of a picture.

2. **Slide the color sliders to the right or left until you achieve your desired color correction.**

 This alteration causes magenta shades to tone down just a bit.

 If the Preview box is checked, you're able to view the changes as you make adjustments.

3. **After you are satisfied with your improvements, click OK.**

 If you're unhappy with your changes, click Cancel to reject them all.

Figure 13-5:
If you move the magenta scale, the color saturation increases or decreases.

Selective Color	☒
Colors: ■ Reds ▾	OK
Cyan: 0 %	Cancel
Magenta: -20 %	Load...
Yellow: 0 %	Save...
Black: 0 %	☑ Preview
Method: ⦿ Relative ○ Absolute	

Adjusting brightness

Getting just the right degree of brightness and contrast are common challenges in video. Photoshop provides a way of making adjustments to brightness, contrast, or both.

1. **Open the file in which you want to adjust the brightness and contrast.**

 In this example, colo4.tif needs a little work. To select the photo, select Window⇨colo4.tif in the main menu. As you can see, the man in the photo is slightly muddy. He needs to be lightened up a little.

2. **Select Image⇨Adjust⇨Brightness\Contrast.**

 The Brightness\Contrast palette appears.

3. **Slide the Brightness and Contrast bars to make adjustments.**

 In this example, I suggest you slide the brightness to the right to +25. You can see the difference this change makes in the preview box.

4. **When you're satisfied with how your photo's brightness and contrast look, click OK.**

Preparing Images to Fit into Video

Photoshop enables you to make graphics from scratch or to combine existing images. In this section, you create an area equal in size and aspect ratio (the ratio of an image's width to its height) to a video frame. After you create this area, you can fill it with images and color. Sounds like fun!

Making a new video frame

When you make a new frame for video, it should conform to the same aspect ratio as television screens and computer monitors. Most video displays have an aspect ratio of 4:3. Common multimedia video image sizes are 320 x 240 and 240 x 180. Common sizes for full-screen video are 720 x 486 (digital video) and 640 x 480. In this example, make a 320 x 240 image by following these steps.

A conventional video image has an aspect ratio of 4:3 (4 picture elements in width for every 3 picture elements in height). *Widescreen* displays have an aspect ratio of 16:9, but in general you will want to stick with 4:3.

1. **Select Window➪New in the main menu or press Ctrl+N (Mac ⌘+N).**

 The New dialog box appears (see Figure 13-6).

2. **Give the graphic a name.**

3. **Type** 320 **in the Width text box.**

 The unit of measurement to the right of the width should be in pixels. If there is a different unit of measurement selected, click the down arrow and choose pixels.

4. **Type** 240 **in the Height text box.**

 The unit of measurement to the right of the width should be in pixels. If there's a different unit of measurement selected, click the down arrow and choose pixels.

5. **Type** 150 **in the Resolution text box, making the resolution 150 pixels per inch.**

6. **Set the Mode to RGB Color.**

7. **Set the Contents to Transparent.**

8. **Click OK to activate your choices.**

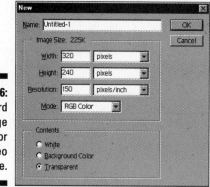

Figure 13-6:
Standard
image
settings for
a video
frame.

The frame you created is where you will put all the photos you fix. The frame can also contain text and some snazzy paint blends.

Sizing old images to fit in video frames

If you have prepared or fixed graphics that you want to include in your video, you need to place them in frames of correct proportion to fit on the screen. For example, if you have several pictures, you are ready to place photos in layers in the new frame. Sometimes you have to change the size of the photos to make them fit correctly into a frame with the video 4:3 aspect ratio. To make this change, follow these steps:

1. **To enlarge an image, click the photo area to activate it.**

2. **Select Image⇨Image Size.**

 The Image Size dialog box appears (see Figure 13-7).

3. **Make sure the Constrain Proportions box is checked.**

 With constrain proportions turned on, your image keeps its proportions if you add height or width.

4. **In the Pixel Dimensions section, type a pixel value.**

 In this example, type **240** in the Height text box. This is the height of the new frame. After you set the height, look at the width. Is the aspect ratio of the graphic 4:3? In the case of the graphic in Figure 13-7, the current ratio for 159 x 240 pixels actually works out to about 2:3. In this case, I plan to place two similarly sized images side by side so that the two together make 4:3. But if this picture were to fill the whole screen, I would have to crop portions off the top and bottom to make it fit a 4:3 video display properly.

Don't be tempted to force a graphic into a 4:3 aspect ratio by deselecting the Constrain Proportions option and adjusting the width and height independently. Doing so will cause graphics that have a distorted appearance. Use the cropping tool (which I describe earlier in this chapter) to make the graphic fit.

When changing an image size, making it smaller is always better because making it larger usually degrades the quality of the image. When you make an image smaller, you are making the image's pixels smaller, causing the image to have more pixels per inch. Enlarging an image causes individual pixels to become visible, making the image look splotchy and jagged.

5. Click OK.

In this example, repeat the above four steps for each of the other photos you want to place into a video.

Figure 13-7:
The
Constrain
Proportions
option
maintains
the
proportion
of an image.

Using color in Photoshop

Manipulation of color is one of the most amazing features that Photoshop offers — and it has a lot of helpful features. In this section, you

✔ Use color in the photos to determine the overall color of the screen.

✔ Fill areas with color.

✔ Create a gradient to match a photo with its color background.

Picking colors

Photoshop offers lots of pen, pencil, spray can, and paint brush tools that let you draw and color all over your graphics. But how do you determine what color will be used for one of these tools? One way is to pick a color that is

already used in the picture. In the toolbox, you find a tool that looks like an eyedropper. Guess what it's called? Yup, an Eye Dropper tool. This tool is used for picking color from an existing photo. To pick a color, do the following:

1. **Activate a photo by clicking on it.**

2. **Click the Eye Dropper tool.**

 The cursor turns into an eyedropper when it passes over images.

3. **Position your cursor over the color you want to pick.**

 In this example (colo2.tif), position your cursor over the background (the landscape) and click.

 When you click a spot in a photo using the Eye Dropper tool, that color becomes the foreground color in the toolbox Foreground Color box.

Another way to pick a color is to double-click the color selection tool near the bottom of the toolbox. This opens a color palette from which you can select virtually any color of the rainbow.

Filling colors

A common use for color is to fill an area. Say, for instance, your picture has an area of blue that you want to change to green. The Paint Bucket tool lets you change the color of an entire area with a few quick mouse clicks. A more precise way to fill an area is to use a selection tool, such as the Marquee tool or the Magic Wand. To fill an area with a chosen color, follow these steps:

1. **Activate the area you want to paint by selecting it with one of the selection tools.**

2. **Click the Paint Bucket tool in the toolbox.**

 You shouldn't have much trouble figuring out which tool that one is. (Hint: It's in the ninth row, left column.)

3. **Place your cursor over the area you want to color and click.**

 The area you select is filled with the same color as the one you chose from the photo.

Creating a gradient

You can use the Photoshop Linear Gradient tool to create a transition. You may want to create a smooth transition of color across the screen, such as a dark blue at the bottom to a deep red at the top to infer a sunrise. Or, you may want to create a gradient from the multiple colors in a photo to a solid color background. This use of a gradient is extremely useful when you need to make text stand out on a screen or have a vertical photo that you want to put into the 4:3 video aspect ratio without cropping.

1. **Click the photo in which you would like to create a gradient.**

2. **Double-click the Linear Gradient tool in the toolbox.**

 The Linear Gradient tool is the eighth tool in the right column. The Linear Gradient Options tab in the Navigator\Info\Options palette appears (see Figure 13-8).

3. **Select a gradient option in the Gradient selection box.**

 In the example shown in Figure 13-8, I have chosen Foreground to Transparent.

4. **You can set the effect of gradient to forward or reverse.**

 Photoshop gives you a choice of which way you want the gradient to go — forward (default) or reverse. In the example in Figure 13-8, I checked the Reverse box.

5. **Place your cursor over the place where you want the gradient to begin and click and drag in the direction you want it to continue.**

 In this example (the colo2.tif image), place your cursor at the girl's knees. Click and drag to the right edge of the frame and release.

 The image is modified with a transparent-to-foreground color gradient. If it doesn't work to your satisfaction, select Edit⇨Undo Gradient (or press Ctrl+Z) in the main menu and try again.

Assembling an image

Whenever you like, you can drag an image into another image. In doing so, Photoshop creates individual layers for the original image and the new image. Layers keep your images separate so that you can work on them independently. To add a layer to a graphic, do the following:

1. **Click the Move tool in the toolbox.**

 The Move tool sits at the upper-right corner of the toolbox.

2. **Click the image you want to move and drag it into the destination image.**

 A copy of the image drops into the frame.

3. **Using your mouse or the arrow keys on the keyboard, adjust the image so that it fits evenly against the left side of the frame, vertically filling the frame.**

4. **When you're finished with the original image, close it.**

 After you drag an image to another frame, you create a new image out of the old one, enabling you to keep your original photo file for other purposes. Now that the image is successfully copied to the new frame, you don't need it anymore and can close the original source image.

Toolbox

Linear Gradient tool

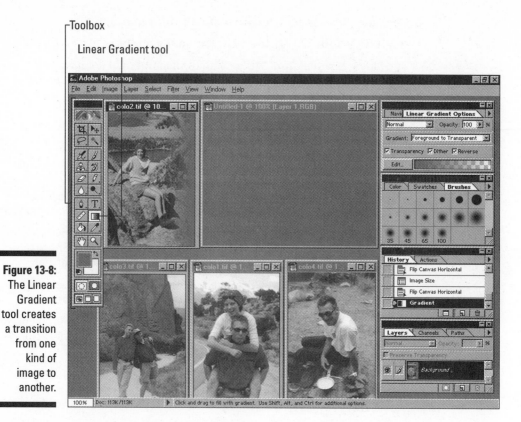

Adding Text to an Image

Photoshop can be used to create text for your video. If you use Adobe Premiere for video editing, you may wonder why you would want to put text onto a graphic when you can add titling in your video editing program. Text in a paint program has more extensive options than titling. Conversely, text titling with Premiere is more dynamic — for example, it enables you to roll text across the screen. Of course, if you use Windows Movie Maker or iMovie, inserting text as still graphics is your only option if you want to have titles.

To add text to an existing graphic, follow these steps:

1. **Highlight the layer where you want to add text.**

2. **Click the Swatches tab in the Colors\Swatches\Brushes palette to select a color for your text.**

3. **Click a color to select it.**

 In this example, click white. White becomes the new Foreground color.

4. **Click the Type Tool in the toolbox.**

 The Type Tool is the big *T*. Notice that as you pass the cursor over the image, the cursor becomes a strange figure with a box around it.

5. **Click anywhere in the graphic area of the new frame.**

 The Type Tool dialog box appears (see Figure 13-9).

6. **Drag the Type Tool dialog box until you expose as much of the new frame window as possible.**

 As you're adding text, you can click and drag the text on the image to move it wherever you want.

7. **Click the arrows to the right of the Font box and select a font and style.**

8. **Select your type justification. The left, center, and right-justify buttons let you format the paragraphs.**

9. **In the Size box, type your desired type size.**

10. **Click in the text window to activate it.**

11. **Type your text.**

 The text simultaneously appears in the new frame and the text window. Notice that in the Layers window the text has its own layer. In the example shown in Figure 13-9, I typed *Eleven,* pressed Enter, typed *Mile,* pressed Enter again, and typed *Canyon*.

12. **When you're satisfied with the size and font of the text, click OK.**

 After you click OK, you can go back and change the text. This is helpful for bad spelers like me. To reopen the text, just double-click the text layer.

If you're creating title screens to use in Windows Movie Maker or iMovie, make sure that you select either *White* or *Background Color* instead of *Transparent* in the Contents section of the New dialog box. Color the background (darker colors often work best) and then use a lighter color for the text that you enter on the title screen.

Fitting Photos into Premiere

Photoshop lets you make files for print or use in other software programs, such as Premiere. Because Photoshop and Premiere are both Adobe products, the procedures for adding still graphics to Premiere are simple and straightforward.

Text window

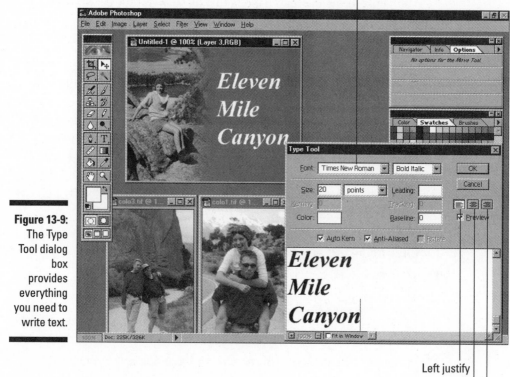

Figure 13-9:
The Type
Tool dialog
box
provides
everything
you need to
write text.

Left justify

Center justify

Right justify

You need to install Premiere on your computer to do the things that I describe here. For information on installing the tryout version of Premiere 5.1, turn to Appendix A. If you haven't used Premiere to create a movie project, turn to Chapter 9 to familiarize yourself with the program.

1. **In Premiere, select File⇨Import or press Ctrl+I (⌘+I on a Mac).**

 The Import window appears.

2. **Click the files that you want to import (Mac: click and drag to select).**

3. **Click Open.**

In Figure 13-10, you can see that I'm creating a project that consists of a series of photos with transitions between them. An audio track below the photos will play in the background as the slide show of photos "plays." After you import some still graphics, you can build a slide show project too:

What about iMovie and Movie Maker?

Yes, you can import still graphics into iMovie or Windows Movie Maker. Both programs support GIF, JPEG, and BMP formats, so when you save the files in Photoshop, make sure that you save a version in one of these three formats. You can easily do this using the File⇨Save a Copy command.

You can import graphics that you produce with Photoshop just as with any other multimedia files supported by those programs (see Chapter 10 for more on using Movie Maker and Chapter 11 for iMovie). They will be imported as still clips, which can then be inserted into a movie project. This is a great way to add titles to an iMovie or Movie Maker project because those programs don't have built-in titling capability.

1. **Click and drag a sound clip to one of the audio tracks in the Timeline window.**

 In this example, drag the mountain sound clip on the Audio 1 track in the Timeline window. The length of the audio clip extends out of the window to the right.

2. **Sometimes, you need to expand or shorten your view of the Timeline to see all or just a portion of your work. Click the Time Unit menu (see Figure 13-10) in the lower-left corner of the Timeline window to change the units of time.**

3. **Change the time unit to show all the clips on the timeline.**

 The entire audio track appears, as shown in Figure 13-10.

4. **Lay your Photoshop graphic on a video track in the Timeline Window.**

 In Figure 13-10, I placed pic1.tif on the Video 1A track in the Timeline window.

5. **As needed, change the still graphic's duration to make it as long as you want.**

 In the example shown in the figure, I changed the pic1.tif duration to 5 seconds.

 See Chapter 9 for information on modifying duration.

6. **Lay your second Photoshop graphic on the timeline — either on the same track with the first graphic or on another video track so that you can create a transition between the graphics.**

 In the figure, I placed pic2.tif on the Video 1B track in the Timeline window. I overlapped pic1.tif by 1 second to make a transition possible.

7. **Change the second picture's duration to whatever you want.**

8. **Lay a Cross Dissolve transition between the clips.**

 See Chapter 9 for information on creating transitions.

9. **Repeat the preceding steps for all other transitions.**

10. **Drag the work area slider to cover all the image area.**

 See Chapter 9 for information on using the work area slider.

11. **Press Enter or the spacebar to watch your Preview.**

A little fine-tuning may be necessary to get everything timed correctly. After you have your slide show "movie" assembled to your satisfaction, you are ready to export it. How you export the movie depends on what type of media you plan to export it to. See Chapter 14 for more on exporting your movie.

Figure 13-10:
The entire sequence is made visible by changing the units at the bottom of the Timeline.

Time Unit menu

Chapter 14

Exporting Your Movies

. .

. .

*W*hen you create a movie project, you usually know who your audience is going to be, but you may not have thoroughly considered how your audience will see your work. Artists paint on canvas and then hang their paintings on a wall. Composers write music and then play them on musical instruments. But what about you? You've used a state-of-the-art video editing program to make a movie. How are you going to make it possible for your intended audience to see your work — what mediums can you use? The answers are in this chapter — where I investigate the fascinating subject of exporting.

To *export* a movie means to turn a video project that you assembled with your editing program into a format that can play outside of that program. During the export, you have to do some file tweaking — such as changing resolution and compression — to increase the chances of successful playback on as many computers as possible. Your decisions during the exporting process can have a long-lasting impact on the playback limitations of your digital video files. You can export a movie into several different storage formats that allow you to reach all of your friends and relatives in one of the following ways:

✔ By transferring the file back into your camcorder and then by having the camcorder play the movie into your VCR and make copies on VHS.

✔ By transferring the file onto a storage device such as a Zip disk or a recordable CD to send to your friends.

✔ By transferring the file via e-mail to people in your address book.

✔ By transferring the file to a Web server so that everyone visiting your Web page can view it.

I discuss these exporting options in this chapter.

Exporting Your Movie to a Tape Device

Digital video can be equivalent in quality to television broadcasts. When you export digital video from your video editing software, you want to maintain as much of this quality as possible. The challenges are enormous, however. Even in the best circumstances, digital video is very demanding on a computer's abilities. Rarely is it worthwhile to export your movie as an uncompressed digital video file. Here are a couple of the reasons:

✔ **File size:** The most obvious challenge to maintaining quality when exporting digital video is the size of the video files. For example, a typical 10-minute digital video file is over 2GB (gigabytes). Therefore, a half-hour of digital video is over 6GB! Obviously, your computer's hard drive can't be used as a video warehouse. Even a huge 30GB drive could be filled by less than three hours of video.

✔ **Throughput:** Throughput entails the speed at which a computer processes data, the capabilities of the computer's operating system, and the efficiency of program software. When it comes to digital video, you can't even play a full-motion, full-screen digital video on a computer without the right capture card (see Chapter 8 about preparing a computer for digital video). Uncompressed digital video is used for exporting to an external recording media such as a video tape recorder. Saving an uncompressed digital movie on your computer is as useful as building a boat in your basement.

After you save your movie in a digital format with your video editing software, your movie is transportable to any other computer (including your own) with virtually no loss of image or audio quality.

Using iMovie

If you don't yet own a computer and would like to purchase a dependable, easy-to-use version for exporting digital video via FireWire to a camcorder, I recommend an iMac computer. With your iMac video editing software (such as iMovie), all you have to do is select File➪Export➪To Camera. Honest — that's all you have to do. iMovie takes care of it from there. So, iMac owners, please take a break while I discuss digital video exporting with my fellow PC owners.

Using Premiere

Exporting can be easy on a PC, too — that is, if you have the correct capture card and software. If you want to investigate what kind of hardware you need to make exporting your video easier, read Chapter 8 before you tackle this chapter.

The instructions given here are written for using a Pinnacle DV300 capture card. The basic procedure is similar for other capture cards, but some specific steps may differ from capture card to capture card. If you get completely lost, consult the documentation for the capture software that came with your capture card.

1. **From the New Project Settings dialog box, choose the Video Editing Mode plug-in.**

2. **Click the down arrow to the right of the Video Editing Mode plug-in.**

 A drop-down list appears.

3. **From the drop-down list, click miroINSTANT Video and then click OK.**

 The Pinnacle plug-ins within Adobe Premiere are activated. The plug-ins cause the miroINSTANT Video software to activate a connection between your computer and your video monitor via your capture card. From now on, anything on your Premiere program monitor will also appear on your video monitor.

4. **Select File⇨Export⇨Export to Tape.**

 An Export to Tape dialog box appears (see Figure 14-1).

5. **In the Export Options area, check Activate Recording Deck.**

 The miroINSTANT Video plug-in flawlessly exports your project to your digital camcorder tape.

6. **Connect the VHS or S-VHS outputs of the Pinnacle DV300 capture card to the inputs of a VHS or S-VHS recorder.**

7. **Connect your monitor to the recorder.**

 This enables the video to play through your recorder to your monitor.

8. **To record, press the Record button on your VCR.**

Pinnacle is a commanding presence in Adobe Premiere — for a good reason. When you run Adobe Premiere with the Pinnacle DV300 plug-ins installed, your computer becomes an integrated video editing system. You are not only working in Premiere, but you also activate the Pinnacle software and capture card, plus you send a signal through the FireWire cable to your digital camcorder and the attached monitor. Whew! All this happens simply by opening Premiere and choosing the miroINSTANT Video Editing Mode. Figure 14-2 shows how a project looks with the miroINSTANT Video Editing Mode activated.

Why is the miroINSTANT Video Editing Mode so significant? Basically, for two reasons — playback and transitions (smooth changes from one clip to the next). The miroINSTANT Video Editing Mode plays back your video using the Pinnacle DV300 capture card. You can use the monitor that is connected to your digital camcorder to watch full-screen playback. Also, when previewing a project on the Timeline, the playback of transitions and effects runs smoothly and without interruption. Essentially, you're a full-fledged digital video editor, capable of watching and recording transitions in real time. Awesome!

Figure 14-1:
The Export
to Tape
dialog box
lets miro-
INSTANT
Video
control your
camcorder
during
recording.

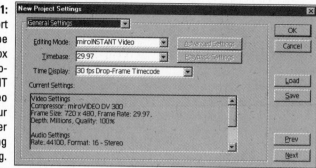

Figure 14-2:
Selecting
the miro-
INSTANT
Video
Editing
Mode plug-
in lets you
dedicate
Adobe
Premiere to
operate as a
digital
camcorder
video editor.

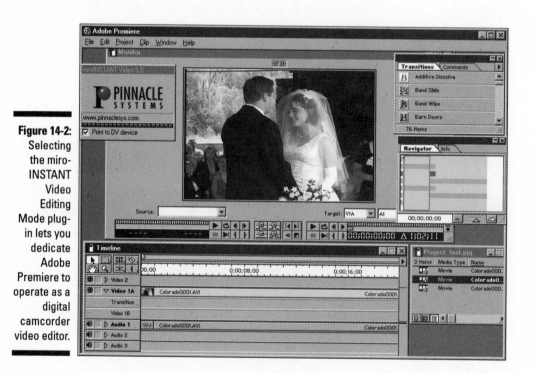

Recording video on tape from Windows Movie Maker is not easy, and if you don't have just the right software and hardware it won't work at all. By itself, Movie Maker doesn't have the ability to export video back through a capture card, which makes it seem as if you're out of luck.

Well, you're not *completely* out of luck. A few FireWire cards come with software that can play Movie Maker's WMV or ASF video files and export them to the tape in your camcorder. Another option is to buy a TV tuner card that offers video output. A TV tuner card lets you watch television on your PC, and although most of these tuner cards do *not* allow video output, a few do, including:

✔ ATI All-in-Wonder 128 and All-in-Wonder Pro (www.atitech.ca)

✔ Hauppauge Win/TV-CinemaPro (www.hauppauge.com)

✔ Matrox Marvel G200-TV (www.matrox.com)

To export a video using your capture card, you must first save the movie in Movie Maker. The process is simple:

1. **Before saving the movie, save your project by choosing File⇨Save Project.**

2. **Click Save Movie on the Project toolbar, or choose File⇨Save Movie.**

3. **In the Save Movie dialog box, choose a quality setting, enter a title for the movie, and click OK.**

 If you're exporting to tape, choose the highest quality setting: Video for broadband NTSC (768 Kbps).

4. **Navigate to the location on your hard drive where you want to save the movie and give the movie a file name.**

5. **Click Save.**

 Movie Maker produces a movie from your project (the process is called *rendering*). When it is done, you can use your capture card software to export the file.

It should be noted, however, that just because you *can* export video from Movie Maker onto tape doesn't mean you *should*. The highest resolution that can be produced by Movie Maker is 320 x 240 pixels. Although this may look okay playing in a small window on a PC monitor, it looks blocky and pixelated when played full screen on a television. If you plan to export video to tape on a regular basis, I suggest that you use Premiere or another video editing program.

Exporting Movies to CD-ROM

One of the most challenging aspects of making a video on a computer is creating a foolproof way to successfully play it on someone else's computer. In this section, I show you some of the limitations that you face by compressing files for use on CD-ROM and some of the ways that you can successfully work within those limitations.

Sometimes when people create video to play on computers, they are making the video to play within a multimedia-authoring program like Microsoft PowerPoint or Macromedia Director. The term *multimedia* refers to video, audio, and graphics — in other words, the sights and sounds in your digital video.

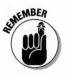

Because of the sheer size and memory requirements of most digital video, multimedia files that are used within multimedia programs are often stored on CD-ROMs. When you export a movie from Adobe Premiere or iMovie to another computer, remember that you're sending a massive file.

When you export a file from your video editing program, you hope that it will be able to play on another computer and sometimes in another computer program, such as PowerPoint. The good news — it probably can, but the possibility of problems always exists. This chapter shows you how to export movies that are most likely to work on other people's computers.

The usual mode of multimedia file transport is via CD-ROM. As a multimedia author, you can use a CD recorder to record on (or *burn*) CDs. A recordable CD is called a *CD-R* (Compact Disc-Recordable). Burning the CD makes it playable on CD-ROM (Compact Disc-Read Only Memory) drives. CD-R drives are relatively inexpensive these days ($150 will get you a good one), and CD-R media is pretty cheap too (about $25–$30 for a spindle of 50 blank CD-Rs). As a result, you can easily share files as large as 650MB.

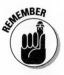

Quite often, people use recordable drives like Zip drives for transferring large files. This is a very good way to transfer files, but Zip drives aren't on every computer. CD-ROM drives are standard on almost every computer, which makes them a reliable way to share large video files.

CD-ROM is great for trading large files, but it can have its limitations during playback. For one thing, some older CD-ROM drives are still in use. These drives may be slow and unable to handle much information at one time. But even the newer drives don't play back at the same speed that hard drives do. So, although you can create a movie that plays well on a computer's hard drive, you may find that it plays poorly or not at all on a CD-ROM drive.

Generally, most multimedia authors keep frame size within the 320 x 240 range. On a video screen with 640 x 480 resolution, 320 x 240 is a quarter of the screen size. A smaller resolution has a much smaller data rate.

Usually frame rate works best at 15 frames per second or less. A computer works half as hard playing 15 frames in a second than it does playing 30 frames in a second (standard video frame rate).

As a general rule, if you don't know who will be playing your movie, be conservative. A double-speed (2X) CD-ROM drive can handle a data rate up to 200K (kilobytes) per second.

Exporting files to CD-ROM using Premiere

A successfully exported video file is a file that works for someone else as intended. To accomplish this feat, you must save the file in a digital format that can be recognized on another computer and probably in different programs.

To ensure that you don't overwhelm the capacity of other computers, you must compress the file by using a method that other computers can recognize and decompress.

CODEC is the shorthand term for compression and decompression. To select an AVI CODEC for a movie you have created in Adobe Premiere that will work on other people's computers, follow these steps:

1. **From the main menu bar, select File⇨Export⇨Movie.**

 The Export Movie dialog box appears.

2. **Click Settings.**

 The Export Movie Settings dialog box appears.

3. **With the File Type Microsoft AVI selected, click the Next button.**

 You're now in the Video Settings dialog box.

4. **Click the down arrow beside the Compressor selection box.**

 A selection of CODECs for AVI files appears.

5. **Click Cinepak CODEC by Radius.**

 Cinepak (available in Microsoft AVI and QuickTime versions) is a dependable CODEC for movies on CD-ROM. Cinepak works well for high compression and fast decompression. These two characteristics greatly enhance a CD-ROM's capability of keeping up with the file during playback. By "keeping up," I mean that you see and hear every frame of video correctly.

If you intend to distribute movie files on CD-ROM for copying and playback on a hard drive, Cinepak may be overkill. The default Microsoft Video 1 CODEC should work fine for playing a movie from a hard drive.

The Cinepak CODEC allows you to adjust data rate. *Data rate* is the amount of video information that is processed during each second of playback. In the CD-ROM world, data rate is often directly related to the age of the drive. Older drives are as slow as 2X (double-speed). Newer CD-ROM drives are many times faster — as fast as 50X.

Choosing Microsoft AVI or Apple QuickTime

For most multimedia uses, you usually choose one of two formats to export — Microsoft AVI or Apple QuickTime.

- ✔ **Microsoft AVI:** AVI is short for *Audio-Video Interleaved.* AVI is a file extension, such as in movie.*avi.* Microsoft Windows contains a multimedia program called Windows Media Player. You can see Media Player by clicking the Windows Start button and selecting Programs⇨ Accessories⇨Multimedia⇨Media Player (in Windows Me choose Start⇨Programs⇨Windows Media Player). Media Player recognizes and plays movies with AVI extensions. A free version of Media Player is also available for Macintosh systems and can be downloaded from www.microsoft.com. Look for Windows Media Player in the Downloads section of the Microsoft Web site and find a version that works with your computer.

- ✔ **QuickTime:** QuickTime is also a media player. Created by Apple, QuickTime files play on Mac, Windows, and UNIX platforms that are equipped with the QuickTime software. QuickTime movies are designated with the MOV extension, such as in movie.*mov.*

Using Premiere to export for CD-ROM

If you're using either the Mac or PC versions of Adobe Premiere, then you have a wide array of compression settings for multimedia:

1. **Select File⇨Export⇨Movie in the main menu bar.**

 The Export Movie dialog box appears.

2. **Select Settings.**

 The Export Movie Settings dialog box appears.

3. **Click the down arrow to the right of File Type.**

 A dialog box appears, showing the kinds of export options available (see Figure 14-3). For now, focus on just two file types — Microsoft AVI and QuickTime.

4. **Leave the File Type set as the default Microsoft AVI.**

 Before you exit the dialog box, take a look at the other file types. Microsoft AVI and QuickTime are generic types of movie files. The others are for specialized uses. For example, Animated GIF is a file type specifically for use with the Internet.

5. **After you select your file type, such as Microsoft AVI, and choose your CODEC, frame size, frame rate, and data rate, you're ready to export the movie.**

6. **Click OK to return to the Export Movie dialog box.**

TIP

Making a multimedia presentation

Adobe Premiere is popular among multimedia authors as a movie-making tool for multimedia applications. The most widely used multimedia-authoring program is Microsoft PowerPoint. PowerPoint enables you to easily insert a video file right into a PowerPoint page. If you have PowerPoint installed on your computer and you want to make a slide show containing a movie, open the program and select Insert⇨Movies and Sounds⇨Movie from File. If you want, you can select one of the movies that comes on the CD-ROM at the back of this book.

Select Insert⇨Movies and Sounds⇨Movie from File and then select the movie to place the video file into the slide show. The inserted video starts when you click it during a PowerPoint slide show.

If you are adventuresome and want to find out about a full-blown professional multimedia-authoring program, check out `www.macromedia.com`. At this Web site, you can read about and try out a number of very good authoring programs.

7. Type your movie's name in the File Name text box and click Save.

Premiere begins exporting your movie file. When Premiere finishes the export process, a clip window appears in Premiere, enabling you to play your exported movie. Your movie is ready to be incorporated into a multimedia application or burned onto a CD-R (recordable CD).

Figure 14-3:
Microsoft AVI is the most commonly used file type for exporting and playing movies on Windows-based computers.

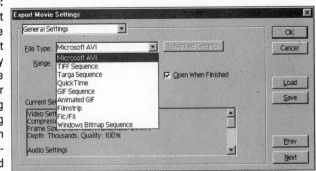

Exporting a movie with iMovie

iMovie makes the process of exporting a video very, very easy. To export your iMovie project:

1. **Open the video you want to export.**

2. **Select File⇨Export Movie.**

 The Export Movie dialog box appears (Figure 14-4).

3. **In the Export to Selection dialog box, select QuickTime.**

 The QuickTime Export Movie dialog box appears.

4. **Select either fail-safe compression by clicking the CD-ROM Movie, Medium selection in the Format drop-down box, or click Export (Figure 14-5).**

 If you click the fail-safe selection, iMovie begins the compression process. The fail-safe selection changes your frames-per-second from 30 frames to 15 frames. Your image size changes from 640 x 480 to one that is much smaller — 320 x 240. The quality of your image is converted from broadcast quality to medium grainy. (Tough to take, isn't it?)

Figure 14-4:
The iMovie Export to Selection dialog box lets you export digital movies to your camcorder or to a QuickTime file.

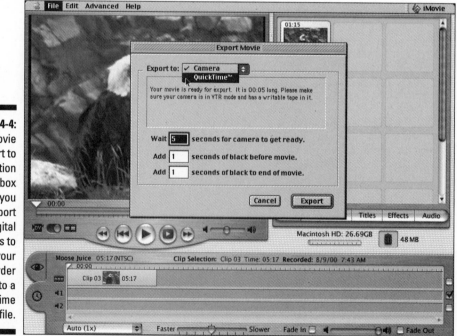

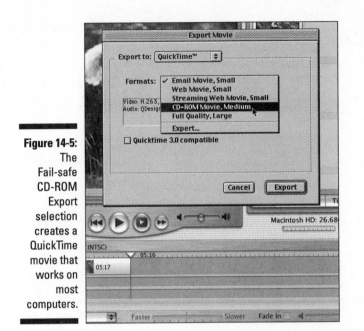

Figure 14-5:
The
Fail-safe
CD-ROM
Export
selection
creates a
QuickTime
movie that
works on
most
computers.

If you select the Export button, iMovie opens the Compression Settings dialog box. In this box, you can select the type of compression that you want, the image size and aspect ratio, and the audio settings.

Exporting a movie from Windows Movie Maker

Windows Movie Maker is an exceedingly simple program. Some people may take this simplicity to mean that it lacks important features, but the program does let you export movies that can be placed on CD, the Internet, or your hard drive. To export a movie in Movie Maker, do the following:

1. **Before saving the movie, save your project by choosing File➪ Save Project.**

2. **Click Save Movie on the Project toolbar, or choose File➪Save Movie.**

3. **In the Save Movie dialog box, choose a quality setting, enter a title for the movie, and click OK.**

 If you're exporting to CD, choose a higher quality setting. Unless your audience has very slow CD-ROM drives, you are usually safe choosing Video for broadband NTSC (768 Kbps). Even at this setting, a CD-R will be able to hold about two hours of video produced by Windows Movie Maker.

4. **Navigate to the location on your hard drive where you want to save the movie and give the movie a filename.**

5. **Click Save.**

 Movie Maker produces a movie from your project (the process is called *rendering*). When it is done, you can record the file onto a CD-R using your CD-R mastering software.

Video files produced by Windows Movie Maker are in WMV format. To view these movies, your audience must have Windows Media Player Version 6 or higher. Versions of Media Player are available for Windows and Macintosh.

Recording movies on CD

Your CD-R drive should include software that allows you to master and record CDs. If you are interested in different mastering software, visit an online software site such as www.tucows.com. Adaptec (www.adaptec.com) makes some of the most popular mastering software, including Easy CD Creator for Windows and Toast for Macs. Follow the instructions for the software you have to master and record the CD. When you record the CD, keep several things in mind:

✔ Most CD-Rs hold only 650MB of data. Some CDs are said to hold 700MB, but in general, I have found that they become unreliable when you try to squeeze more than 690MB onto them.

✔ Buy CD-Rs in bulk. Spindles of 50 or 100 blank CD-Rs offer the best value, but you may have to buy CD cases (called *jewel cases*) separately.

✔ If you record on a PC using Windows, remember that Macintosh users will only be able to see the first eight characters of a filename. Most CD-R mastering programs for Windows give you a choice between two file systems: ISO-9660 and Joliet. ISO-9660 only allows eight character filenames plus a three-character extension, and Joliet allows up to 64 characters. However, what the software doesn't tell you is that Mac users will probably only be able to see an ISO-9660 file system even though you selected Joliet.

✔ When you record a CD on a Mac, make sure that you format the CD so that the people you plan to share it with can access it. If you only plan to share the CD with other Mac users, you can just use the "Macintosh Volume" setting for the CD in your mastering software. But if you want Windows users to access it as well, create a Mac/ISO Hybrid.

Preparing Your Video for the Web

If you're like me, one of the greatest love/hate relationships you'll have as a digital video home moviemaker is the World Wide Web. Your tumultuous affair will be filled with glowing promises and shocking disappointments.

I spend a large percentage of my workweek searching the Web's enormous wealth of information and services. But, then again, I hate the World Wide Web for all the things it should be able to do, hints that it can do, but actually can't do. Video on the Web is the epicenter of my love/hate relationship.

In this section, I show you some really neat video stuff that you can accomplish with the World Wide Web. At the same time, however, I try to be candid and save you the frustration of attempting to do things that aren't yet possible. The day is quickly approaching when the Web will be an extraordinary delivery medium for video. In the meantime, you want to make the most of what is currently possible. You may even have fun doing it.

Preparing video for the Web requires some major compromises of video quality (but at least it can be done). Right now, you can make a movie for all the world to see on the World Wide Web. You essentially have two ways to create such a video. One way is to make a normal AVI, QuickTime, or Windows Media (WMV) file. Free players for each type of file are available for both Windows and Macintosh. The other way is to encode a video file for on-demand playback. See the "Streaming your video" section for more on encoding video for on-demand playback.

One way to put video on the Web is simply to store it there. By storing, I mean you can make and export a movie with your video editing software, upload the file to your Web site, and create a Web page that makes it possible to download the file to a computer. Or, even more simply, you can attach a video file to an e-mail message. However, video files (especially AVI and QuickTime) tend to be very large and many people aren't patient enough to spend hours downloading them. Most of your audience will find little or no pleasure sitting around for an hour waiting for a 10-second video to download. Instead, my suggestion is to create a Movie Maker or an iMovie file, which is described in the "Putting your movie on the Web" section.

One of the most important decisions that you'll make about your video for the Web is also the toughest. You need to decide who will and who won't be able to watch your video. This is a crazy kind of censorship based on the speed of modems and Internet connections. Here are some basic considerations:

 ✔ Many Internet users will not be able to watch your video, no matter what you do. In order to view any video on the Internet, computer users need up-to-date Web browsers like Microsoft Explorer 5.5, and multimedia capabilities in their operating systems, including at least a 56 Kbps modem.

 ✔ Also, do your viewers want mono or stereo sound? This isn't a critical issue on the surface, but your decision can directly affect the size of your encoded video file. Any time you choose to add quality beyond basic video, you're increasing the size of the file. The larger the file, the longer it takes to upload to the Internet, and the longer it takes for your audience to download.

Putting your movie on the Web

Two of the video editing software programs that I discuss in this book are capable of creating video for use on the World Wide Web — Windows Movie Maker and iMovie for iMac. When it comes to video for the Web, Movie Maker is the choice if you use a PC. Movie Maker (described in Chapter 10) is made specifically for exporting movies to the World Wide Web or via e-mail.

Using iMovie to export movies to the Web

Earlier, in the "Exporting Movies to CD-ROM" section, I show you how to export movies to CD. In that section, I show you where to click the button for creating *streaming video* (video for the Web). To create streaming video in iMovie:

1. **Select File⇨Export Movie.**

2. **In the Export to Selection box, select QuickTime.**

 The QuickTime Export Movie dialog box appears.

3. **In the Format drop-down box, select the Export button.**

 iMovie opens the Compression Settings dialog box.

4. **In the iMovie Compression Settings dialog box, select the Streaming, Standard Web Server option.**

5. **Click the Export button.**

 iMovie creates the streaming file.

Unfortunately, iMovie leaves you hanging at this point. You need to know how to upload your file to a server and how to connect hyperlinks to the file on the server. In this particular instance, Windows Movie Maker has much more to offer. Otherwise, see the upcoming "Creating an online home for your movies" section.

Using Movie Maker to export movies to the Web

Movie Maker is great for exporting movies to the Web. When you complete your movie, sending it online is a breeze. Just follow these steps:

1. **Select File➪Send Movie To Web Server.**

 Movie Maker opens the Send Movie to Web Server dialog box (Figure 14-6).

Figure 14-6:
Movie
Maker lets
you send
your movies
directly to
the Web.

2. **Choose a quality setting.**

 Notice that as you select different quality settings from the drop-down menu, an estimate of the file size and download time at various Internet connection speeds is given. Use this information to balance your quality desires with the reality of the slow connections you or your audience might be saddled with.

3. **Click OK.**

4. **Select a Web server to upload your movie to in the Send To Web dialog box.**

 Movie Maker gives you quick access to several free Web servers. If you haven't already done so, click the Sign Me Up button. Movie Maker uploads your movie file directly to a free Web Server (Figure 14-7).

A free service by POPcast (www.popcast.com/) lets you to make a hyperlink on your own Web page to connect to your movie residing on this server. POPcast provides 10MB of free server space.

After your movie uploads, other people can view it. After the upload, make a note of the movie's Web address so that you can tell other people where to find it.

Figure 14-7:
POPcast
helps you
set up a free
account so
that you can
store your
video on its
Web server.

E-mailing a movie

An easy way to send a movie to one person or a group of people is via e-mail. You can send any movie file as an e-mail attachment, as long as your e-mail program and e-mail account support file attachments. Windows Movie Maker takes the process one step further by streamlining the process. To e-mail a movie with Movie Maker, simply click Send⇨E-mail on the Project toolbar. Movie Maker takes you through the standard procedure of choosing a quality level and giving the movie a filename before it renders the movie and then automatically generates a new e-mail message in your default e-mail program with the movie already attached. All you have to do is enter an e-mail address for the person you want to send it to and click Send.

But e-mailing movies does present a few pitfalls. Before you send a movie via e-mail, keep several things in mind:

✔ Always warn the recipient before you send the movie and tell them not only what you want to send but also how big the movie file is. If the recipients have a slow Internet connection, they will not appreciate waiting an hour or more as your huge video downloads.

✔ Double-check that the movie will not overload your mail server or the recipient's server. Some e-mail service providers limit mailbox sizes, and if the movie you send it is too big, it will be rejected by the server.

✔ Select a quality level for the movie based on the recipient's connection speed rather than your own. Even though you may have a fast DSL or cable modem connection, many of your friends are probably still creeping along at 28.8 Kbps due to poor phone lines.

Never, ever send a movie to everyone in your address book, no matter how cute you think that movie is. File attachments in e-mail are a touchy subject for some people, and you are sure to aggravate many of the people you send the movie to (even though they might not say anything).

Creating an online home for your movies

So you have some server space available, and you have a movie that you just can't wait to put online so everyone can see it. How do you do this? The easiest way is to use Windows Movie Maker's Web server upload feature (described earlier in this chapter). But if you don't use Movie Maker or you'd rather create an actual Web page that your audience can visit, you have two options:

✔ Create an HTML (HyperText Markup Language, a basic programming language for Web pages) page with a text editor, and then upload the page to a server using an FTP (File Transfer Protocol, a method for transferring files between your computer and a Web server) client.

✔ Use a Web page editing program such as Microsoft FrontPage (www.microsoft.com), MicroVision WebExpress (www.mvd.com), or Adobe Pagemill (www.adobe.com). These programs take the fuss out of creating and uploading HTML pages.

The second option is by far the easiest, although creating a very simple HTML page is not that hard and if you have a computer you already have all the tools you need. In Windows, open the Start menu and choose Programs⇨Accessories⇨Notepad. On a Mac, open the Apple menu and choose Applications⇨SimpleText. Now type the following:

```
<HTML>
<HEAD>
<TITLE>My Online Movies</TITLE>
</HEAD>
<BODY>
<H1>My Online Movies</H1>
<P>Click the title view the movie.</P>
<P><A HREF="wedding.wmv">My Wedding Video</A></P>
</BODY>
</HTML>
```

This is raw HTML. It looks complicated, but if you type it just like this it will open in any Web browser including Internet Explorer, Netscape, and Opera. The main thing you will want to change for yourself is the hyperlink to the actual movie file, which begins with ``. In this case, you want to replace *wedding.wmv* with whatever the actual filename for your movie is. Also keep in mind that this hyperlink assumes that the HTML file and the movie file will be in the same directory or folder on the Web server. If you store your movies in a subdirectory on the Web server called movies, the hyperlink should read ``.

When you finish editing your HTML file, save it with the HTML extension. A good filename is HOME.HTML.

Most Web servers are case sensitive when it comes to file names. This means that if you create a hyperlink that lists the file wedding.wmv, but the file name is actually Wedding.WMV (or something like that), an error might occur when visitors try to link to your movie.

After you have an HTML file and a movie ready, you need to upload them to the Web server. Every Web server has a different procedure for uploading files, and they are all complicated. Some have you use an FTP client such as WS_FTP (`www.ipswitch.com`) for Windows or Fetch (`www.dartmouth.edu/pages/softdev/fetch.html`) for Macs. Check with your Web server for exact procedures and instructions for uploading your files. They should also tell you what the Web address of the files you upload will be so that you can inform other people where to find them.

Of course, this doesn't even scratch the surface of creating a good Web page, and to give you a thorough breakdown of HTML, FTP clients, and the like is way beyond the scope of this book. Still, this section should get you started. For more on Web-related issues check out *Creating Web Pages For Dummies,* 5th Edition, by Bud Smith and Arthur Bebak and *Internet Bible,* 2nd Edition, by Brian Underdahl and Keith Underdahl, both published by IDG Books Worldwide, Inc.

Streaming your video

Another alternative is to distribute your movie in a *streaming* format. Streaming video plays as the user is downloading it, which provides a bit more instant gratification for your audience. The most common type of streaming media found on the Internet today is RealVideo and RealAudio, which use formats produced by Real Networks (`www.real.com`). Unfortunately, RealVideo development tools are expensive and you can't really take advantage of them unless you have your own full-time Web server.

A simpler option is to use Microsoft's Windows Media WMV format. Video that uses this format can be played using Windows Media Player, a free version of which is available for Windows and Macintosh systems from Microsoft. In fact, anyone with Windows 98 or later already has a version of Media Player that can play WMV files.

Microsoft provides free tools for turning AVI movies into Windows Media files. The best tool is called Windows Media Encoder and can be downloaded from `http://msdn.microsoft.com/windowsmedia/`. After an AVI is encoded into WMV format, all you have to do is upload the WMV files to a Web server and they will stream as a Windows Media Player user downloads them.

Part V
The Part of Tens

The 5th Wave By Rich Tennant

ROOM 101

"I failed her in algebra but was impressed with the way she animated her equations to dance across the screen, scream like hyenas, and then dissolve into a clip art image of the La Brea Tar Pits."

In this part . . .

You wanna make a home movie, but you're kinda embarrassed because that's all you want to do? No problem. This part has lots of stuff just for you. In fact, this part has lots of stuff for lots of people — how-to stuff about shooting and editing digital video home movies and weddings.

You also get to go on an Internet shopping spree to outfit yourself with the equipment and software that will make your movies simply marvelous.

Chapter 15

Ten Tips on Making Spectacular Home Movies

*H*ere's a plea from all the huddled masses who have ever sat in a darkened living room, unable to escape, desperately trying to act politely interested while being tortured beyond the limits of human video-watching endurance. For all these wretched people everywhere, I cry out: Stop punishing your friends and relatives with bad video! Whatever the pounds of sugar and dozens of eggs they owe you, no matter how many of your lawn-mower blades they've dulled, nothing they've done deserves this kind of retribution. In the name of all that is decent and kind, have pity on these poor people.

Let's face it: The ubiquitous home movie has become more an institution of torture in modern society rather than one of entertainment. But with some careful shooting and creative editing, you can turn your home movies into videos that people other than yourself actually enjoy watching. In this chapter, I walk you through ten steps that can assure positive neighborhood notoriety.

Shoot and Capture Video as Clips

The first and best thing that you can do when you shoot video with your camcorder is to remember that videotaping is only half of the moviemaking process. You have to edit that video later on. When you shoot your video, keep in mind that it will be broken up into clips later on for editing. These clips are like the visual paragraphs of a story and your video editing program is like a word processor for video clips. In editing, you can make your clips shorter; you can take portions of clips and add them to portions of other clips; and you can move your clips around in any order you wish. As you record, think about the potential of what you're doing — creating a bunch of individual clips that you will later edit into a cohesive story. You can make this process easier by keeping the following advice in mind:

✔ Start recording sooner and end recording later to ensure that none of the important action gets cut off by the camcorder. You can always edit "dead air" off the ends of your clips.

✔ Be on the lookout for subjects that will make useful clips for special effects and graphics. For instance, a clip showing the sign at the entrance to the zoo can serve as a good opener for a video about visiting the zoo. Likewise, a clip showing only a monument or other symbol might make a good background for other clips. For instance, a clip of a fluttering flag will have a dramatic effect if you use your editing program to superimpose it over a clip that pans across a national cemetery.

✔ Shoot clips from multiple angles. This gives you more editing options, especially if one angle provided better lighting than another did.

Look for a Story

You want to make an interesting movie. You've got clips of kids and dogs, clips of relatives and friends, clips of interesting places, and clips of meaningful events. So what's keeping you from making the movie? Absolutely nothing if you've got an idea for a story.

No matter how well you shot your clips or how interesting they appear, they need to weave together into a story. A story gives viewers a logical basis and a compelling need to watch your video.

So, how do you create a story? One very effective way is to let the video tell you what to do. Commonly, you shoot video of things that are interesting to you or others. While shooting, think of *what* makes these shots interesting. Is it that you're shooting the Grand Canyon? Or is your video interesting because it's a documentation of your presence at the Grand Canyon?

Ninety-nine percent of the time, the latter is the correct answer. So, when you shoot your trip at the Grand Canyon, you need to convey how you and your family felt about the experience. What was fun? What was a surprise? What is something that went wrong that would make for a great yarn? To answer these questions you need to spend a lot more time with the camcorder pointed at your family rather than that big hole in the ground.

Of course, no trip to the Grand Canyon — or any other fabulous destination — is complete without some video of it. Spend time getting good video of the destination. These clips may appear only briefly in the final movie, but they help establish a setting for your story.

Set the Point of View

Give your story a perspective. By perspective, I mean the way that you portray people, places, and things — a point of view. For instance, if your video is of a family vacation, make the video more than a sequence of chronological events. At the beginning of the video, make a promise to the viewer that this is going to be especially interesting because the video portrays the attitude of you, the producer, or perhaps the attitude of one of the people in the video. For a family vacation, you may want to tell the story as seen through the eyes of your children.

After you select a point of view, make a conscientious effort to videotape the things and the events that are consistent with that viewpoint. For instance, if your video is about your trip to Disneyland, and your point of view is your children's reactions to the experience, be sure to shoot video of their reactions. Mickey Mouse may be the source of the wonderment, but the look in your child's eyes is what you treasure for the rest of your life.

Maintain the Fable

When you create a home movie, you're the storyteller. One of the most important responsibilities you have in storytelling is not to break the rule of the fable. For instance, if you have established that your story is told primarily through the eyes of your children, stick to that perspective. People (including adults of all ages) love to pretend. People like to have their imaginations tickled. So, if you decide your family vacation story will be more interesting if narrated by one of your children, then stick with that idea throughout the shooting and editing of the video. You find that your shooting opportunities are increased rather than limited by having a story to tell. And your enjoyment of the shooting increases because you're on a mission.

Add Voice-Overs and Music

Take advantage of the audio features of your nonlinear editing software program. Two of the most powerful ways you can improve the quality of your home movie is by giving it a musical score or adding narration. Music can make the most boring video exciting and the coldest relationships seem warm.

The next time you're at the movies, disengage from the story for a while and pay special attention to the music. In many films, you find that there is almost always some kind of music playing in the background, reinforcing the mood of the scene. You quickly observe how music affects the sense of emotion or stress within the story.

If you want to use music in your movie, consider laying down the music on an audio track with the video editing program before you add video clips or graphics to the timeline. Laying music down first is a common procedure among professional editors. The reason this is a common procedure is because you find that the beat of music and its phrasing will help dictate where you begin or end video sequences. You find that laying down the music first is much easier than editing all your video and then going back and trying to make it fit a soundtrack that was laid down afterwards.

Narration is a great tool for tying your story together. You don't need to record narration while you're on your vacation or at the school play. After you have shot the video, captured it, and laid the clips on the timeline in your editing program, you can then determine what narration might be helpful. What in the movie doesn't make sense without narrative explanation? What can be said to bring out the humor or the emotional impact of a sequence? Whatever your answer, that's how you begin writing a narration script.

Write in a manner that is normal, conversational English rather than grammatically perfect composition. As you write, look for how you can say the least to accomplish the most. Remember that the video will tell most of the story. After you're sure about what you want to say, step in front of the camera, press the record button, read a phrase, and repeat it if you blunder. If you're like most people, you'll get some of the phrases right on the first try. Others sentences will take a couple of attempts. When you're done, capture the narration onto your computer as a series of audio clips (just as you capture video). You'll appear in the captured video, but you can delete the video portion of the clip in editing. Import the clips into your editing program and add them to the timeline where they are needed in your story. See Chapter 8 for more on capturing.

When you're on vacation or an outing with your family, it's not always possible to drag every piece of movie-making equipment along with you. One of the most common items that gets left behind is the microphone. Thus, you're left to rely on the camcorder's built-in microphone, resulting in poor audio. Adding musical soundtracks and narration when you edit the movie can be a great way to cover up poor audio recorded by your camcorder.

Get People to Be Themselves

How can you get people to act naturally on camera? There is no easy answer. It can be tough to get people to be themselves when being videotaped. Frankly, children are easier to set at ease than adults are. Children usually forget about the camera within seconds. Adults aren't so lucky. Just watch the Sunday morning news talk shows where politicians unsuccessfully pretend to act naturally. And they are pros.

So what do you do with that wonderful, deep, personable person who turns to cardboard as soon as the camera begins to record? How do you help him or her? If you figure that out, please let me know. My experience ranges from total failure to limited success in this area.

Here's something I learned from years of recording people on camera. The biggest problem you usually face when confronted with a person who freezes on camera is that you don't have the luxury of patience. When you're recording, you're recording. No one else is willing to wait while you help a frozen adult melt a little. My advice, if you want to call it that, is to laugh it off. Some people simply can't function in front of a camera. When you encounter these people (and you will, I promise), keep your composure, try to show compassion toward their embarrassment, and just keep going with your recording.

Make Funny Funny

Funny stuff is serious business. I guess that's logical when you consider all the kazillions of dollars that are spent by advertisers who are betting that you think an advertisement is so funny that you resurrect from your TV-watching stupor to buy a particular brand name the next time you go shopping. How else can you explain lizards electrocuting frogs so that you'll want to buy a particular kind of beer?

Fortunately, you don't have to spend lots of money to be funny. You just have to be funny. So how do you do that? Well, I don't know; just be funny. When producing a video, funny can be slapstick or subtle. Usually, it emerges from the cleverness (both intended and unintended) of a moment. Funny moments are usually simple, unintended goofs. In editing you can dramatize a goof with a sound effect or a special effect.

Maybe even more important than making funny be funny is ensuring that serious is serious. I'm serious. My worst memories as a producer come from people laughing at the wrong time.

Here is a word of advice from a graduate of the School of Hard Knocks: People are callous when they watch video. People will laugh at things in video that they would never consider laughing at in real life.

Video separates us from reality to the degree that we are separated from people's feelings. For example, if something odd is in a video taken at a funeral, people will laugh. I guarantee it. It doesn't matter how tragic the circumstance. If you're the producer, you'll know what it means to feel mortified. Take much care in your handling of serious moments.

Creatively Keep the Point of View

When you establish a point of view in a video (such as seeing your family vacation through a child's eyes), use your creativity to accomplish that end all the way through the editing of the movie. Creativity is a combination of limitation and freedom. You are creative because you have a goal — you know what you want to make. And you are also creative because you are open to any ideas that might help you achieve your goal in a more interesting or effective manner.

One of the creative editing challenges that you face when making a story out of your video is to maintain the story's perspective and fable. For instance, if you are making a movie about your vacation trip as seen through your child's eyes, maintaining the child's point of view requires occasionally reestablishing the viewer's relationship with your child. You accomplish point of view with creative camera location and creative editing.

Pay attention to how camera angles make your subjects look. If all the video you shoot of your kids is shot from adult height looking down, the children will look small and unimportant in the video. Lower the camera if necessary to ensure that your subjects look as important on video as they really are.

Maintaining point of view is a subjective endeavor. For example, if I were to use a stationary camera to record a child on his bike, the viewer might feel unconnected to the child because the child is simply passing by. However, if I used a moving camera to record the child on his bicycle, I would be giving the viewer the feeling that he or she is moving with the child — thereby connecting the viewer and the subject and maintaining point of view. In this example, the moving video has to be shot with the expectation of how the clip will look in editing.

To maintain any kind of energy in a video, you need to film what's interesting, and then cut it in half. The best and easiest way to create interesting and exciting video is to have less of it. You maintain people's interest by giving them just enough in order to understand your message and no more.

Use Titles and Graphics

When building a must-see home movie, remember that your video editor has the capability of layering images over other images. The most common form of layering is adding titles and graphics:

- A title is wording added to your video using the titling tool in your video editor. The value of titling is that you can use your video editor to move words across the screen or have them easily appear and disappear.

- Sometimes, you can add a look of spontaneity and uniqueness by using a graphic rather than your titling tool to create your text (see Figure 15-1). Graphic programs such as Adobe Photoshop help you make still frames of video mixed with drawn text. Chapters 9, 10, 11, and 12 illustrate how you can add titles and graphics to your video. The addition of a few well-placed messages on the screen can greatly affect the interest and personal nature of your video.

Make the End a Beginning

Most good stories end with a beginning. For example, in a family vacation story, the beginning clip may be the family packing the car in anticipation of the trip. The conclusion could be the family car driving into the setting sun. This is just an example, but it illustrates the need for the closing of a loop. When you start a story by establishing the beginning of an endeavor, close the story with the resolution of the same endeavor, or even the beginning of a new one.

Figure 15-1:
A freehand
drawing of
words
created in a
program like
Adobe
Photoshop.

Chapter 16

Ten (Or So) Pointers for Producing a Digital Video Wedding

*I*f there is a made-in-heaven use for digital video, it has to be weddings. The combination of a digital camcorder and computer-based video editing system (such as Adobe Premiere) make possible (and affordable) what could not be imagined a couple of years ago in wedding videography. Beautiful and vibrant are terms often attributed to newlyweds. Those adjectives are now being used for wedding videos, too.

Until recently, most weddings were recorded and edited in VHS or S-VHS formats, which offered limited special effects and editing capabilities. Weddings look best with lots of editing. And weddings can be beautiful on video with special effects like slow transitions from one scene to the next — both of which are easily and beautifully accomplished with digital video recording and editing.

In this chapter, I give you some pointers for planning and creating a knockout wedding video. After you make a beautiful wedding video, you're going to become more popular than you may want to be. By the way, I know a place where you can order boxes of rice by the case.

To illustrate many of the topics in this chapter, you find a sample wedding video on this book's CD-ROM. In the folder Chap09 on the CD, you will find the file wedding.avi (on a Mac, use wedding.mov). To make the clip play properly, you'll probably need to copy it temporarily onto your computer's hard drive. See Appendix A for more on using the CD.

Survey the Wedding Location Before the Ceremony

Creating a wedding video can be lots of fun, but it can also be tough. And you can be surprised by what will be tough and what will be easy. Simple ceremonies can provide you with beautiful, emotionally compelling recording opportunities and elaborate ceremonies can leave you limited opportunities for any kind of worthwhile recording.

Many weddings are performed in churches. Some congregations allow you to record close to the front of the church, while others may make you stay near the back or restrict you from shooting video of the service at all. If you cannot position your camcorder near the front of the church, you will have few opportunities to document the wedding with live video, but you do have the option of putting lots of photos from the wedding into your wedding video. Wedding videos comprised of photo galleries can be quite lovely if done creatively.

If a professional photographer has taken wedding photos, you must get permission from the photographer to use the photos in your wedding video. Believe or not, professionally photographed wedding photos are owned by the photographer — not the wedding couple.

If you are recording a wedding out of doors, you might want to check out Chapter 3 and Chapter 5,which include tips for making the best use of your camcorder and recording sound in tough situations, respectively. Keep in mind that weather and time of day can dramatically affect lighting and other factors important to your shoot.

So what can you do if you're limited in what you can shoot at the ceremony? Use something else. Put more of one kind of video into the movie to compensate for less available video of another kind. For instance, if you don't have much video of the wedding itself, devote only 20 percent of the video to the ceremony, and perhaps 40 percent to the reception, and the remaining 40 percent to areas such as the friendship and engagement stages and the wedding preparations. If you get lots of good recording at the ceremony, devote 60 percent of the video to this part, 30 percent to the reception, and the remaining 10 percent to the engagement and courtship moments.

TIP

Following the wedding and reception, if you lack sufficient video, start seeking help from friends and relatives of the newlyweds. Ask them to provide photos and video from earlier times in the couple's relationship. You will usually get more help than you need.

The wedding ceremony itself is only a part of what the newlyweds will want to see in the finished video. A wedding video may have multiple parts — for example, photographs from early in the relationship, the engagement period, the wedding preparations, and the wedding ceremony (such as the smiling couple in Figure 16-1) and the reception. If you keep these parts in mind, you can create a very meaningful video — even when you're limited in how you can record the actual ceremony.

Figure 16-1:
The
wedding
ceremony is
only one
part of a
wedding
video.

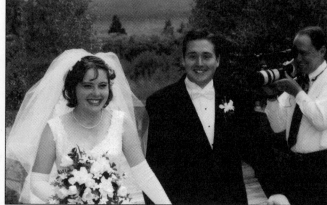

Understand What the Couple Wants

Before shooting a wedding video, sit down with the couple and talk with them about what they want in the video. Too often the person shooting the video imposes his or her own preferences and standards on the wedding video, much to the chagrin of the newlyweds. As the videographer, remember to keep the couple's objectives in mind. For example, if the couple is deeply religious, find out whether they would like to include special images or religious symbols in their video. Also, you might ask them whether anyone other than the immediate family should receive special attention in the video. And, if circumstances dictate, should anyone *not* appear in the video?

Develop a list with the couple to outline all of the people they want to make sure to include in the video and the sequence of events that the couple want recorded.

When making this list, be sure to caution the couple that this list is only a wish list. You may not be able to record everything they want. But at least you can create a mutual road map.

As the videographer, you must never forget whom the video is for. Many of the people at the wedding may be your friends or family. Just keep in mind that for the time being the wedding couple are also your clients, whether you're being paid with dollars or a spaghetti dinner.

You must show impartiality in your recording. I emphasize this because impartiality is so hard to maintain. No matter how much more attractive one of the families appears on camera than the other, balance is your job. Total balance is tough with a single camera. By virtue of where you stand (assuming you're situated somewhere at the front), one side of the wedding party will automatically look into the camera and one will look away. So what can you do? Balance your footage. If one side of the family is shot more favorably during the ceremony, get plenty of footage of the other side outside the ceremony.

Better yet, if your budget allows for two cameras, position one on each side of the ceremony! Later, during the editing phase, you can switch back and forth between video from one camera or the other. This will greatly ease the task of creating a video that provides balanced coverage for both sides of the family.

Use an Audio Recorder

When filming the wedding, you must determine what your audio needs. No matter how beautiful the visual part of video is, the sound is just as important. First, you need to record the marriage vows. Second, you need to record the minister's (rabbi, justice of the peace, ship captain) voice. Third, you may want to record the music.

If you use the microphone on your camcorder, be careful not to place your camcorder near the music source or near the speakers for the music system. In addition to headaches during the ceremony, you'll have headaches during the editing as you try to overcome the imbalance of the sound on your videotape. You can use headphones to check for imbalanced sounds. But be careful to protect your ears against sudden, large changes in volume.

You can record the vows with a wired or a wireless microphone. However, you may run into a situation in which neither of these options is possible. When all else fails, place a battery-operated recorder as close as possible to where the vows are taken. Turn the recorder on before the wedding begins — and remember to collect it at the end!

You can later record the audio from the recorder directly into your computer using the line input on your computer's sound card. The audio recording becomes a .WAV file on PCs and an .AIFF file on Macs. After you record the audio file, you can import it into your video editing software. Your biggest challenge is to match the audio with the speaker's lip movements in the video.

Chapter 9 provides suggestions for using "scrubbing" in the editing process. Scrubbing is a way of moving your video and your audio frame by frame. A common way of matching video and audio from two different sources is to create a synchronization of the sound and the video through scrubbing.

Position Yourself for the Shot

Whether you like it or not, you can't avoid calling attention to yourself when you use a camcorder at a wedding. But you can help avoid distracting the guests' attention from the wedding ceremony itself.

One of the most useful tools I have in my arsenal as a videographer is tactful boldness. By this I simply mean taking advantage of whatever shot is immediately available. Often, I attempt to tactfully set up for a shot when attention is diverted somewhere away from where I am positioning my camcorder. A good example of a situation in which to use tactful boldness is during the wedding processional, like the one shown in Figure 16-2. (Notice that the camcorder height is appropriate for the two being recorded.)

Without undue attention, you can position yourself (holding your camera, rather than using a tripod) at the front of the church when people are looking the other way. By taking this position, though, you need to communicate to the minister that you know what you're doing and that you know when and how to retreat without being noticed. Obviously, that moment is when the bride begins to come down the aisle. If you handle this moment correctly, you will most likely be trusted throughout the rest of the ceremony.

Here's my basic ethic of recording: Never record something you haven't received permission for or been asked to record. Before the ceremony, ask the bride, the bride's parents, and the minister if you have their permission to discreetly move about the sanctuary during the ceremony. Though not always, usually you receive permission. Either way, though, you have demonstrated courtesy.

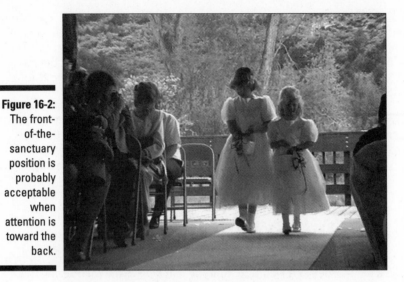

Figure 16-2:
The front-
of-the-
sanctuary
position is
probably
acceptable
when
attention is
toward the
back.

Seeing a Wedding through a Videographer's Eyes

After you accept the invitation to record a wedding, you are no longer a guest. You are part of the wedding party. You are the historian. Accept your role with pride — but also with humility. From the time you arrive, your role is only to be the videographer. Keep in mind that you won't have a lot of time to chat with friends and throw rice; you'll be shooting video of everyone else having all the fun!

Still, guest or not, dress appropriately for the occasion. Even if you don't know a single person at the ceremony, a wedding is a wedding and you should dress accordingly. Not only will this help you blend in and make you feel less awkward, it will also help extend some goodwill that you will inevitably need throughout the day.

Adding to Your Material After the Ceremony

A videographer's number one attribute is having an elephant's memory. I take great pains to remember the people who, for some reason, I couldn't get on camera during the ceremony. Then I seek out those people during the reception (or whatever kind of congregating that takes place after the wedding)

and get lots and lots of flattering video (video of someone eating or drinking is usually *not* flattering). If anything, I tend to overcompensate by giving them too much attention.

Look for the person who may be easily overlooked or who seems to be intentionally avoiding your lens. I figure that if I give special attention to such a person, everything else will take care of itself. And it almost always does. Inevitably, when the wedding couple reviews my finished work, they react with glee that I recorded Aunt Norma or Cousin Dick. They wonder how I knew that I should include her or convince him to agree to being recorded.

One powerful way to make your wedding video special is to use your camcorder to collect all the little details of the wedding that might otherwise be forgotten. You can shoot the invitation, the menu, the birdseed and rice, a corsage, the table decorations, and whatever else you have the patience and the artist's eye to notice. A segment of video showing a collection of the cards people gave to the couple can make a nice backdrop for credits at the beginning or end of the video.

A wedding videographer is a storyteller. Your main story line, of course, is the wedding and you have no trouble identifying the hero and heroine. But much of the quality of the story is in its depth and its surprising twists and turns of plot provided by the supporting cast — the wedding guests. Spend a lot of your time pointing your camcorder at them (as I'm doing in Figures 16-3 and 16-4).

Figure 16-3:
Always keep an eye trained on the bride and groom and watch for the unexpected guest.

Figure 16-4:
Sometimes a layered shot (a picture within a picture) of guests admiring the newlyweds is very effective.

Looking for a Symbol

The advancements of digital video allow you to make a small amount of video footage look like a lot, to mask imperfections, and to add beauty and energy to seemingly trivial moments of life. Digital video allows you to be a story-teller. You find yourself imagining and playing with "what-ifs" rather than fiddling and struggling to make machines perform correctly.

For instance, you can make a common, inanimate object become a dynamic symbol of a wedding. Each wedding is different and each provides you with its own symbol. For the wedding video on the CD-ROM (in the back of the book), I chose the figures on top of the wedding cake (see Figure 16-5) as the symbol. You could just as easily choose a still photo of the bride and groom kissing or hugging.

Editing in Some Magic

Every wedding video is the unique product of the people who appear in it, as well as the person who puts it all together. While the desires of the wedding couple and their families determine many of the details of the video, your own creative vision is what makes it truly enjoyable to watch as the years roll by. This is why the editing stage plays such an important role in any wedding video you work on.

Figure 16-5:
A figurine
atop a
wedding
cake can
serve as a
symbol in
the wedding
video.

The sample wedding video on the CD (wedding.avi for Windows users, wedding.mov if you have a Mac) contains some creative elements that were incorporated during the editing phase:

✔ **Pick the key moments and best shots to include in the video.** In the sample video you find a sequence that includes the procession of the bride, the father "giving her away," and the couple turning towards each other. Although this sequence lasts less than a minute in the video, it was culled from over ten minutes of actual footage.

✔ **Transitions between clips feature a tender image of the couple.** This special effect is the result of modifying a picture in Photoshop (covered in Chapter 13), and then using the modified graphic in Premiere (Chapter 9) during transitions. Figure 16-6 illustrates how Photoshop was used to produce the transition graphic.

These are just two examples of creative ideas for making the wedding video more enjoyable and special for the couple. Dig into your own bag of video editing tricks to see what you can find!

Once you've constructed your gorgeous wedding video, you can put it on videotape or on the Web, you can send it to far-away relatives as email, and you can burn it on a CD-Recordable disk. See Chapter 14 for more on distributing movies.

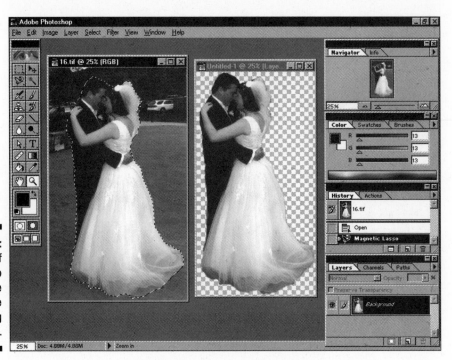

Figure 16-6:
Cutouts of
actual video
can be
effective
wedding
symbols.

Chapter 17

Ten Great Toys Under $200

*O*nce upon a time, someone with a keen sense of reality referred to film and video creation gear as "toys." The name stuck, probably for good reason. The term says more about the users than it does about the equipment. Many people who like to play by making videos still aren't sure what they want to do when they grow up — even though many of them have children (and grandchildren) of their own. After all, creating video is a child of the entertainment industry. So, how serious can you get?

This chapter features many products that are available and worth your consideration. I offer suggestions about these products based on my own experience and recommendations from other videographers who have been around the block a couple of times. Just remember that these are only suggestions and that only you know if they fit your needs.

I included only products that are available online because you'll never find products like these in stores unless you live in a large city. (And even if you do live in a large city, you might not find them all.) The Web site for each of these products contains a wealth of information, and for that reason, my product descriptions are brief. And one last point: Although I suggest an online vendor for each product, this doesn't mean that you can't shop around to find an even better deal.

Digital Sound Effects

What's the least you can pay for sound effects for your movie editing project? How about free? Yup. That's what I said. All you need is a connection to the Internet to download a wide variety of free sound effects for your video. At www.hollywoodedge.com, you find immediate access to everything from the sound of someone eating potato chips to the sound of a spaceship landing. Although I can't think of many applications for either of these particular sounds, you'll find lots of other sound effects that may prove to be useful, such as baseball hits, airplane sounds, and bugle charges. Of course, the people at Hollywoodedge.com hope you like their service so much that you'll pay money to download something from their extensive library that is available only to paying customers. Prices start in the low hundreds.

Using Someone Else's Music

Sometimes what your video project needs is just the right music. If you aren't a musician yourself, you'll have to use someone else's music. How do you get around the problem of copyright restrictions for using someone else's music in your video? The answer is, you don't. You either need to get permission to use the music or create music of your own.

Most of the music you find in music stores and elsewhere is *not* available for use in video or other presentations without permission. If you want to get permission for using some good background music, I suggest you go to www.sigmusic.com, the Internet home of Signature Music, Inc., which offers a wide variety of music styles. For $99.95, you receive permission to copy and use music in their database.

Adding Animations to Your Video

Looking for animation to add to your video production? For just $29.95, you can subscribe to a service that provides access to virtually thousands of animations. Go to www.animfactory.net and enter Animation Factory's Premium Gold Site. All of the animations on this site have been created by the Animation Factory staff and can be used on Web pages, in movies for e-mail, multimedia presentations, and video.

You may not believe this until you try it, but making your own custom three-dimensional animation is extremely easy. Ulead Cool 3D (www.ulead.com) offers a very cool way to make powerful three-dimensional titles and animations. For $79.95, you get 24 impressive special effects and the ability to create custom three-dimensional spheres, cones, and other shapes. The

software includes a large number of textures for your animation. The combination of special effects and textures makes the variety of your animation possibilities extensive.

Available Software and Capture Cards

Pinnacle Systems offers its award-winning Studio DV capture card and software for transferring full-screen, full-motion video from your digital camcorder to your PC. The Studio DV software allows you to capture video clips and still frames in any order from your digital video tape. The Studio DV software contains titling and basic video editing capabilities. The IEEE-1394 capture card can be used with Adobe Premiere and Microsoft Movie Maker. You can purchase Pinnacle Studio DV online at www.pinnaclesys.com for $149.

If all you need is a good IEEE-1394 (FireWire) capture card, many other affordable alternatives are available for less than $50. But before you jump at the cheapest deal you can find, check three things:

✔ Make sure that any IEEE-1394 card you buy is open host controller interface (OHCI) compliant. If the card's documentation does not clearly identify it as OHCI compliant, it may not work for capturing digital video.

✔ Check to see if the card comes with at least one 6-pin to 4-pin IEEE-1394 cable. The 6-pin connector on one end of the cable attaches to the IEEE-1394 card, and the 4-pin end connects to your camcorder. IEEE-1394 cables aren't necessarily available at every corner computer store, so getting one with the card should save you the headache of finding one on your own.

✔ Browse online for product reviews and buyer feedback. A good place to research almost any hardware you plan to buy is CNET (www.cnet.com).

Recordable CDs

Compact Disc-Recordable (CD-R) drives have gone down in price dramatically during the last few years. Fast, reliable CD recorders are widely available for $200 or less. CD-R drives can be found at nearly all computer stores. Blank CD-R discs are pretty cheap; 50-disc spindles sell for as little as $25. Many new computers come with CD-R drives built in.

A CD recorder can be an important tool for your personal video studio. Most CD-R discs hold 650MB (megabytes) of data. This may not sound like a lot in the storage-hungry world of digital video, but it is a useful size for backing up clips, exchanging short videos, or sharing longer videos that are saved at a lower-quality level.

Writing Material for Your Movie

Have you ever wanted to write a video script or short story but didn't know where to start? You're not alone. Writing is tough — even for professionals. What the professionals won't tell you is that many of them use an inexpensive, powerful little software program called DreamKit. DreamKit walks you through the steps of creative writing — from the raw idea all the way through to the finished product. You can read about this $99.00 product and purchase it by going to www.screenplay.com. I think you'll be pleasantly surprised.

Organize Your Digital Photos

Chapter 12 presents information on Epson Film Factory. A free trial version of the software is on the CD-ROM at the back of this book. If you're interested in reading more about the software program or buying it, go to www.epson.com. For only $39.95, you can receive a key via e-mail that turns your trial version into your own permanent copy.

Working with a Tripod

If you use your camcorder a lot, sooner or later you're probably going to need a tripod and head. Tripods and their heads can be extremely expensive. The cost of a professional tripod and head starts at around $1,500. Most users of digital camcorders are looking for something a little more basic. A good, basic tripod and head is available at www.888camcorder.com. I wouldn't go so far as calling this product deluxe or professional (as the advertisement suggests) but at $135, they are reasonably priced and good for holding your digital camcorder in situations when you need stability and the ability to pan and tilt smoothly.

Cheaper tripods are available for as little as $20 at your local department store. Many of these tripods claim to be "designed for video use," and sure enough they will thread into the bottom of your camcorder just fine. The problem with cheaper tripods is that as you try to pan or tilt the camera, the head will not move smoothly, resulting in jerky movements in the video. A good video tripod has a fluid head, which eliminates the jerky pans and tilts associated with cheaper tripods.

Shoulder Mounts for Your Camcorder

If you have seen *The Blair Witch Project,* you probably remember that a lot of that movie's video was shot while people were walking or running, evidenced by the rough movement and handling of the camera. The jerky video was intentional because the video crew was actually part of the story. Most of the time, however, you want your video to be smooth and as free from movement as possible. This is easy if you have a tripod, but if you must hold the camcorder in your hand — and especially if you must walk as you shoot — holding the camera steady can be a real challenge.

One solution is the DV Steadicam, but it costs way more than $200 (see Chapter 18 for more on the Steadicam). A simpler, more reasonably priced solution is a shoulder mount. A shoulder mount attaches to your camcorder and rests on your shoulder. Like the stock of a rifle, this mount uses your body to stabilize the unit. The 888-Camcorder folks (www.888camcorder.com) offer a shoulder mount for $85.

A Web-Based Slide Show

Wouldn't it be nice to create a slide show of your favorite digital stills and put them on a Web page for relatives and friends to see instantly anywhere in the world? You can. RealNetworks, the company famous for creating the RealPlayer streaming video application, has distributed a product for placing your digital photos into a slide presentation and uploading it to a free Web server. The product is called RealSlideshow Plus. It costs only $69.95 and you can read all about it and purchase it online at www.real.com.

Chapter 18

(Almost) Ten Great Toys Over $200

*I*n this chapter, I give you a tour of equipment and software that gave birth to digital video creation and the video editing suite. Depending on your individual needs and what you can afford, you can start just about anywhere in building your own suite.

So what do you want to play with? Do you want to dabble only in a few inexpensive necessities? Or do you want to jump fully clothed into a vat of electronic slush and make a complete idiot of yourself? Most of us fall somewhere in between these two scenarios. We don't want anyone laughing at our toys because they're dime store stuff, but we want to somehow justify our financially sound decisions. Basically, we want to enjoy our toys now *and* when the rent is due.

In this chapter, you find products that can be bought online. I focus on Internet shopping because you won't find products like these in stores unless you live in a very large city. And even if you do, you still may not find them. The Web sites for each of these products contains a wealth of information. For this reason, my product descriptions in this chapter are brief. And even though I suggest an online vendor for each product, feel free to shop around to find an even better deal.

Canon FR-100 Floppy Disk

One of the problems that you may have already experienced with your digital camcorder is that you can't share your digital gems with people unless their computer is equipped with a FireWire card. Canon Corporation offers a new product called the FR-100 Floppy Disk that helps you avoid this situation. This little hummer connects to the digital video port on your camcorder and records still images in one of three resolution choices. Images on the disk can then be transferred to any computer. Slick, huh? You can read more about this $239 product by going to www.dvdirect.com.

Adobe Photoshop

Adobe Photoshop 6.0 continues to be the image-editing software program of choice for graphics professionals. With Photoshop, you can perform advanced editing of pictures and other graphics (see Chapter 13).

Photoshop provides features that offer something for every user. It supports the user — novice or professional — with features that help achieve the highest quality results. If you're new to graphics software programs, you can quickly learn how to create powerful text, to crop, and to resize your image. If you're a frequent user, you'll easily pick up features such as filtering and special printing techniques. Photoshop helps you discover your creativity.

You can check out this software program by reading Chapter 13 and by using the free trial version available on the CD that comes with this book. You can read about Adobe Photoshop and purchase this $609 product online by going to www.adobe.com/products/photoshop/main.html.

Adobe Premiere

Adobe Premiere is one of the most powerful tools for digital video editing available to the home moviemaker. You'll find this tool easy to use if you're new to digital video but, unlike some other programs, you won't outgrow its abilities as your skills become more advanced. Many video professionals use Premiere, too, which is a testament to its power and versatility.

If you can imagine it, you can probably do it with Adobe Premiere. You can produce for video, for multimedia, and for the Web — or even all three simultaneously. A trial version of Premiere is on the CD that comes with this book, and I cover some of the basics in Chapter 9. Adobe Premiere costs $549, and you can purchase it online at www.adobe.com/products/premier/main.html.

iMac

The stage was set with the advent of FireWire, an Apple innovation. The technology was advanced through professional Mac-based products like Avid. Now you, the home moviemaker, have the opportunity to create digital video with the iMac computer. iMac makes your creative potential come alive with a version designed specifically for digital video. Read all about it and purchase iMac online at www.apple.com. Prices for the digital video version start at $1,000.

Sony's Digital Studio

Any number of PCs have digital video-related features. Some PCs are even designed exclusively for digital video creation. One such PC is the Sony Vaio PCV-R545DS Digital Studio computer. Priced for the home moviemaker with features found on more-expensive professional models, this computer offers FireWire, a CD rewriteable drive, and a full-fledged video editing system. This computer costs $1,200 and you can find it at www.compusa.com.

DV Steadicam

Okay — I'll admit it — this is a frill. Nevertheless, DV Steadicam is a very popular frill. Designed by the folks who created the Oscar-winning Steadicam for the film industry, this little device (made specifically for camcorders weighing 2 to 5 pounds) holds your camcorder like a portable tripod. The DV Steadicam makes it possible for you to float like a butterfly through rough territory with virtually no shake to your camcorder. Ever wonder how *Monday Night Football* gets such steady game footage from camera operators who must run along the sidelines to keep up with the action? You guessed it; the camera operators have their cameras mounted on Steadicams.

Even if this is something you may never need or want, I suggest that you at least visit the site at www.steadicam.com. Oh, by the way, this little toy costs a mere $1,395.

Microphones

Here's a common video creation problem: You need to set up your camcorder in a not-so-great spot. For example, say that you're 75 feet from your subject. You can zoom in and pick up most of what you need visually. The only real

problem is the sound. To make matters worse, an audience of coughing, sneezing, yawning, whispering people sits between you and your star. Sound familiar? Were you shooting your child's school play?

Your camcorder's microphone is worse than worthless. It picks up everything except your child's kazoo masterpiece. But . . . no problem! Unbeknownst to your first-grader's friends and teachers, she's wearing a wireless microphone hidden in her platypus costume. Because of your camcorder's advanced audio features, you can dial out the camcorder microphone and input symphony-quality digital sound. You couldn't do much better in a studio. You accomplish this with a wireless microphone.

A *wireless microphone* is actually three pieces of equipment:

- A microphone
- A transmitter
- A receiver

The microphone collects the sound. The transmitter turns the sound into a radio signal. The receiver picks up the radio signal and turns it back into sound. The receiver is connected to the camcorder.

Samson's UM1 Micro Diversity System offers three choices of microphones: a hand-held microphone, a lavalier microphone (worn on a lapel), and a head-set microphone. The transmitter is small and can be worn on a belt. The receiver is housed in a compact package and provides crystal-clear reception for digital-quality sound. Because of the receiver's small size (2.63 inches wide, 4.21 inches high, and 0.91 inches in diameter), the UM1 fits easily on a digital camcorder. I discuss sound in detail in Chapter 5. You can read more about the Samson UM1 Micro Diversity System and purchase it online for $519 at www.fullcompass.com.

Stock Footage

Imagine this scenario. You're making a video and you need a clip that takes a viewer on a trip through the clouds, around a racecourse at 200 mph, or inside a sunken ship 300 feet below the surface of the ocean. You've got to have the clip, but you don't have a clue where to find it. Now you know. Go to www.artbeats.com. When you pay the one-time fee, you can use the video in any way that you want. Stock footage isn't cheap — it starts at around $200. But for some projects, the price is worth it.

Recordable DVDs

You've been to the video rental stores. Half the space is devoted to the standard VHS movies, and half the space is now devoted to DVD. DVD is taking over the world of movie playback. And now, if you have a CD burner, you can burn DVDs, too. Make your video and burn it to DVD with DVDit! Learn about this breakthrough system (prices start at $499) by going to www.dvdit.com.

High-End Software

Have you ever watched one of those "making of" documentaries where you learn how movies such as *Star Wars, Titanic,* and *Toy Story* were made? You probably saw lots of scenes of video artists slaving away in front of computer screens, creating computer graphics (CG). If the pros can use CG software to create Jar Jar Binks, surely some of that technology is available to you, as well. Indeed, Digital Video Direct (www.dvdirect.com) is an excellent source for advanced CG software, as well as software to help you create your own music and almost anything else you might need to outfit your digital video studio. Of course, most of the high quality software available here isn't cheap; a program called ElectricImage, which can be used to animate 3-D objects, retails for $995.

Part VI
Appendixes

The 5th Wave — By Rich Tennant

@RICHTENNANT

"WELL! IT LOOKS LIKE SOMEONE FOUND THE 'LION'S ROAR' ON THE SOUND CONTROL PANEL."

In this part . . .

In the chapters throughout this book, I've tried to cover all that you need to know to be a top-notch digital home moviemaker. But I have more helpful info to share in this part.

Appendix A is essential: It tells you how to copy or install all the neato stuff from this book's CD-ROM onto your computer. Appendix B is a glossary of all the terms that you wish you didn't have to know for video production and editing.

Appendix A

About the CD

● ●

*H*ere is a sample of the programs available on the *Digital Video For Dummies,* 2nd Edition, CD-ROM:

- ✔ **QuickTime 4.1:** A free program that provides you the means to import, play, and store over 200 types of media with your Mac or PC.

- ✔ **QuickEditor 6.0:** A shareware program that allows you to edit movies and add special touches such as titles, transitions, and audio that make your videos even better.

- ✔ **Adobe Premiere 5.1** and **Adobe Photoshop 5.5:** These tryout versions for Windows and Mac offer professional-quality video and graphics.

- ✔ **MainVision 1.0:** This demonstration version for Windows is another high-end video-editing programs with tons of additional features that are perfect for editing and enhancing your videos.

- ✔ **MovieWorks:** This trial version for Macs offers a suite of applications for creating Web movies.

- ✔ **Film Factory:** Available for Mac and PC, this program provides a user-friendly interface for editing your still photos taken from video.

- ✔ **Zwei-Stein 2.28:** This trial version for Windows is a Multitrack video editing/compositing system.

- ✔ **Ulead COOL 3D 3.0** and **Ulead MediaStudio Pro 6.0:** These trial versions for Windows offer 3D graphics and video editing.

System Requirements

Make sure that your computer meets the minimum system requirements listed below. If your computer doesn't match up to most of these requirements, you may have problems using the contents of the CD-ROM.

- ✔ A PC with a 486 or faster processor, or a Mac OS computer with a 68040 or faster processor.

- ✔ Microsoft Windows 95 or later, or Mac OS system software 7.55 or later.

- ✔ At least 32 MB of total RAM installed on your computer. For best performance, we recommend at least 64 MB of RAM installed.

- ✔ At least 120 MB of hard drive space available to install all the software from this CD-ROM. (You need less space if you don't install every program.)

- ✔ A CD-ROM drive — double-speed (2x) or faster.

- ✔ A sound card for PCs. (Mac OS computers have built-in sound support.)

- ✔ A monitor capable of displaying at least 256 colors or grayscale.

- ✔ A modem with a speed of at least 14,400 bps.

If you need more information on the basics, check out *PCs For Dummies,* 7th Edition, by Dan Gookin; *Macs For Dummies,* 6th Edition, by David Pogue; *iMac For Dummies,* by David Pogue; *Windows 98 For Dummies,* or *Windows 95 For Dummies,* 2nd Edition, both by Andy Rathbone (all published by IDG Books Worldwide, Inc.).

Using the CD-ROM with Microsoft Windows

To install the items from the CD-ROM to your hard drive, follow these steps.

1. **Insert the CD-ROM into your computer's CD-ROM drive.**

2. **Click Start➪Run.**

3. **In the dialog box that appears, type** D:\IDG.EXE.

 Replace *D* with the proper drive letter if your CD-ROM drive uses a different letter. (If you don't know the letter, see how your CD-ROM drive is listed under My Computer.)

4. **Click OK.**

 A license agreement window appears.

5. **Read through the license agreement, nod your head, and then click the Accept button if you want to use the CD-ROM — after you click Accept, you'll never be bothered by the License Agreement window again.**

 The CD interface Welcome screen appears. The interface is a little program that shows you what's on the CD-ROM and coordinates installing the programs and running the demos. The interface basically enables you to click a button or two to make things happen.

6. **Click anywhere on the Welcome screen to enter the interface.**

 Now you are getting to the action. This next screen lists categories for the software on the CD-ROM.

7. **To view the items within a category, just click the category's name.**

 A list of programs in the category appears.

8. **For more information about a program, click the program's name.**

 Be sure to read the information that appears. Sometimes a program has its own system requirements or requires you to do a few tricks on your computer before you can install or run the program, and this screen tells you what you may need to do, if necessary.

9. **If you don't want to install the program, click the Back button to return to the previous screen.**

 You can always return to the previous screen by clicking the Back button. This feature allows you to browse the different categories and products and decide what you want to install.

10. **To install a program, click the appropriate Install button.**

 The CD interface drops to the background while the CD-ROM installs the program you chose.

11. **To install other items, repeat Steps 7–10.**

12. **When you finish installing programs, click the Quit button to close the interface.**

 Eject the CD-ROM and carefully place it back in the plastic jacket of the book for safekeeping.

In order to run some of the programs on the *Digital Video For Dummies,* 2nd Edition, CD-ROM, you may need to keep the CD-ROM inside your CD-ROM drive. Otherwise, the installed program will require you to install a very large chunk of the program to your hard drive, which may have kept you from installing other software.

Using the CD-ROM with Mac OS

To install the items from the CD-ROM to your hard drive, follow these steps.

1. **Insert the CD-ROM into your computer's CD-ROM drive.**

 In a moment, an icon representing the CD-ROM you just inserted appears on your Mac desktop. Chances are, the icon looks like a CD-ROM.

2. **Double-click the CD icon to show the CD's contents.**

3. **Double-click the License Agreement icon.**

 This is the license that you are agreeing to by using the CD-ROM. You can close this window after you look over the agreement.

4. **Double-click the Read Me First icon.**

 The Read Me First text file contains information about the CD's programs and any last-minute instructions you may need in order to correctly install them.

5. **To install most programs, open the program folder and double-click the icon called "Install" or "Installer."**

 Sometimes the installers are actually self-extracting archives, which just means that the program files have been bundled up into an archive, and this self-extractor unbundles the files and places them on your hard drive. This kind of program is often called a .sea. Double click anything with .sea in the title, and it will run just like an installer.

6. **Some programs that don't come with installers. In that case, just drag the program's folder from the CD window and drop it on your hard drive icon.**

After you install the programs you want, eject the CD-ROM. Carefully place it back in the plastic jacket of the book for safekeeping.

What You'll Find

Shareware programs are fully functional, free trial versions of copyrighted programs. If you like particular programs, register with their authors for a nominal fee and receive licenses, enhanced versions, and technical support. Freeware programs are free, copyrighted games, applications, and utilities. You can copy them to as many PCs as you like — free — but they have no technical support. GNU software is governed by its own license, which is included inside the folder of the GNU software. There are no restrictions on distribution of this software. See the GNU license for more details. Trial, demo, or evaluation versions are usually limited either by time or functionality (such as being unable to save projects).

Here's a summary of the software on this CD-ROM arranged by category. If you use Windows, the CD interface helps you install software easily. (If you have no idea what I'm talking about when I say "CD interface," flip back to the section, "Using the CD-ROM with Microsoft Windows.")

If you use a Mac OS computer, you can take advantage of the easy Mac interface to quickly install the programs.

Film Factory

Film Factory is a photo-editing program that delights the eyes. Available in both Mac and PC versions, this easy-to-use program allows you to take the still photos from your video, scanner, or digital camera and prepare them to send as e-mails or print them out for everyone to enjoy. Film Factory is also available at www.epson.com/cgi_bin/Store/Redirect.jsp?link=esff.

Adobe Photoshop 5.5 Tryout Version

Adobe Photoshop for Windows and Mac is an image-editing program, which enables you to create, change, and correct images for your video.

Photoshop is located in the folder Programs\Photoshp. Visit the Adobe Web site for more information at www.adobe.com/products/photoshop. Photoshop is covered in greater detail in Chapter 13.

Adobe Premiere 5.1 Tryout Version

Adobe Premiere is an easy-to-use, powerful, professional-quality application for video editing.

It is located in the folder Programs\Premiere. Visit the Adobe Web site for more information at www.adobe.com/products/premiere. Chapter 9 shows you how to use this powerful program.

QuickEditor 6.0 Shareware

QuickEditor 6.0 is available for both Mac and PC and provides an easy-to-understand interface that allows for fast viewing, editing, and management of your videos. For more information, visit the QuickEditor Web site at http://wild.ch/quickeditor/.

MovieWorks Trial Version

MovieWorks for Mac is a suite of easy-to-use applications that work together to create videos, Web movies, and slide shows.

You can find MovieWorks in the folder Programs\moviewor. MovieWorks can also be downloaded at Interactive Solutions Web site for MovieWorks at www.movieworks.com/download.html.

QuickTime 4.1

QuickTime 4.1.2, for Mac and Windows, is the latest version of Apple's free player for video, sound, animation, graphics, text, and music.

QuickTime is located in the folder Programs\quicktim. Quicktime 4.1 can also be downloaded from Apple's Web site at www.apple.com.

Main Vision 1.0 Demo

For Windows only, the Main Vision 1.0 demo enables you to manipulate videos and add special effects using the easy-to-use interface. We have provided a demo on the CD-ROM, but you can also download Main Vision 1.0 from the Main Concept Web site located at www.mainconcept.com/products/mainvisionWin.shtml.

Ulead COOL 3D 3.0 Trial Version

This Windows program uses 24 special effects to create animated 3-D titles and graphics.

You can find Ulead COOL 3D in the folder Programs\ulead3d. A 15-day free trial version of Ulead COOL 3D can also be downloaded from the Web site at www.ulead.com.

Ulead MediaStudio Pro Trial Version

MediaStudio Pro 6.0 for Windows is an advanced, professional-quality video-editing program and is located in the folder Programs\uleadmed. Ulead Systems also offers a 15-day free trial version at www.ulead.com.

Zwei-Stein 2.28 Shareware

Zwei-Stein is a video-editing and compositing program for Windows that creates RealVideo files.

It's located in the folder Programs/zwei. Zwei-Stein 2.28 is also available at Thugsatbay's Web site at www.musicref.com.

Clips folder and contents

The CD-ROM includes a folder named CLIPS that contains the following graphics, video, and audio files:

Chapter 9 (Folder: CHAP09)

- girl1.avi
- girl1.mov
- jars1.avi
- jars1.mov
- natural1.aif
- natural1.wav

Chapter 10 (Folder: Chap10)

- eagle.avi
- title.bmp
- whitept1.bmp
- whitept2.bmp
- whitept3.bmp
- windwave.wav

Chapter 12 (Folder: Chap12)

- baddeck.jpg
- boatride.jpg
- cove.jpg
- lighthse.jpg
- seal.jpg
- whale.jpg

Chapter 13 (Folder: Chap13)

- colo1.tif
- colo2.tif
- colo3.tif
- colo4.tif

- colorado.avi
- colorado.mov
- mountain.aif
- mountain.wav
- pic1.tif
- pic2.tif
- pic3.tif
- pic4.tif

Chapter 15 (Folder: Chap 15)

- brian.avi
- brian.mov

Chapter 16 (Folder: Chap 16)

- wedding.avi
- wedding.mov

If You've Got Problems (of the CD Kind)

I tried my best to compile programs that work on most computers with the minimum system requirements. Alas, your computer may differ, and some programs may not work properly for some reason.

The two likeliest problems are that you don't have enough memory (RAM) for the programs you want to use, or you have other programs running that are affecting installation or running of a program. If you get error messages such as Not enough memory or Setup cannot continue, try one or more of these methods and then try using the software again:

- **Turn off any antivirus software that you have on your computer.** Installers sometimes mimic virus activity and may make your computer incorrectly believe that a virus is infecting it.

- **Close all running programs.** The more programs you're running, the less memory is available to other programs. Installers also typically update files and programs. If you keep other programs running, installation may not work properly.

✔ **In Windows, close the CD interface and run demos or installations directly from Windows Explorer or My Computer.** The interface itself can tie up system memory or even conflict with certain kinds of interactive demos. Use Windows Explorer or My Computer to browse the files on the CD-ROM and launch installers or demos.

✔ **Have your local computer store add more RAM to your computer.** This is, admittedly, a drastic and somewhat expensive step. However, if you have a Windows 95 PC or a Mac OS computer with a PowerPC chip, adding more memory can really help the speed of your computer and enable more programs to run at the same time.

If you still have trouble installing the items from the CD-ROM, please call the IDG Books Worldwide Customer Care phone number: 800-762-2974 (outside the U.S.: 317-572-3342).

Glossary

● ●

1 love the scene in one of the *Star Wars* films where Hans Solo runs out of ideas for repairing the Millennium Falcon. In hopeless frustration, he hits the dashboard, the ship bursts into full gear (or whatever a spaceship does) and the heroes and heroine streak into hyperdrive. The Rebellion lives for another day to fight The Dark Side.

Well, I imagine that you may have come back here in the recesses of this book with waning hope of finding the meaning of a technical word or phrase. May the influence on a body or system, producing or tending to produce a change in movement or shape or other effects be with you.

A/B roll editing: Editing from two video cassette players (source deck A and source deck B) or other video sources to a third VCR. This allows transition effects (such as wipes or dissolves) or special effects to be made using both video signals at the same time.

acquisition (collection): Creation of media for video production. Examples of acquisition can include recording with a camcorder, audio recording with an audio tape deck, and graphics creation with a computer.

aliasing: An undesirable jagged appearance of angled lines in a graphic or text caused by a computer's inability to display ascent or descent in any other manner than in square steps. See also *anti-aliasing*.

ambient sound: Background sound within range of a microphone such as the background sound of machinery within an office or the sound of traffic on a nearby street.

analog video: A video signal that represents a continuous variable of smooth gradations (like waves) of given levels. See also *digital video*.

anti-aliasing: The filtered blurring of the edges of a computer graphic or text to make the edges appear smooth. See also *aliasing*.

aperture: Controls the amount of light that reaches the focal plane. Aperture is the relationship between two factors: the diameter of the lens opening and the distance from the lens to the focal point. Aperture is controlled by iris adjustment. The higher the f-stop (for example, f2.0, f5.6, and so on), the lower the amount of light permitted to pass through the aperture. See also *focal plane*, *iris*, and *f-stop*.

artifact: A spurious distortion of a signal (picture or sound). An example of an artifact is partial "ghost" images slightly to the side of actual images.

aspect ratio: The ratio of an image's width to its height. For example, a conventional video display has an aspect ratio of 4:3 (4 picture elements in width for every 3 picture elements in height). An HDTV video display has an aspect ratio of 16:9, the same as most movie theater screens. The 16:9 aspect ratio is often called *widescreen*.

assemble editing: Adding to the end of a previously recorded videotape. Assemble editing in the middle of an existing program causes an undesirable glitch on the tape. This is due to an abrupt change in the sync information of the video signal.

AV (audiovisual): An abbreviation for anything having to do with hearing and sight in electronic media.

AVI (Audio Visual Interleaved): A file format in which audio and video are stored in alternate blocks. AVI is the Microsoft file format in Video for Windows.

backlight: Increases the perception of depth and dimension by separating a foreground subject from its background.

balanced cable: Typically refers to an audio cable configuration that cancels noise. Balanced cable often uses XLR connectors. See also *unbalanced cable*.

Betacam: A broadcast-quality videocassette format developed by Sony.

Betacam SP: Offers superior picture quality over Betacam. Betacam SP has a high signal-to-noise ratio. The Betacam SP uses metal particle tape.

BIOS (Basic Input Output System): System settings of a PC are stored in the BIOS. The settings include information about memory, hard disks, and disk drives.

bit: A unit of information in a computer. Bits store the color values of pixels in an image. The larger the number of bits used for each pixel, the more colors available:

- **1-bit color depth:** Pixels are either black or white.
- **4-bit color depth:** Pixels can be any of 16 colors or shades of gray.
- **8-bit color depth:** Pixels can be any of 256 colors or shades of gray.
- **16-bit color depth:** Pixels can be any of 65,536 colors.
- **24-bit color depth:** Pixels can be any of 16.7 million colors.

blocking: When shooting video or film, blocking refers to the intentional positioning of people on camera.

BNC connector: A twist-type connector often used with professional video equipment for connecting video cables.

broadcast quality: A video recording of high quality that would compare to the video quality of commercial television program.

B-Roll: A film and video slang term referring to a secondary footage (such as location shots) usually played from the "B" source player while continuing with audio from the "A" source in an A/B Roll editing system. The term is not precise in that all "B-Roll" isn't necessarily played on just the "B" source player. See also *A/B roll editing*.

capture: A procedure performed by a computer's capture card to digitize material from a video/audio source (camcorder, VCR, or audio playing device) and store it on the computer's hard disk.

capture card: A computer card that converts video from a camcorder into video in your computer.

CCD chip: In video, a camera acquires light and color on chips called *Charge-Coupled Devices,* or CCDs. These CCDs collect visual images and convert them into either an analog or a digital signal.

CD-R: *Compact Disc-Recordable.* A recordable version of a standard CD-ROM disc.

CD-ROM: *Compact Disc-Read Only Memory.* A mass storage medium for digital data such as software programs and multimedia. Most CD-ROMs can hold 650MB of data.

chip: A tiny electronic circuit that's mass-produced on a tiny wafer of silicon.

chroma key: Overlaying one video signal over another. Areas of the overlay are a specific color (such as chroma blue). The chroma color is made transparent.

chrominance: The part of a video signal pertaining to hue and saturation. See also *luminance*.

clip: Audio, video, or still graphics used in a nonlinear editing program.

coaxial cable: A heavily shielded cable that carries both audio and video signals.

CODEC (compressor/decompressor): A method used to compress and decompress image and sound data so that files are smaller and easier for a computer to manage.

collection: A folder for clips within Microsoft Movie Maker.

color depth: The number of bits used to define colors for screen pixels. See also *bit*.

color temperature: Measured in degrees Kelvin, color temperature is a way of standardizing the interpretation of color among various recording and playback devices. See also *Kelvin*.

content: A term referring to audio, video, graphics, and scripts used within a video.

continuity: A natural flow of events within a finished video. For example, a person entering a door should use the same hand (right or left) in a wide shot and a close-up. Otherwise, the change of right to left or left to right causes a break in continuity.

control track: Video editing equipment that reads the control track information from separate video player machines (source decks) in order to synchronize the editing between the two source decks. Control track editing is not as frame accurate as time code editing. See also *frame accurate*.

CPU (Central Processing Unit): The primary intelligence chip of a computer system. The term is often used to refer to the entire housing of a computer.

craning: Lifting or lowering of a camera.

DAT (Digital Audio Tape): A high-quality recording medium utilizing a small 4mm tape. The DAT format is often used to master a sound track or musical composition.

data rate: The amount of data a mass storage medium (such as a hard disk) saves and plays back per second. Also, the amount of data in one second of a video sequence.

depth of field: A dimension in front of and behind the focal plane where objects appear to be in focus. See also *focal plane*.

Digital 8: A format for digital camcorders that use 8mm or Hi8 tapes for storage. Sony and Hitachi both offer Digital 8 (also called D8) camcorders.

digital video (DV): Information stored bit by bit in a file representing video images. The digital video format is characterized by the absence of the noise and lost information — both of which are disadvantages of analog formats such as VHS and S-VHS.

digitize: The process of converting an analog signal (such as the waveform of a VHS video signal) into a binary signal.

dollying: Moving a camera forward or backward.

drop frame: Though the frame rate of video is 30 frames per second, it is actually 29.97 frames per second. Drop frame is a process developed by the Society of Motion Picture Engineers (SMPE) for television networks to keep video recording time within a real time frame, such as an hour-long program. Video editors such as Premiere offer drop frame and non-drop frame options for exporting movies. See also *non-drop frame*.

dropped frames: Missing data during the capture process.

dubbing: The procedure of making a video or audio copy. Also, to furnish a new sound track to film or video for exporting to another country.

duration: The length of a video clip or animation.

DVD: Digital Versatile Disc. The size of a CD, yet able to hold up to 17GB of data, DVDs are replacing VHS tapes as the standard for consumer video storage and playback.

editing: The portion of a video or film project after all the camera recording is completed. Sometimes professionals call it postproduction.

EIDE: *Enhanced IDE:* a faster version of the IDE hard drive interface. See also *IDE* and *Ultra ATA*.

export: You export a movie or audio file to turn the file into a movie or audio clip. After a video or audio file is exported, you can play it in other video or audio playback and editing programs and move it to other disks or platforms.

field: A video image made up of half the scan lines of a full image. All TV systems (NTSC, PAL, SECAM) use fields to avoid flickering images. For example, in NTSC (30 frames per second), half of the 256 lines of video (odd) are displayed 30 times per second and the other 256 (even) are also displayed 30 times per second — each half in its own field. The process is called interlace scanning. The images consisting of either odd or even lines are called fields.

file extension: The letters to the right of the period in a filename. The extension identifies the file type. The following are extensions common to software programs used for desktop publishing and video editing:

- ✔ **.ai:** A drawing created in Adobe Illustrator. These files can be used by Premiere for laying drawings on top of video images.
- ✔ **.aiff and .wav:** These are audio files created for use in a software program capable of playing or editing audio files.

✔ **.avi and .mov:** These are both video files either captured via a video capture card or created in a nonlinear editing program such as Adobe Premiere. The .mov and .avi files can be video only or video and audio files. The .mov file extension is recognized by the QuickTime video player. After the QuickTime player is installed, Adobe Premiere recognizes and allows you to use QuickTime files. The .avi file extension is recognized by Video for Windows (built into your Windows operating system).

✔ **.bmp, .tif, and .gif:** Each of these is a graphics file and can be created in a graphics program such as Adobe Photoshop. A .bmp file has a 256-color palette. A .tif file has a color palette of millions of colors. A .gif file is a graphic of limited color and resolution quality, but is well-suited for use in Web graphics because of its small file size.

✔ **.psd:** This is a multilayered graphic file created in Adobe Photoshop.

✔ **.rm:** These are RealPlayer files created in a RealNetworks RealProducer encoder. The .rm files are usually .avi, .mov, or .wav files created in a program such as Adobe Premiere and then encoded for playing on the Internet. After an .avi, .mov, or .wav file is encoded, it becomes an .rm file.

✔ **.WMV:** A Windows Media Video file. Movies saved in Movie Maker use this format.

FireWire: A commonly used synonym for IEEE-1394. FireWire is a trademarked term owned by Apple. Digital camcorders can connect to your computer using a FireWire port. See also *IEEE-1394*.

flag: In video and film production, a cloth or solid object used to block unwanted light.

focal length: The distance between the lens and the focal point is called the lens focal length.

focal plane: In video and film, the point where the object being photographed is in focus.

focal point: Lenses are convex in shape (curved outward) and bend an image and reduces it to a point, called the focal point. Focal point is halfway between the lens and the focal plane.

frame: A frame is a single video image. NTSC video plays 30 frames per second, and each video frame consists of two half-frames called fields. See also *field*.

frame accurate: The ability of editing equipment to start, stop, and search for specific frames of video. Frame accurate editing requires the use of time code. See also *control track*.

frame rate: The number of frames that play per second.

f-stop: Adjusting the diameter of the lens (controlling the amount of light that reaches the focal plane) by adjusting the iris of the lens. See also *focal plane* and *iris*.

generations: The number of times a video clip is copied or processed.

hard light: A single light source (such as a lamp) that illuminates an image and creates distinct shadows.

Hi-8: A video format using 8mm-wide tape. Hi-8 is equivalent in quality to S-VHS.

IDE: *Integrated Drive Electronics*. This is a common hard drive interface used in many PCs. See also *EIDE* and *Ultra ATA*.

IEEE (Institute for Electrical and Electronics Engineers): Sets standards for electrical and electronic devices and systems.

IEEE-1394: A low-cost digital interface developed by Apple that integrates cameras, recorders, and computers. For example, digital video images on a cassette in a digital camcorder can be transmitted through 1394 cable connected to a 1394 capture card to a computer hard drive. IEEE-1394 adapters can also be used to connect external hard drives, printers, and other devices. See also *FireWire*.

in point: The first frame in an edit.

in's and out's: The first and last frame of a video edit. See also *in point* and *out point*.

interactive multimedia: Graphics and video signal played from a CD-ROM, hard drive, laserdisc, DVD, or over the Internet allowing the viewer to respond directly to questions or options.

interleave: An arrangement in some CODECs (such as AVI) in which audio and video data alternate.

JPEG (Joint Photographic Experts Group): Sets standards for image compression.

Kelvin (K): A unit of measurement of the temperature of light in color recording.

key frames: Frames selected within a timeline for beginning or ending an action or effect.

key light: The primary light source on an image. A key light sets the directions of shadows in a scene.

LCD (liquid crystal display): Most commonly known for its use in wristwatch faces. LCD often refers to a display system used for some projectors and monitors. Some cameras have LCD viewfinders.

linear editing: The recording of video from a source tape to a recording tape. Linear editing is performed by adding video segment by segment, one after the other, onto the recording tape.

location planning: Planning for recording a video production away from your home or business.

log: A time code list of beginnings and endings of scenes during video recording.

luminance: The part of a video image signal carrying brightness information.

maximum aperture: The widest diameter allowed by the lens for collecting light.

MIDI (Musical Instrument Digital Interface): A standard means of sending digitally encoded music information between electronic devices, such as between a synthesizer and a computer.

MiniDV (minidigital video): A miniaturized digital video format. MiniDV is standardized among many manufacturers (such as Canon, JVC, Panasonic, and Sony) making it possible to record or play MiniDV tapes in any device designed for this format. MiniDV tapes can also be played on some professional devices, such as Sony DVCAM players.

moire: A herringbone-like form of video noise caused by some close-knit fabrics or surfaces.

monitor: A type of television that receives a composite and/or component video signal directly from a VCR or camera.

MPEG (Motion Pictures Expert Group): This group defines standards for compressing moving images. Also, a kind of compression that reduces the size and bandwidth of a video signal.

multimedia: Refers to the combining of different computer-based media into a single presentation. Audio, text, graphics, and animation are often the basis of a multimedia presentation. Typically, multimedia presentations are played back directly from the computer.

non-drop frame: Uses the 30 frames per second. Non-drop frame is an inaccurate rate recording. For example, one hour of playback of non-drop frame is 08 frames longer than an actual hour. See also *drop frame*.

nonlinear editing: A computer-based form of video editing. As its name implies, nonlinear editing allows open-ended, unlimited adding or changing of video and audio edits within a video editing project.

normal angle: Describes angles of view and perspective that seem natural to the eye. Normal angles lie somewhere between wide and telephoto angles.

NTSC (National Television Standards Committee): Maintains the standardized NTSC color broadcasting system that is used in the U.S. and many other countries. NTSC video is based on 525 lines of interlaced resolution delivered at 60 fields per second (30 frames per second).

out point: The last frame of an edit.

PAL (Phase Alternate Line system): Television broadcast standard for most of western Europe and Asia. Based on 625 lines interlaced at 50 fields per second (25 frames per second).

panning: The horizontal turning of a camera.

PCI bus (Peripheral Component Interconnect): A 32-bit local bus for transferring data. A PC1 bus can transfer 132 megabytes per second maximum at a clock frequency of 33 MHz.

pixel (picture element): The smallest "unbreakable" element of a picture on a monitor's screen.

playhead: When editing, the place of a video in an editing monitor.

plug-in: A software tool designed to be used as an accessory to another program. For example, extra graphics filters can be added to Adobe Photoshop as plug-ins.

prosumer: A term coined in the video production industry to denote equipment that may be classified as both "professional" and "consumer."

RAM (Random Access Memory): The memory (measured in megabytes) used in personal computers.

RCA connector: A connector used for connecting consumer (and some prosumer) audio and video equipment. Virtually all digital camcorders have three RCA connectors (one video, two audio) that allow them to be connected to an analog VCR.

reaction shot: Examples are a camera shot of a narrator listening to an interview or an isolated camera shot of a person listening to a conversation.

resolution: A measure that shows to what extent details can be distinguished on a computer, video monitor, or television screen.

safety margins: Also referred to as "safe title area," safety margins are two imaginary rectangles on the outer edges of a video picture. The outer rectangle warns that any images or characters outside the rectangle's boundaries may not appear on some monitors.

scan converter: An electronic device that changes the scan rate of a video signal. A scan converter provides the means for computer image to be recorded on videotape or displayed on a standard video monitor or projector.

scene: A portion of a video recording containing an apparent beginning and ending of a thought or action.

script/scripting: Written dialogue and planned actions for a video production or play.

scrub: The action with a video editing program with which you cause video to move frame by frame.

scrubber bar: A bar found in most video editing programs that permits you to drag right or left with your mouse to slowly move video or sound back and forth.

SCSI (Small Computer Systems Interface): A high-speed, standardized means for connecting hard drives, CD-ROM drives, and peripheral devices to a computer.

SECAM (Sequential Couleur a Memoire): The television broadcast standard for France, Russia, and various eastern European countries. SECAM displays 819 lines interlaced at 50 fields per second.

shelf: A term used in iMac iMovie to describe where you store video and audio clips.

shoot: Record something to videotape. The term also refers to the actual process of projection.

shot: An individual segment within a scene.

shutter speed: A measurement in fractions of a second denoting the length of time light is permitted to reach the chips in a camera. Shutter speed is used to avoid blur when recording high-speed movement, such as racecars. Also, shutter speed is used to mask flickering when recording a computer screen on video.

signal-to-noise ratio (S/N): The ratio of video noise to the total signal. S/N is a measurement showing how much higher the signal level is than the level of noise. S/N is expressed in decibels (dB).

soft light: A soft-shadowed illumination of an image.

still frame: A single frame of video repeated over a series of frames. For instance, a still frame is by default given a duration of 30 frames (1 second) in Adobe Premiere.

storyboard: A plan for the shooting of a scene or scenes for a video. Also, a plan for the ordering of individual segments during editing.

take: An individual video recording of a shot within a scene. "Takes" are more than one attempt to adequately record a shot.

take board: A message written on a slate and recorded at the beginning of each take during video production.

telephoto image: An image similar to what you might see in a telescope — magnified but narrow.

tilting: Turning a camera up or down on a tripod.

time code: Electronic chronological names given to video frames within a video sequence. Time code is designated in hours-minutes-seconds-frames. For example, 02:33:44:55 refers to frame position at in hour 2, minute 33, second 44, frame 55.

timeline: A workspace within a video editing program in which clips are laid in a chronological order.

trucking: Physically moving a camera right or left.

Ultra ATA: *Ultra AT Attachment*. A hard drive interface used with EIDE drives that allows data transfer rates of up to 33.3 megabytes per second. See also *EIDE* and *IDE*.

VGA (Video Graphics Adaptor): VGA is a graphics display standard for PCs.

VHS (video home system): Used for recording and playing back video on home VCRs. VHS systems use composite signals consisting of brightness and color information.

video noise: Seen on video as dancing specks. A CCD chip typically has 400,000 or more pixels. Each of those pixels must receive information in the form of color and light. If the object is underlit, many of the pixels do not receive this information. As a result, the camcorder replaces the missing visual information with gibberish, causing dark colors to appear as though they're covered with dancing specks. See also *CCD chip* and *pixel*.

videographer: A person who records video.

VTR: A videotape recorder.

white balancing: A procedure for establishing true white in video recording. White balancing establishes true color under various types of indoor and outdoor lighting conditions.

XLR connector: A three-conductor connector used in high-quality audio equipment, typically with a balanced signal. See also *balanced cable*.

Y/C: A signal consisting of two components — Y for brightness and C for color. The S-VHS format uses a Y/C signal.

• *N* •

• *O* •

Dummies Books™
Bestsellers on Every Topic!

 ## GENERAL INTEREST TITLES

BUSINESS & PERSONAL FINANCE

Title	Author	ISBN	Price
Accounting For Dummies®	John A. Tracy, CPA	0-7645-5014-4	$19.99 US/$27.99 CAN
Business Plans For Dummies®	Paul Tiffany, Ph.D. & Steven D. Peterson, Ph.D.	1-56884-868-4	$19.99 US/$27.99 CAN
Business Writing For Dummies®	Sheryl Lindsell-Roberts	0-7645-5134-5	$16.99 US/$27.99 CAN
Consulting For Dummies®	Bob Nelson & Peter Economy	0-7645-5034-9	$19.99 US/$27.99 CAN
Customer Service For Dummies®, 2nd Edition	Karen Leland & Keith Bailey	0-7645-5209-0	$19.99 US/$27.99 CAN
Franchising For Dummies®	Dave Thomas & Michael Seid	0-7645-5160-4	$19.99 US/$27.99 CAN
Getting Results For Dummies®	Mark H. McCormack	0-7645-5205-8	$19.99 US/$27.99 CAN
Home Buying For Dummies®	Eric Tyson, MBA & Ray Brown	1-56884-385-2	$16.99 US/$24.99 CAN
House Selling For Dummies®	Eric Tyson, MBA & Ray Brown	0-7645-5038-1	$16.99 US/$24.99 CAN
Human Resources Kit For Dummies®	Max Messmer	0-7645-5131-0	$19.99 US/$27.99 CAN
Investing For Dummies®, 2nd Edition	Eric Tyson, MBA	0-7645-5162-0	$19.99 US/$27.99 CAN
Law For Dummies®	John Ventura	1-56884-860-9	$19.99 US/$27.99 CAN
Leadership For Dummies®	Marshall Loeb & Steven Kindel	0-7645-5176-0	$19.99 US/$27.99 CAN
Managing For Dummies®	Bob Nelson & Peter Economy	1-56884-858-7	$19.99 US/$27.99 CAN
Marketing For Dummies®	Alexander Hiam	1-56884-699-1	$19.99 US/$27.99 CAN
Mutual Funds For Dummies®, 2nd Edition	Eric Tyson, MBA	0-7645-5112-4	$19.99 US/$27.99 CAN
Negotiating For Dummies®	Michael C. Donaldson & Mimi Donaldson	1-56884-867-6	$19.99 US/$27.99 CAN
Personal Finance For Dummies®, 3rd Edition	Eric Tyson, MBA	0-7645-5231-7	$19.99 US/$27.99 CAN
Personal Finance For Dummies® For Canadians, 2nd Edition	Eric Tyson, MBA & Tony Martin	0-7645-5123-X	$19.99 US/$27.99 CAN
Public Speaking For Dummies®	Malcolm Kushner	0-7645-5159-0	$16.99 US/$24.99 CAN
Sales Closing For Dummies®	Tom Hopkins	0-7645-5063-2	$14.99 US/$21.99 CAN
Sales Prospecting For Dummies®	Tom Hopkins	0-7645-5066-7	$14.99 US/$21.99 CAN
Selling For Dummies®	Tom Hopkins	1-56884-389-5	$16.99 US/$24.99 CAN
Small Business For Dummies®	Eric Tyson, MBA & Jim Schell	0-7645-5094-2	$19.99 US/$27.99 CAN
Small Business Kit For Dummies®	Richard D. Harroch	0-7645-5093-4	$24.99 US/$34.99 CAN
Taxes 2001 For Dummies®	Eric Tyson & David J. Silverman	0-7645-5306-2	$15.99 US/$23.99 CAN
Time Management For Dummies®, 2nd Edition	Jeffrey J. Mayer	0-7645-5145-0	$19.99 US/$27.99 CAN
Writing Business Letters For Dummies®	Sheryl Lindsell-Roberts	0-7645-5207-4	$16.99 US/$24.99 CAN

TECHNOLOGY TITLES

INTERNET/ONLINE

Title	Author	ISBN	Price
America Online® For Dummies®, 6th Edition	John Kaufeld	0-7645-0670-6	$19.99 US/$27.99 CAN
Banking Online For Dummies®	Paul Murphy	0-7645-0458-4	$24.99 US/$34.99 CAN
eBay™ For Dummies®, 2nd Edition	Marcia Collier, Roland Woerner, & Stephanie Becker	0-7645-0761-3	$19.99 US/$27.99 CAN
E-Mail For Dummies®, 2nd Edition	John R. Levine, Carol Baroudi, & Arnold Reinhold	0-7645-0131-3	$24.99 US/$34.99 CAN
Genealogy Online For Dummies®, 2nd Edition	Matthew L. Helm & April Leah Helm	0-7645-0543-2	$24.99 US/$34.99 CAN
Internet Directory For Dummies®, 3rd Edition	Brad Hill	0-7645-0558-2	$24.99 US/$34.99 CAN
Internet Auctions For Dummies®	Greg Holden	0-7645-0578-9	$24.99 US/$34.99 CAN
Internet Explorer 5.5 For Windows® For Dummies®	Doug Lowe	0-7645-0738-9	$19.99 US/$28.99 CAN
Researching Online For Dummies®, 2nd Edition	Mary Ellen Bates & Reva Basch	0-7645-0546-7	$24.99 US/$34.99 CAN
Job Searching Online For Dummies®	Pam Dixon	0-7645-0673-0	$24.99 US/$34.99 CAN
Investing Online For Dummies®, 3rd Edition	Kathleen Sindell, Ph.D.	0-7645-0725-7	$24.99 US/$34.99 CAN
Travel Planning Online For Dummies®, 2nd Edition	Noah Vadnai	0-7645-0438-X	$24.99 US/$34.99 CAN
Internet Searching For Dummies®	Brad Hill	0-7645-0478-9	$24.99 US/$34.99 CAN
Yahoo!® For Dummies®, 2nd Edition	Brad Hill	0-7645-0762-1	$19.99 US/$27.99 CAN
The Internet For Dummies®, 7th Edition	John R. Levine, Carol Baroudi, & Arnold Reinhold	0-7645-0674-9	$19.99 US/$27.99 CAN

OPERATING SYSTEMS

Title	Author	ISBN	Price
DOS For Dummies®, 3rd Edition	Dan Gookin	0-7645-0361-8	$19.99 US/$27.99 CAN
GNOME For Linux® For Dummies®	David B. Busch	0-7645-0650-1	$24.99 US/$37.99 CAN
LINUX® For Dummies®, 2nd Edition	John Hall, Craig Witherspoon, & Coletta Witherspoon	0-7645-0421-5	$24.99 US/$34.99 CAN
Mac® OS 9 For Dummies®	Bob LeVitus	0-7645-0652-8	$19.99 US/$28.99 CAN
Red Hat® Linux® For Dummies®	Jon "maddog" Hall, Paul Sery	0-7645-0663-3	$24.99 US/$37.99 CAN
Small Business Windows® 98 For Dummies®	Stephen Nelson	0-7645-0425-8	$24.99 US/$34.99 CAN
UNIX® For Dummies®, 4th Edition	John R. Levine & Margaret Levine Young	0-7645-0419-3	$19.99 US/$27.99 CAN
Windows® 95 For Dummies®, 2nd Edition	Andy Rathbone	0-7645-0180-1	$19.99 US/$27.99 CAN
Windows® 98 For Dummies®	Andy Rathbone	0-7645-0261-1	$19.99 US/$27.99 CAN
Windows® 2000 For Dummies®	Andy Rathbone	0-7645-0641-2	$19.99 US/$27.99 CAN
Windows® 2000 Server For Dummies®	Ed Tittel	0-7645-0341-3	$24.99 US/$37.99 CAN
Windows® ME Millennium Edition For Dummies®	Andy Rathbone	0-7645-0735-4	$19.99 US/$27.99 CAN

Dummies Books™
Bestsellers on Every Topic!

GENERAL INTEREST TITLES

FOOD & BEVERAGE/ENTERTAINING

Title	Author	ISBN	Price
Bartending For Dummies®	Ray Foley	0-7645-5051-9	$14.99 US/$21.99 CAN
Cooking For Dummies®, 2nd Edition	Bryan Miller & Marie Rama	0-7645-5250-3	$19.99 US/$27.99 CAN
Entertaining For Dummies®	Suzanne Williamson with Linda Smith	0-7645-5027-6	$19.99 US/$27.99 CAN
Gourmet Cooking For Dummies®	Charlie Trotter	0-7645-5029-2	$19.99 US/$27.99 CAN
Grilling For Dummies®	Marie Rama & John Mariani	0-7645-5076-4	$19.99 US/$27.99 CAN
Italian Cooking For Dummies®	Cesare Casella & Jack Bishop	0-7645-5098-5	$19.99 US/$27.99 CAN
Mexican Cooking For Dummies®	Mary Sue Miliken & Susan Feniger	0-7645-5169-8	$19.99 US/$27.99 CAN
Quick & Healthy Cooking For Dummies®	Lynn Fischer	0-7645-5214-7	$19.99 US/$27.99 CAN
Wine For Dummies®, 2nd Edition	Ed McCarthy & Mary Ewing-Mulligan	0-7645-5114-0	$19.99 US/$27.99 CAN
Chinese Cooking For Dummies®	Martin Yan	0-7645-5247-3	$19.99 US/$27.99 CAN
Etiquette For Dummies®	Sue Fox	0-7645-5170-1	$19.99 US/$27.99 CAN

SPORTS

Title	Author	ISBN	Price
Baseball For Dummies®, 2nd Edition	Joe Morgan with Richard Lally	0-7645-5234-1	$19.99 US/$27.99 CAN
Golf For Dummies®, 2nd Edition	Gary McCord	0-7645-5146-9	$19.99 US/$27.99 CAN
Fly Fishing For Dummies®	Peter Kaminsky	0-7645-5073-X	$19.99 US/$27.99 CAN
Football For Dummies®	Howie Long with John Czarnecki	0-7645-5054-3	$19.99 US/$27.99 CAN
Hockey For Dummies®	John Davidson with John Steinbreder	0-7645-5045-4	$19.99 US/$27.99 CAN
NASCAR For Dummies®	Mark Martin	0-7645-5219-8	$19.99 US/$27.99 CAN
Tennis For Dummies®	Patrick McEnroe with Peter Bodo	0-7645-5087-X	$19.99 US/$27.99 CAN
Soccer For Dummies®	U.S. Soccer Federation & Michael Lewiss	0-7645-5229-5	$19.99 US/$27.99 CAN

HOME & GARDEN

Title	Author	ISBN	Price
Annuals For Dummies®	Bill Marken & NGA	0-7645-5056-X	$16.99 US/$24.99 CAN
Container Gardening For Dummies®	Bill Marken & NGA	0-7645-5057-8	$16.99 US/$24.99 CAN
Decks & Patios For Dummies®	Robert J. Beckstrom & NGA	0-7645-5075-6	$16.99 US/$24.99 CAN
Flowering Bulbs For Dummies®	Judy Glattstein & NGA	0-7645-5103-5	$16.99 US/$24.99 CAN
Gardening For Dummies®, 2nd Edition	Michael MacCaskey & NGA	0-7645-5130-2	$16.99 US/$24.99 CAN
Herb Gardening For Dummies®	NGA	0-7645-5200-7	$16.99 US/$24.99 CAN
Home Improvement For Dummies®	Gene & Katie Hamilton & the Editors of HouseNet, Inc.	0-7645-5005-5	$19.99 US/$26.99 CAN
Houseplants For Dummies®	Larry Hodgson & NGA	0-7645-5102-7	$16.99 US/$24.99 CAN
Painting and Wallpapering For Dummies®	Gene Hamilton	0-7645-5150-7	$16.99 US/$24.99 CAN
Perennials For Dummies®	Marcia Tatroe & NGA	0-7645-5030-6	$16.99 US/$24.99 CAN
Roses For Dummies®, 2nd Edition	Lance Walheim	0-7645-5202-3	$16.99 US/$24.99 CAN
Trees and Shrubs For Dummies®	Ann Whitman & NGA	0-7645-5203-1	$16.99 US/$24.99 CAN
Vegetable Gardening For Dummies®	Charlie Nardozzi & NGA	0-7645-5129-9	$16.99 US/$24.99 CAN
Home Cooking For Dummies®	Patricia Hart McMillan & Katharine Kaye McMillan	0-7645-5107-8	$19.99 US/$27.99 CAN

TECHNOLOGY TITLES

WEB DESIGN & PUBLISHING

Title	Author	ISBN	Price
Active Server Pages For Dummies®, 2nd Edition	Bill Hatfield	0-7645-0603-X	$24.99 US/$37.99 CAN
Cold Fusion 4 For Dummies®	Alexis Gutzman	0-7645-0604-8	$24.99 US/$37.99 CAN
Creating Web Pages For Dummies®, 5th Edition	Bud Smith & Arthur Bebak	0-7645-0733-8	$24.99 US/$34.99 CAN
Dreamweaver™ 3 For Dummies®	Janine Warner & Paul Vachier	0-7645-0669-2	$24.99 US/$34.99 CAN
FrontPage® 2000 For Dummies®	Asha Dornfest	0-7645-0423-1	$24.99 US/$34.99 CAN
HTML 4 For Dummies®, 3rd Edition	Ed Tittel & Natanya Dits	0-7645-0572-6	$24.99 US/$34.99 CAN
Java™ For Dummies®, 3rd Edition	Aaron E. Walsh	0-7645-0417-7	$24.99 US/$34.99 CAN
PageMill™ 2 For Dummies®	Deke McClelland & John San Filippo	0-7645-0028-7	$24.99 US/$34.99 CAN
XML™ For Dummies®	Ed Tittel	0-7645-0692-7	$24.99 US/$37.99 CAN
Javascript For Dummies®, 3rd Edition	Emily Vander Veer	0-7645-0633-1	$24.99 US/$37.99 CAN

DESKTOP PUBLISHING GRAPHICS/MULTIMEDIA

Title	Author	ISBN	Price
Adobe® In Design™ For Dummies®	Deke McClelland	0-7645-0599-8	$19.99 US/$27.99 CAN
CorelDRAW™ 9 For Dummies®	Deke McClelland	0-7645-0523-8	$19.99 US/$27.99 CAN
Desktop Publishing and Design For Dummies®	Roger C. Parker	1-56884-234-1	$19.99 US/$27.99 CAN
Digital Photography For Dummies®, 3rd Edition	Julie Adair King	0-7645-0646-3	$24.99 US/$37.99 CAN
Microsoft® Publisher 98 For Dummies®	Jim McCarter	0-7645-0395-2	$19.99 US/$27.99 CAN
Visio 2000 For Dummies®	Debbie Walkowski	0-7645-0635-8	$19.99 US/$27.99 CAN
Microsoft® Publisher 2000 For Dummies®	Jim McCarter	0-7645-0525-4	$19.99 US/$27.99 CAN
Windows® Movie Maker For Dummies®	Keith Underdahl	0-7645-0749-1	$19.99 US/$27.99 CAN

Dummies Books™
Bestsellers on Every Topic!

GENERAL INTEREST TITLES

EDUCATION & TEST PREPARATION

Title	Author	ISBN	Price
The ACT For Dummies®	Suzee Vlk	1-56884-387-9	$14.99 US/$21.99 CAN
College Financial Aid For Dummies®	Dr. Herm Davis & Joyce Lain Kennedy	0-7645-5049-7	$19.99 US/$27.99 CAN
College Planning For Dummies®, 2nd Edition	Pat Ordovensky	0-7645-5048-9	$19.99 US/$27.99 CAN
Everyday Math For Dummies®	Charles Seiter, Ph.D.	1-56884-248-1	$14.99 US/$21.99 CAN
The GMAT® For Dummies®, 3rd Edition	Suzee Vlk	0-7645-5082-9	$16.99 US/$24.99 CAN
The GRE® For Dummies®, 3rd Edition	Suzee Vlk	0-7645-5083-7	$16.99 US/$24.99 CAN
Politics For Dummies®	Ann DeLaney	1-56884-381-X	$19.99 US/$27.99 CAN
The SAT I For Dummies®, 3rd Edition	Suzee Vlk	0-7645-5044-6	$14.99 US/$21.99 CAN

AUTOMOTIVE

Title	Author	ISBN	Price
Auto Repair For Dummies®	Deanna Sclar	0-7645-5089-6	$19.99 US/$27.99 CAN
Buying A Car For Dummies®	Deanna Sclar	0-7645-5091-8	$16.99 US/$24.99 CAN

LIFESTYLE/SELF-HELP

Title	Author	ISBN	Price
Dating For Dummies®	Dr. Joy Browne	0-7645-5072-1	$19.99 US/$27.99 CAN
Making Marriage Work For Dummies®	Steven Simring, M.D. & Sue Klavans Simring, D.S.W	0-7645-5173-6	$19.99 US/$27.99 CAN
Parenting For Dummies®	Sandra H. Gookin	1-56884-383-6	$16.99 US/$24.99 CAN
Success For Dummies®	Zig Ziglar	0-7645-5061-6	$19.99 US/$27.99 CAN
Weddings For Dummies®	Marcy Blum & Laura Fisher Kaiser	0-7645-5055-1	$19.99 US/$27.99 CAN

TECHNOLOGY TITLES

SUITES

Title	Author	ISBN	Price
Microsoft® Office 2000 For Windows® For Dummies®	Wallace Wang & Roger C. Parker	0-7645-0452-5	$19.99 US/$27.99 CAN
Microsoft® Office 2000 For Windows® For Dummies® Quick Reference	Doug Lowe & Bjoern Hartsfvang	0-7645-0453-3	$12.99 US/$17.99 CAN
Microsoft® Office 97 For Windows® For Dummies®	Wallace Wang & Roger C. Parker	0-7645-0050-3	$19.99 US/$27.99 CAN
Microsoft® Office 97 For Windows® For Dummies® Quick Reference	Doug Lowe	0-7645-0062-7	$12.99 US/$17.99 CAN
Microsoft® Office 98 For Macs® For Dummies®	Tom Negrino	0-7645-0229-8	$19.99 US/$27.99 CAN
Microsoft® Office X For Macs For Dummies®	Tom Negrino	0-7645-0702-8	$19.95 US/$27.99 CAN

WORD PROCESSING

Title	Author	ISBN	Price
Word 2000 For Windows® For Dummies® Quick Reference	Peter Weverka	0-7645-0449-5	$12.99 US/$19.99 CAN
Corel® WordPerfect® 8 For Windows® For Dummies®	Margaret Levine Young, David Kay & Jordan Young	0-7645-0186-0	$19.99 US/$27.99 CAN
Word 2000 For Windows® For Dummies®	Dan Gookin	0-7645-0448-7	$19.99 US/$27.99 CAN
Word For Windows® 95 For Dummies®	Dan Gookin	1-56884-932-X	$19.99 US/$27.99 CAN
Word 97 For Windows® For Dummies®	Dan Gookin	0-7645-0052-X	$19.99 US/$27.99 CAN
WordPerfect® 9 For Windows® For Dummies®	Margaret Levine Young	0-7645-0427-4	$19.99 US/$27.99 CAN
WordPerfect® 7 For Windows® 95 For Dummies®	Margaret Levine Young & David Kay	1-56884-949-4	$19.99 US/$27.99 CAN

SPREADSHEET/FINANCE/PROJECT MANAGEMENT

Title	Author	ISBN	Price
Excel For Windows® 95 For Dummies®	Greg Harvey	1-56884-930-3	$19.99 US/$27.99 CAN
Excel 2000 For Windows® For Dummies®	Greg Harvey	0-7645-0446-0	$19.99 US/$27.99 CAN
Excel 2000 For Windows® For Dummies® Quick Reference	John Walkenbach	0-7645-0447-9	$12.99 US/$17.99 CAN
Microsoft® Money 99 For Dummies®	Peter Weverka	0-7645-0433-9	$19.99 US/$27.99 CAN
Microsoft® Project 98 For Dummies®	Martin Doucette	0-7645-0321-9	$24.99 US/$34.99 CAN
Microsoft® Project 2000 For Dummies®	Martin Doucette	0-7645-0517-3	$24.99 US/$37.99 CAN
Microsoft® Money 2000 For Dummies®	Peter Weverka	0-7645-0579-3	$19.99 US/$27.99 CAN
MORE Excel 97 For Windows® For Dummies®	Greg Harvey	0-7645-0138-0	$22.99 US/$32.99 CAN
Quicken® 2000 For Dummies®	Stephen L . Nelson	0-7645-0607-2	$19.99 US/$27.99 CAN
Quicken® 2001 For Dummies®	Stephen L . Nelson	0-7645-0759-1	$19.99 US/$27.99 CAN
Quickbooks® 2000 For Dummies®	Stephen L . Nelson	0-7645-0665-x	$19.99 US/$27.99 CAN

Dummies Books™
Bestsellers on Every Topic!

GENERAL INTEREST TITLES

CAREERS

Cover Letters For Dummies®, 2nd Edition	Joyce Lain Kennedy	0-7645-5224-4	$12.99 US/$17.99 CAN
Cool Careers For Dummies®	Marty Nemko, Paul Edwards, & Sarah Edwards	0-7645-5095-0	$16.99 US/$24.99 CAN
Job Hunting For Dummies®, 2nd Edition	Max Messmer	0-7645-5163-9	$19.99 US/$26.99 CAN
Job Interviews For Dummies®, 2nd Edition	Joyce Lain Kennedy	0-7645-5225-2	$12.99 US/$17.99 CAN
Resumes For Dummies®, 2nd Edition	Joyce Lain Kennedy	0-7645-5113-2	$12.99 US/$17.99 CAN

FITNESS

Fitness Walking For Dummies®	Liz Neporent	0-7645-5192-2	$19.99 US/$27.99 CAN
Fitness For Dummies®, 2nd Edition	Suzanne Schlosberg & Liz Neporent	0-7645-5167-1	$19.99 US/$27.99 CAN
Nutrition For Dummies®, 2nd Edition	Carol Ann Rinzler	0-7645-5180-9	$19.99 US/$27.99 CAN
Running For Dummies®	Florence "Flo-Jo" Griffith Joyner & John Hanc	0-7645-5096-9	$19.99 US/$27.99 CAN

FOREIGN LANGUAGE

Spanish For Dummies®	Susana Wald	0-7645-5194-9	$24.99 US/$34.99 CAN
French For Dummies®	Dodi-Kartrin Schmidt & Michelle W. Willams	0-7645-5193-0	$24.99 US/$34.99 CAN

TECHNOLOGY TITLES

DATABASE

Access 2000 For Windows® For Dummies®	John Kaufeld	0-7645-0444-4	$19.99 US/$27.99 CAN
Access 97 For Windows® For Dummies®	John Kaufeld	0-7645-0048-1	$19.99 US/$27.99 CAN
Access 2000 For Windows For Dummies® Quick Reference	Alison Barrons	0-7645-0445-2	$12.99 US/$17.99 CAN
Approach® 97 For Windows® For Dummies®	Deborah S. Ray & Eric J. Ray	0-7645-0001-5	$19.99 US/$27.99 CAN
Crystal Reports 8 For Dummies®	Douglas J. Wolf	0-7645-0642-0	$24.99 US/$34.99 CAN
Data Warehousing For Dummies®	Alan R. Simon	0-7645-0170-4	$24.99 US/$34.99 CAN
FileMaker® Pro 4 For Dummies®	Tom Maremaa	0-7645-0210-7	$19.99 US/$27.99 CAN

NETWORKING/GROUPWARE

ATM For Dummies®	Cathy Gadecki & Christine Heckart	0-7645-0065-1	$24.99 US/$34.99 CAN
Client/Server Computing For Dummies®, 3rd Edition	Doug Lowe	0-7645-0476-2	$24.99 US/$34.99 CAN
DSL For Dummies®, 2nd Edition	David Angell	0-7645-0715-X	$24.99 US/$35.99 CAN
Lotus Notes® Release 4 For Dummies®	Stephen Londergan & Pat Freeland	1-56884-934-6	$19.99 US/$27.99 CAN
Microsoft® Outlook® 98 For Windows® For Dummies®	Bill Dyszel	0-7645-0393-6	$19.99 US/$28.99 CAN
Microsoft® Outlook® 2000 For Windows® For Dummies®	Bill Dyszel	0-7645-0471-1	$19.99 US/$27.99 CAN
Migrating to Windows® 2000 For Dummies®	Leonard Sterns	0-7645-0459-2	$24.99 US/$37.99 CAN
Networking For Dummies®, 4th Edition	Doug Lowe	0-7645-0498-3	$19.99 US/$27.99 CAN
Networking Home PCs For Dummies®	Kathy Ivens	0-7645-0491-6	$24.99 US/$35.99 CAN
Upgrading & Fixing Networks For Dummies®, 2nd Edition	Bill Camarda	0-7645-0542-4	$29.99 US/$42.99 CAN
TCP/IP For Dummies®, 4th Edition	Candace Leiden & Marshall Wilensky	0-7645-0726-5	$24.99 US/$35.99 CAN
Windows NT® Networking For Dummies®	Ed Tittel, Mary Madden, & Earl Follis	0-7645-0015-5	$24.99 US/$34.99 CAN

PROGRAMMING

Active Server Pages For Dummies®, 2nd Edition	Bill Hatfield	0-7645-0065-1	$24.99 US/$34.99 CAN
Beginning Programming For Dummies®	Wally Wang	0-7645-0596-0	$19.99 US/$29.99 CAN
C++ For Dummies® Quick Reference, 2nd Edition	Namir Shammas	0-7645-0390-1	$14.99 US/$21.99 CAN
Java™ Programming For Dummies®, 3rd Edition	David & Donald Koosis	0-7645-0388-X	$29.99 US/$42.99 CAN
JBuilder™ For Dummies®	Barry A. Burd	0-7645-0567-X	$24.99 US/$34.99 CAN
VBA For Dummies®, 2nd Edition	Steve Cummings	0-7645-0078-3	$24.99 US/$37.99 CAN
Windows® 2000 Programming For Dummies®	Richard Simon	0-7645-0469-X	$24.99 US/$37.99 CAN
XML For Dummies®, 2nd Edition	Ed Tittel	0-7645-0692-7	$24.99 US/$37.99 CAN

Dummies Books™
Bestsellers on Every Topic!

GENERAL INTEREST TITLES

THE ARTS

Art For Dummies®	Thomas Hoving	0-7645-5104-3	$24.99 US/$34.99 CAN
Blues For Dummies®	Lonnie Brooks, Cub Koda, & Wayne Baker Brooks	0-7645-5080-2	$24.99 US/$34.99 CAN
Classical Music For Dummies®	David Pogue & Scott Speck	0-7645-5009-8	$24.99 US/$34.99 CAN
Guitar For Dummies®	Mark Phillips & Jon Chappell of Cherry Lane Music	0-7645-5106-X	$24.99 US/$34.99 CAN
Jazz For Dummies®	Dirk Sutro	0-7645-5081-0	$24.99 US/$34.99 CAN
Opera For Dummies®	David Pogue & Scott Speck	0-7645-5010-1	$24.99 US/$34.99 CAN
Piano For Dummies®	Blake Neely of Cherry Lane Music	0-7645-5105-1	$24.99 US/$34.99 CAN
Shakespeare For Dummies®	John Doyle & Ray Lischner	0-7645-5135-3	$19.99 US/$27.99 CAN

HEALTH

Allergies and Asthma For Dummies®	William Berger, M.D.	0-7645-5218-X	$19.99 US/$27.99 CAN
Alternative Medicine For Dummies®	James Dillard, M.D., D.C., C.A.C., & Terra Ziporyn, Ph.D.	0-7645-5109-4	$19.99 US/$27.99 CAN
Beauty Secrets For Dummies®	Stephanie Seymour	0-7645-5078-0	$19.99 US/$27.99 CAN
Diabetes For Dummies®	Alan L. Rubin, M.D.	0-7645-5154-X	$19.99 US/$27.99 CAN
Dieting For Dummies®	The American Dietetic Society with Jane Kirby, R.D.	0-7645-5126-4	$19.99 US/$27.99 CAN
Family Health For Dummies®	Charles Inlander & Karla Morales	0-7645-5121-3	$19.99 US/$27.99 CAN
First Aid For Dummies®	Charles B. Inlander & The People's Medical Society	0-7645-5213-9	$19.99 US/$27.99 CAN
Fitness For Dummies®, 2nd Edition	Suzanne Schlosberg & Liz Neporent, M.A.	0-7645-5167-1	$19.99 US/$27.99 CAN
Healing Foods For Dummies®	Molly Siple, M.S. R.D.	0-7645-5198-1	$19.99 US/$27.99 CAN
Healthy Aging For Dummies®	Walter Bortz, M.D.	0-7645-5233-3	$19.99 US/$27.99 CAN
Men's Health For Dummies®	Charles Inlander	0-7645-5120-5	$19.99 US/$27.99 CAN
Nutrition For Dummies®, 2nd Edition	Carol Ann Rinzler	0-7645-5180-9	$19.99 US/$27.99 CAN
Pregnancy For Dummies®	Joanne Stone, M.D., Keith Eddleman, M.D., & Mary Murray	0-7645-5074-8	$19.99 US/$27.99 CAN
Sex For Dummies®	Dr. Ruth K. Westheimer	1-56884-384-4	$16.99 US/$24.99 CAN
Stress Management For Dummies®	Allen Elkin, Ph.D.	0-7645-5144-2	$19.99 US/$27.99 CAN
The Healthy Heart For Dummies®	James M. Ripple, M.D.	0-7645-5166-3	$19.99 US/$27.99 CAN
Weight Training For Dummies®	Liz Neporent, M.A. & Suzanne Schlosberg	0-7645-5036-5	$19.99 US/$27.99 CAN
Women's Health For Dummies®	Pamela Maraldo, Ph.D., R.N., & The People's Medical Society	0-7645-5119-1	$19.99 US/$27.99 CAN

TECHNOLOGY TITLES

MACINTOSH

Macs® For Dummies®, 7th Edition	David Pogue	0-7645-0703-6	$19.99 US/$27.99 CAN
The iBook™ For Dummies®	David Pogue	0-7645-0647-1	$19.99 US/$27.99 CAN
The iMac For Dummies®, 2nd Edition	David Pogue	0-7645-0648-X	$19.99 US/$27.99 CAN
The iMac For Dummies® Quick Reference	Jennifer Watson	0-7645-0648-X	$12.99 US/$19.99 CAN

PC/GENERAL COMPUTING

Building A PC For Dummies®, 2nd Edition	Mark Chambers	0-7645-0571-8	$24.99 US/$34.99 CAN
Buying a Computer For Dummies®	Dan Gookin	0-7645-0632-3	$19.99 US/$27.99 CAN
Illustrated Computer Dictionary For Dummies®, 4th Edition	Dan Gookin & Sandra Hardin Gookin	0-7645-0732-X	$19.99 US/$27.99 CAN
Palm Computing® For Dummies®	Bill Dyszel	0-7645-0581-5	$24.99 US/$34.99 CAN
PCs For Dummies®, 7th Edition	Dan Gookin	0-7645-0594-7	$19.99 US/$27.99 CAN
Small Business Computing For Dummies®	Brian Underdahl	0-7645-0287-5	$24.99 US/$34.99 CAN
Smart Homes For Dummies®	Danny Briere	0-7645-0527-0	$19.99 US/$27.99 CAN
Upgrading & Fixing PCs For Dummies®, 5th Edition	Andy Rathbone	0-7645-0719-2	$19.99 US/$27.99 CAN
Handspring Visor For Dummies®	Joe Hubko	0-7645-0724-9	$19.99 US/$27.99 CAN

IDG Books Worldwide, Inc., End-User License Agreement

READ THIS. You should carefully read these terms and conditions before opening the software packet(s) included with this book ("Book"). This is a license agreement ("Agreement") between you and IDG Books Worldwide, Inc. ("IDGB"). By opening the accompanying software packet(s), you acknowledge that you have read and accept the following terms and conditions. If you do not agree and do not want to be bound by such terms and conditions, promptly return the Book and the unopened software packet(s) to the place you obtained them for a full refund.

1. **License Grant.** IDGB grants to you (either an individual or entity) a nonexclusive license to use one copy of the enclosed software program(s) (collectively, the "Software") solely for your own personal or business purposes on a single computer (whether a standard computer or a workstation component of a multiuser network). The Software is in use on a computer when it is loaded into temporary memory (RAM) or installed into permanent memory (hard disk, CD-ROM, or other storage device). IDGB reserves all rights not expressly granted herein.

2. **Ownership.** IDGB is the owner of all right, title, and interest, including copyright, in and to the compilation of the Software recorded on the disk(s) or CD-ROM ("Software Media"). Copyright to the individual programs recorded on the Software Media is owned by the author or other authorized copyright owner of each program. Ownership of the Software and all proprietary rights relating thereto remain with IDGB and its licensers.

3. **Restrictions on Use and Transfer.**

 (a) You may only (i) make one copy of the Software for backup or archival purposes, or (ii) transfer the Software to a single hard disk, provided that you keep the original for backup or archival purposes. You may not (i) rent or lease the Software, (ii) copy or reproduce the Software through a LAN or other network system or through any computer subscriber system or bulletin-board system, or (iii) modify, adapt, or create derivative works based on the Software.

 (b) You may not reverse engineer, decompile, or disassemble the Software. You may transfer the Software and user documentation on a permanent basis, provided that the transferee agrees to accept the terms and conditions of this Agreement and you retain no copies. If the Software is an update or has been updated, any transfer must include the most recent update and all prior versions.

4. **Restrictions on Use of Individual Programs.** You must follow the individual requirements and restrictions detailed for each individual program in Appendix A of this Book. These limitations are also contained in the individual license agreements recorded on the Software Media. These limitations may include a requirement that after using the program for a specified period of time, the user must pay a registration fee or discontinue use. By opening the Software packet(s), you will be agreeing to abide by the licenses and restrictions for these individual programs that are detailed in Appendix A and on the Software Media. None of the material on this Software Media or listed in this Book may ever be redistributed, in original or modified form, for commercial purposes.

Installation Instructions

For Mac OS users

1. **Insert the CD into your computer's CD-ROM drive.**

 In a moment, an icon representing the CD you just inserted appears on your Mac desktop. Chances are, the icon looks like a CD-ROM.

2. **Double-click the CD icon to show the CD's contents.**

3. **Double-click the Read Me First icon.**

 The Read Me First text file contains information about the CD's programs and any last-minute instructions you may need in order to correctly install them.

4. **To install most programs, just drag the program's folder from the CD window and drop it on your hard drive icon.**

5. **Other programs come with installer programs — with these, you simply open the program's folder on the CD and then double-click the icon with the words "Install" or "Installer."**

 Sometimes the installers are actually self-extracting archives, which just means that the program files have been bundled up into an archive, and this self-extractor unbundles the files and places them on your hard drive. This kind of program is often called a .sea. Double-click anything with .sea in the title, and it will run just like an installer.

For Windows users

1. **Insert the CD into your CD-ROM drive.**

 Wait a few seconds while your CD-ROM reads the CD.

2. **Double-click the My Computer icon on your desktop and then double-click the icon for your CD-ROM drive.**

 A window opens that reveals the contents of the CD.

3. **Please read the ReadMe file (readme.txt) and End User License file (license.txt) by double-clicking their icons.**

For more information, see the "About the CD" in Appendix A.

YOUR ONLINE RESOURCE

WWW.DUMMIES.COM

Discover Dummies Online!

The Dummies Web Site is your fun and friendly online resource for the latest information about *For Dummies*® books and your favorite topics. The Web site is the place to communicate with us, exchange ideas with other *For Dummies* readers, chat with authors, and have fun!

Ten Fun and Useful Things You Can Do at www.dummies.com

1. Win free *For Dummies* books and more!
2. Register your book and be entered in a prize drawing.
3. Meet your favorite authors through the IDG Books Worldwide Author Chat Series.
4. Exchange helpful information with other *For Dummies* readers.
5. Discover other great *For Dummies* books you must have!
6. Purchase Dummieswear® exclusively from our Web site.
7. Buy *For Dummies* books online.
8. Talk to us. Make comments, ask questions, get answers!
9. Download free software.
10. Find additional useful resources from authors.

Link directly to these ten fun and useful things at **http://www.dummies.com/10useful**

For other technology titles from IDG Books Worldwide, go to www.idgbooks.com

Not on the Web yet? It's easy to get started with *Dummies 101*®: *The Internet For Windows*® *98* or *The Internet For Dummies*® at local retailers everywhere.

Find other *For Dummies* books on these topics:

Business • Career • Databases • Food & Beverage • Games • Gardening • Graphics • Hardware Health & Fitness • Internet and the World Wide Web • Networking • Office Suites Operating Systems • Personal Finance • Pets • Programming • Recreation • Sports Spreadsheets • Teacher Resources • Test Prep • Word Processing

IDG BOOKS WORLDWIDE
BOOK REGISTRATION

Register This Book and Win!

We want to hear from you!

Visit **http://my2cents.dummies.com** to register this book and tell us how you liked it!

- Get entered in our monthly prize giveaway.

- Give us feedback about this book — tell us what you like best, what you like least, or maybe what you'd like to ask the author and us to change!

- Let us know any other *For Dummies*® topics that interest you.

Your feedback helps us determine what books to publish, tells us what coverage to add as we revise our books, and lets us know whether we're meeting your needs as a *For Dummies* reader. You're our most valuable resource, and what you have to say is important to us!

Not on the Web yet? It's easy to get started with *Dummies 101*®: *The Internet For Windows*® *98* or *The Internet For Dummies*® at local retailers everywhere.

Or let us know what you think by sending us a letter at the following address:

For Dummies Book Registration
Dummies Press
10475 Crosspoint Blvd.
Indianapolis, IN 46256

BESTSELLING BOOK SERIES